Graphic idea notebook

Second Edition

notebook

ROCKPORT PUBLISHERS – Rockport, Massachusetts
DISTRIBUTED BY NORTH LIGHT BOOKS – Cincinnati, Ohio

Copyright © 1980 by Jan White

First published 1980 in the United States and Canada by
Watson-Guptill Publications,
a division of Billboard Publications, Inc.
1515 Broadway, New York, NY 10036

Revised edition published 1991 by
Rockport Publishers, Inc.
P.O. Box 397 · 5 Smith Street
Rockport, MA 01966
(508) 546-9590

Distributed to the art trade and book trade in the U.S. and Canada by
North Light, an imprint of F&W Publications
1507 Dana Avenue
Cincinnati, OH 45207
(800) 289-0963
(513) 531-2222

Distributed to the art trade and book trade throughout the rest of the world by
Rotovision SA
9 Route Suisse
CH-1295 Mies
Switzerland
(0)22-755 30 55

Other distribution by Rockport Publishers, Inc.

New material for revised edition by Jan V. White
Revised Edition produced by Ken Pfeifer/Rockport Publishers
Production Artist: Cathy Gale/Rockport Publishers
Production coordination: Stephen Bridges/Bridges Design

Library of Congress Cataloging in Publication Data
White, Jan V 1928–
 Graphic idea notebook

 Includes index.
 1. Printing, Practical—Layout. 2. Graphic arts.
3. Pictures—Printing. I. Title.
Z246.W58 1980 686.2′24 80-423
ISBN 0-935603-64-6

Printed by BookCrafters, Chelsea, Michigan, USA.

Graphic idea notebook

Graphic Design for the Electronic Age
The manual for traditional and desktop publishing

Color for the Electronic Age
What every desktop publisher needs to know about using color effectively

Great Pages
A common sense approach to effective desktop design

Great Color
How to make pages sparkle, type talk and diagrams sing

Editing by Design
Word and picture communication for editors and designers

Designing for Magazines
Common problems, realistic solutions

Using Charts and Graphs
1000 Ideas for visual persuasion

Mastering Graphics
Design and production made easy

The Grid Book
A guide to page planning

On Graphics: Tips for Editors
A miscellany of practical fundamentals

18 Ready-to-use Grids
For standard and 8½″ x 11″ pages

Xerox Publishing Standards (co-author)
A manual of style and design

Learn Graphic Design
A 6-hour seminar-length video

Imagine a time when there were no faxes, no answering machines, no micro-waves, no CD players, no VCRs, no Cuisinarts, no Post-its—how primitive. No computers? (Big number-crunchers were around at that time. They didn't do pages.) You mean people actually *enjoyed* making up pages using rubber cement, razor blades and scotch tape? Indeed they did ten short years ago, when the first edition of this book was published. It feels like yesterday, but look how much has changed. I was then still very much involved in the magazine end of publishing. That is why the original introduction is worded the way it is. It makes as much sense today. That's why it follows this one with no changes. We didn't even bother to reset it from the original Century Expanded into Trump 'for the sake of consistency'.

The fundamental problems of communication that obtained ten short/long years ago have not gone away, nor have they been solved. They are still with us, and they are the same as they ever were. No, that is not true. They are worse. More printed matter masquerading as "information" is produced every year and the flood rises ever higher. Add electronic information systems, film, television, radio, billboards, junk mail—no wonder we don't listen or read or pay attention as we used to. A hundred years ago a newspaper was a valued commodity whose arrival was awaited with anticipation. Today we sift the pile of stuff that comes in every day and reject as much of it as we can. We have to protect ourselves. We avoid getting involved. Involvement means paying attention, concentrating, read-ing, working. There's just too much. If we don't start we won't get caught.

What about that much-vaunted technology of this so-called Information Age? Hasn't it helped? No, it has not improved the way we think. It has just made it easier to churn out printed matter *faster,* rarely *better.* It has merely added a layer of heavy user manuals, service documents, installation instructions and whatnot. It has also introduced glossaries-ful of new words, new concepts, new techniques that make those who don't understand them feel inferior. At the same time, Technology has also forced a lot of people who had never dreamed of getting involved in "publishing" into the publication-making profession. Charming, friendly, innocent people suddenly find themselves putting out newsletters, announcements, technical documents, you name it. They are awed by the appar-ent complexity of the task and their own lack of expertise. "I don't know how it's s'posed to be done . . . I haven't been trained for it . . . I gave up art in Junior High . . . so is it OK if I indent paragraphs or is it better to have a space between them instead—hey, maybe both?" They believe that there must be answers, since they have so many questions.

Authoritative answers imply that there is a Truth somewhere and that the Experts, especially those who went to J-school (J = journalism) or the Artists, know them, because they were officially revealed to them as part of their initiation rites. Ha! Let's let the secret out of the bag: ain't no Santa Claus, ain't no Easter Bunny, ain't no Design Laws. In communication there is nothing Correct or Incorrect. We can only rely on our judgment, and use the techniques that expose what we have to say vividly.

Our audience, no matter how demographically sophisticated or primitive, is busy. They have no time. Nor are they inclined to pay attention, given all the tempta-tions that pull them this way and that. First we must therefore fascinate them, if we ever hope to catch them. We must intrigue them by showing them the value, the benefit, the what's-in-it-for-me factor of the information, so they will *want to* pay attention. We must expose its value-to-them both verbally and visu-ally. We must organize the information in logical, accessible units. We must pre-sent the material so its segments are easy to recognize and find. We must prepare it so the recipients will realize that they are getting the greatest benefit most quickly with the least amount of work.

We must learn to think both verbally and visually. Show-and-tell is a successful technique in kindergarten. It works just as well for grownups. Showing (OK, call it "Design") is fast becoming an integral factor in the structure and thus the appearance—and interpretation—of our product. Mere graphic cosmetic prettification is no longer good enough. We must control not just what we say or how we say it, but also how it looks on the page, so the listener/viewer will *want to* heed, hear, and understand.

The trouble is that most presentation-in-print follows established, traditional, immutable practices. Where do they come from? They are an accumulation of experience encrusted with misunderstood and unquestioned axioms. To make matters worse, they are also what we believe the boss (or that vague entity known as "They") expects. I am not suggesting that we should throw them out. They work reasonably well and the system is geared to them. What I am suggesting is that we have to enrich them, if we want to make them work better. That is why we must open our minds to other means of communication, to add a little startling spice to that dull old stew.

Verbo-visual spice is what this book is about. It is a collection of suggestions intended to spark ideas. The principles are grouped in logical batches, but that is merely for the sake of traditional bookmaking. They could have been organized as stream of consciousness just as well. Forget the Table of Contents or the Index. Dip in at random. I have tried to make the points vivid, so you'll probably find some silly, outrageous nonsense in here. Great. It is supposed to startle and provoke. It is supposed to make you say, "Hey, yeah!"

How does this edition differ from its predecessor? Magazine-makers' jargon has been reworded to make the principles more accessible. New subjects have also been added: two more pages on mugshots, six arguing for the human touch in drawing (illustrated by skulls: you can't miss them as you flip the pages), and 14 on arrows and their communication potential. Other than that, it remains the swipe-file that it was intended to be.

Please realize that the visual ideas in this compendium are merely the first step in making your printed pages livelier. The best visual ideas are never merely illustrations of something. They *are* that something in and of themselves. Accompany the visuals with vivid, appropriate wording and you have created an irresistible force. Here are a few working tips that might also help:

- Don't search for the Ideal Answer, because there is none. Most problems have many answers, all of them right. Go with the good one you have and work it up so it sings.

- Exaggerate an aspect of the problem. Make a parody. Work with unexpected contrasts such as old/young, light/dark, smooth/scratchy, tiny/huge, etc.

- Discipline yourself to solving the problem only pictorially or only typographically or only in red or something. Force yourself to think differently.

- If you are stuck, go away and think about something else. When you come back, a germ of an idea will probably have appeared. Better still, sleep on it, and trust the brain to do its work independently. It is amazing how well that works.

- Don't reject ideas just "because we've never done it that way," "they won't understand it," "they won't like it," or "it will cost too much."

- Don't be afraid to look foolish. Risk is inevitable when thinking up new ideas. It is better to try and flop than to wimp out.

- Most of all, have fun. Your own confidence communicates itself to the audience, builds trust, helps credibility, and reinforces the message.

Westport, Connecticut, August 1990

A few words about word-people and "Art":

Editors are inevitably overworked, short-handed, underfinanced, and behind schedule. That is simply part of the definition of "editor." But, much more serious, editors of all varieties of publications—magazines, newspapers, books, newsletters, house organs; cheap or expensive, flossy or plain—are also fundamentally word-oriented.

For many editors, "art" is secondary, after-the-fact, and something that has to be grudgingly accepted as an unavoidable nuisance, necessary for "dressing up" the pages. An editor may be a former English major, or an ex-engineer who gravitated to the magazine of his or her specialty, or a newspaper-oriented journalism graduate who sees pictures as sidebars, or maybe just a generalist who somehow got stuck with the company periodical. As such, all of them are experts when it comes to knowing what the story is about, understanding its content and gauging its potential effect on their audience. They are eminently qualified to make judgments about these things.

They also *know what they like* in terms of "design" when they see it somewhere else. But they are too often unable to combine these insights: that is, to give form (i.e. "design") to those precious words. They are stumped because they must deal with what they fear as "art." So they pass the buck to the art department (or whatever version of art help is available) or if they are do-it-yourselfers, they most probably put off thinking about it until the last possible moment.

Many editors feel hamstrung by their lack of expertise in "art"; they are daunted by their unfamiliarity with the jargon; and they are worried by their admitted incapacity to draw a straight line (which seems to be the standard excuse not to try). Many of them are so needlessly intimidated by their lack of knowledge about graphic design that they don't see the simple truth: ninety-nine percent of what is called "art" or "design" in publishing is really nothing but common sense. It is simply the graphic expression of the content of the story. It is just taking a bunch of thoughts and giving them visible form in type, in illustrative images of some sort, and in the arrangement of those elements on the page.

Publication design is not an arcane, occult, esoteric skill. There is no secret password or handshake to get into the club. Page design is merely the last step of the editing process.

All that editors need to do is broaden their view to include that extra dimension their stories take when they are metamorphosed from manuscript into printed page form. Obviously, there must be a natural relationship between the direction of a story's thoughts and the appearance of those thoughts in print. That relationship must be simple, clear, and appropriate. It is successful only when it is editorially logical. And logic is another word for common sense—a commodity that word-people have plenty of.

now a few words about picture-people:

Designers, like editors, are overworked, short-handed, and underfinanced. They are even farther behind schedule than editors because they get squeezed between editorial delays and unextendable publishing deadlines. Too often they are asked to be brilliant and creative under the gun, thinking up clever concepts on the one hand, and solving jigsaw puzzles on the other—both on the spur of the moment. To complicate matters, seldom if ever do the editors help them by explaining the purpose of the story so they can bring it out and give it visibility through expressive handling of the material on the page. Most likely, the editors don't realize how essential such an understanding is and how much better the result could be if the designer had it!

As a result, the designers' job remains limited to making handsome page arrangements for the sake of making handsome page arrangements. Prettification.

Frankly, such prettification is indeed that arcane mystery editors believe it to be, because it is based on subjective "liking" by the designer. But good publication design is far more functional and important than just that. Given half a chance to base his work on an understanding of the journalism involved, the designer can be of tremendous help to the editors in producing a piece that *communicates* while looking pretty. Looking pretty is a by-product: the prime purpose of an art director's work is to apply his or her knowledge of design techniques to catapult ideas off the page into the reader's mind.

This implies an understanding of both editorial purposes and graphic techniques, to make sure that the graphic techniques that are chosen are the right ones for the job, for editorial reasons and not artistic reasons: for reasons that are significant and justified by the contents of the story. That is why understanding the purpose of the story is the first essential for the designer. And that is why designers have to add journalistic ambition to their artistic ambition and get their kicks from achieving a well-communicated message rather than from devising a stunning layout.

about the team of word-people and picture-people:

Editors and designers must work together as a team. To function optimally they should keep two very important factors in mind:

1/ There's nothing new under the sun. Someone somewhere thought up the same idea or used the same trick. There is no point in trying to reinvent the wheel. All that is needed is to use common sense and intelligence in order to turn the same old tried-and-true materials into a fresh and unexpected mix. Such a new mix may well turn out to be clever and innovative, even original. Wonderful! But that's just gravy. Originality per se is not the purpose of the exercise. The true purpose is to make dull material interesting, thus to catch the reader's attention, hold it, and transmit a message. To do this successfully means that we must make the most of those special qualities that are inherent in the material, be they thoughts, facts, words, images, charts, tables, diagrams or whatnot. We must bring those qualities out and give them unmistakable visibility, so they can do their attention-attracting and story-telling.

2/ The vast majority of raw material we are faced with using in our publications is just plain dull. Most of it is repetition of, or (if we're lucky) variation on the same old themes whose importance lies in the information they contain. There's nothing wrong with that prosaic dullness. On the contrary: it provides an opportunity for editors and designers to become alchemists who transmute the dross into editorial gold.

Needed are: imagination; ingenuity; courage; time; effort; and some investment of treasure of course. But above all, what is needed is clear editing: a lucid understanding of what the point of all the material is—*the reason for publishing*. Once that is articulated, it can be given visibility and emphasis by graphics. In fact, GRAPHICS = EDITORIAL TOOL. That is the secret formula. Like all such "secrets" it is both obvious and deceptively simple.

and about this book:

It is a compendium of answers to various kinds of needs. When it was first conceived, (and when its first few pages were published in FOLIO magazine), it was entitled somewhat bombastically the *Editor's Vademecum*. I used the Latin because there seems to be no English equivalent to the concept of *vademecum*, which literally means "go with me." In English, the term refers to a ready reference book or manual that is *regularly* carried about by a person: a working companion. This is exactly what the *Graphic Idea Notebook* is intended to be—and it does this by fulfilling several functions.

Its fundamental purpose is to act as a SPARKPLUG FOR IDEAS, to jolt editors and art directors out of the habit patterns of thinking and working that we all fall into. We develop these habits as shortcuts for getting the job done as expediently as possible, but they can often become substitutes for original thinking and prevent us from seeing acutely, and solving problems inventively. This book is designed to be thumbed through when you need a new approach to handling some graphic dilemma. When the book is used in this general way, the fact that it is organized in categories can become a hindrance. So forget the arbitrary division of the subject matter in this case, and just riffle through the pages—the nub of the idea you need may well lie concealed where you might not expect it.

One important plea: don't get lost in the specifics of the illustrations. They are just "dummy" images to illustrate underlying principles. Avoid getting locked into thinking that the principle—as shown, perhaps, by an upside-down cow on page 15—can only be legitimately used for cows. It has validity for upside-down *anythings*; it is the upside-down-ness that matters, not the silly cow.

Most editors (and certainly all art directors) establish a secret file into which they stuff tearsheets of good ideas. Needless to say, these ideas are seldom properly filed. It usually follows that when an idea is needed in a hurry (meaning, of course, whenever one is needed), it cannot be found. What is usually found is a cache of oddments whose significance you cannot for the life of you recall. For frustrating years I dug through such a drawerful myself until, in desperation, I organized all the material according to problems-and-their-solutions: how to make things look old; how to show the passage of time; how to indicate improvement in value; how to symbolize ethnicity, and so forth. That was the foundation of this book, which is organized along the same lines.

Inclusion of material was based on three rational criteria: 1) Usefulness to the working editor and designer; 2) ease of production (cheapness); and 3) simplicity of explanation to suppliers and printers. So this book is a PRACTICAL GUIDE to what ought to be realistically feasible without too much stress on either patience or budget. And this brings us to another of the book's basic purposes.

How often do you remember some effective graphic technique you saw somewhere—yet you cannot remember exactly what it looked like, let alone where you saw it? But you know that it would be just right for this particular situation. It's nearly impossible to communicate this kind of half-recalled, undefined image to someone else without an example to show them. This book is arranged as a catalog precisely to help you deal with situations like this. If one of the illustrations can jog the memory of a specific technique you once saw, then it can be used as a SHOW-AND-TELL DOCUMENT to point to as you say, "Let's try something like this."

Since the book is organized around problems commonly faced in daily publishing practice, it also functions as a QUICK REFERENCE AID to help the enlightened editor or designer who is searching for that one special technique for dealing with a particular situation: how to make the most of a box, if that's all there is to work with; what to do with that bunch of uninspiring mugshots so they don't look like the ones in last month's issue; how to break up the text to turn it from a field of monolithic, daunting grey, into apparently shorter and easier-to-tackle chunks; how to bring out the hidden qualities in photos that are editorially significant but photographically dull—and so forth.

By the way, please note that the design of *The Graphic Idea Notebook* is itself a DEMONSTRATION of some of the graphic possibilities of our medium. The chapter openers all illustrate the three-dimensionality of a piece of paper—their purpose is to show that the flow of space from one side of

the paper overleaf to the other can well be utilized for editorial purposes.

The cover, half-title, and title pages are also intended to be examples of this three-dimensionality. The positive front cover contrasted with the negative-and-backwards back cover illustrates the object-ness of the book; its "thing-ness." The half-title and title pages show the possibilities of making opaque paper appear to be transparent by printing identical images on both sides of the sheet, with the verso flopped, of course. What is it meant to prove? Who knows? But isn't it interesting?

The titles to some of the chapters are placed at peculiar angles. Why? As a reminder that everything need not be imposed in the available space in the expected vertical/horizontal relationship to the page's edges.

While on the subject of chapter openers, the pages opposite the chapter titles have been left blank expressly for the purpose of giving you space to annotate cross-references to your own material. As the "notebook" sits on the shelf above your desk and as you keep adding notes to it, it will become an increasingly useful PERSONAL SWIPEFILE. That's why I wrote the notes in it by hand rather than having them set in formal typography; I wanted to establish an informal atmosphere to encourage your own scribbling in it.

Now, as far as the irreverent bits of humor are concerned: they, too, are here for a serious purpose—to serve as a reminder not to take ourselves too seriously. Obviously, we try to make everything we publish as worthy, useful, and valuable as possible. But let's not forget that any single impression on a page is just one of a sequence of impressions in the publication as a whole, and that the next issue (next week, next month) will displace everything in the current one with a completely new set of such impressions. So how much does it really matter if we try a graphic trick and it falls flat (in our own hypercritical eyes)? There's always the next issue, so let us see our work in its full context, and take it with a pinch of salt or a grain of humor.

In no way does this imply that what editors and designers do is unimportant! The total image we build through our publications—in both their journalistic and graphic aspects—is desperately important. But any single detail must always be perceived as just that: a small part of a larger whole. To a great extent, this book is about DETAILING, and it is in the details that we can give free rein to our sense of humor and our desire to play. That is, after all, how we can make the product more lively. So let us risk failure in such a good cause, and if we don't create perfection every time, who cares?

There is no editor-in-chief in the sky keeping score!

It is customary to thank the people who have been helpful in the process of book-making. How I wish I could have palmed off some of the labors onto someone else! Alas, this book being the personal document it is, I was stuck with doing it all, even typing the damned manuscript. That's why there is so little text. But I must mention my dear wife, Clare, whose patience with ruined weekends ("I've got to get on with the *Notebook*, I can't go to the beach") was Job-like, and whose encouragement and support made it all possible.

And I must thank my friends Joe Hanson, Howard Ravis, and Chuck Tannen of FOLIO Magazine, who published many of these pages during the past three years. I do not thank them merely for the space they gave me—though that in itself ought to be enough—but because they ran the pages as delivered. Can you imagine? No editing! What luxury! What fun!

Westport, December 1979

Graphic Idea Notebook

Table of contents

Graphic Idea Notebook

Getting attention

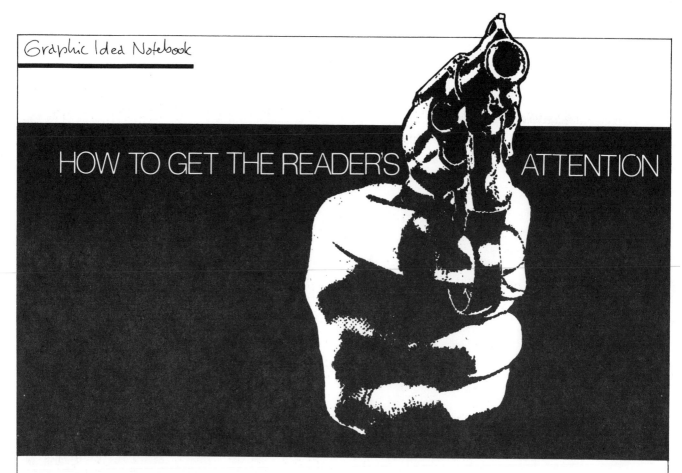

HOW TO GET THE READER'S ATTENTION

The essential ingredient: a good editorial idea—one that is worth calling attention to. Without such value, no amount of graphic flamboyance makes sense. It may work that first time, and it may well yield some visual excitement for the issue. But that's cheating the reader who will grow suspicious of hype. And the publication will suffer in the long run because of this inflation of presentation techniques.

BUT, if there is something worth trumpeting out loud, here is a collection of ways to do it (besides, of course, the fundamental way of making it big). Below: two useful attention-getting devices: 1) pinning the idea on someone the reader is likely to recognize and respect (Messrs. Napoleon, Beethoven and Shakespeare might fill the requirements?) and 2) elaborating the idea with symbols the reader recognizes as importance symbols (big exclamation points, out-of-scale quote marks, fat balloons).

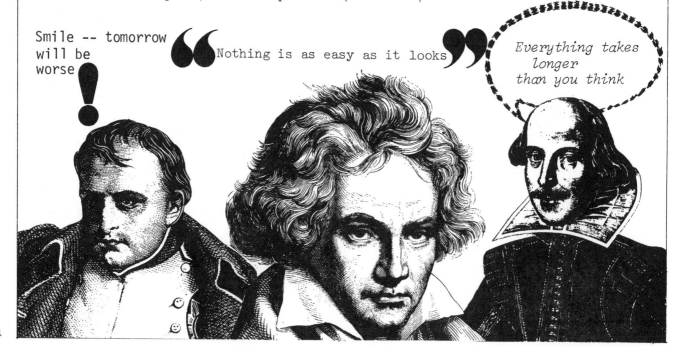

Smile -- tomorrow will be worse !

"Nothing is as easy as it looks"

Everything takes longer than you think

Simplify: edit out the competition. Get rid of the distractions, so the viewer is forced to pay attention to the elements that are editorially essential (i.e. the reason for publishing).

Graphic Idea Notebook / Getting attention

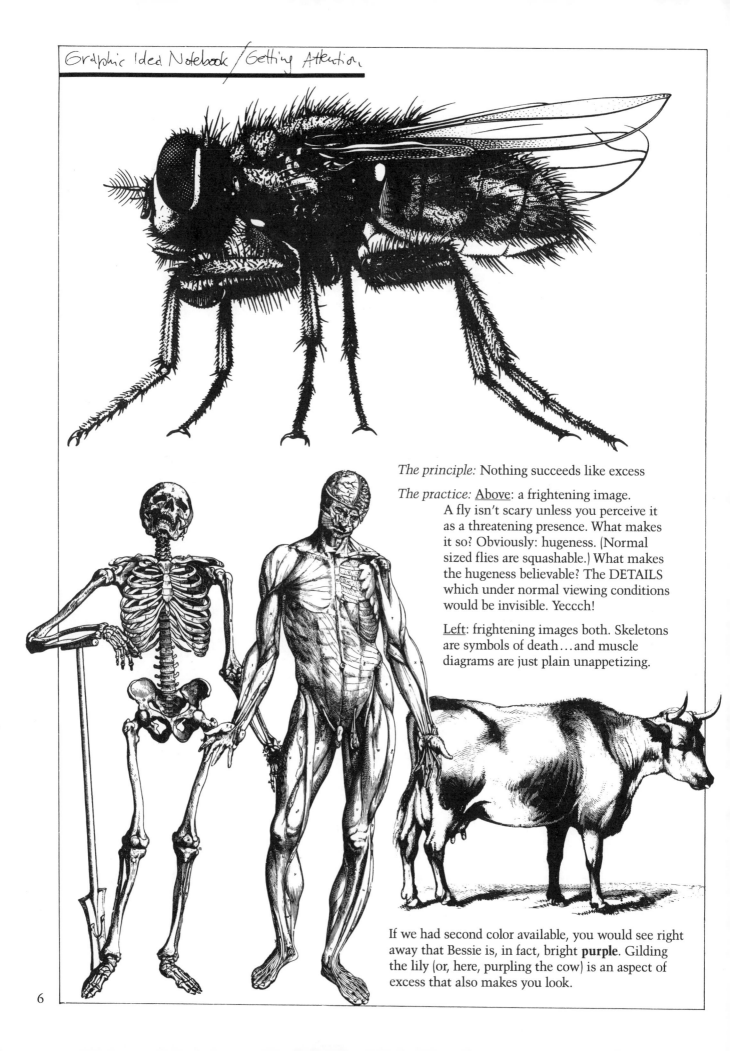

The principle: Nothing succeeds like excess

The practice: <u>Above</u>: a frightening image. A fly isn't scary unless you perceive it as a threatening presence. What makes it so? Obviously: hugeness. (Normal sized flies are squashable.) What makes the hugeness believable? The DETAILS which under normal viewing conditions would be invisible. Yeccch!

<u>Left</u>: frightening images both. Skeletons are symbols of death...and muscle diagrams are just plain unappetizing.

If we had second color available, you would see right away that Bessie is, in fact, bright **purple**. Gilding the lily (or, here, purpling the cow) is an aspect of excess that also makes you look.

42

The principle: Unanticipated incongruity (whether it be playful and whimsical or irrational and thus surrealistic) will astonish, jar, shock, surprise, bewilder, amaze—and gain attention.

The practice: <u>Above</u>: combining images that are unexpected in subject as well as scale.
<u>Right</u>: showing an ordinary image in an extraordinary technique or rendering.
<u>Below</u>: turning an image at an unexpected angle—like the USA map. (The skeleton just looks a bit more dead!)

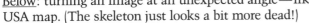

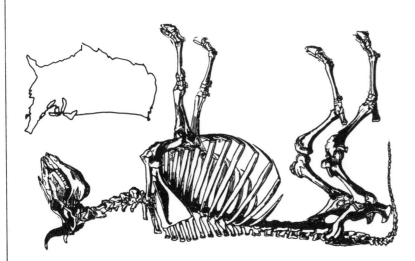

The principle: CONTRAST works (as long as it is obvious enough—deliberately, strongly done).

The practice: contrast of size.
<u>Left</u>: something big in a small space.
<u>Below</u>: something small in a big space.

OK: Not likely to be putting big feet in a box? How about applying the principle to plain typography?

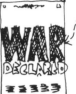

Bigness in type (or anything else) is the most widely accepted symbol for importance)

Smallness in a big space is even more effective

The principle holds true for any other sort of contrast—style, language, material, color, etc., etc.

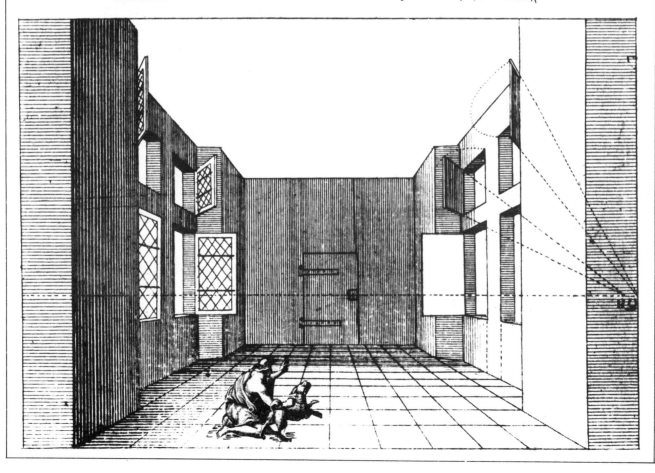

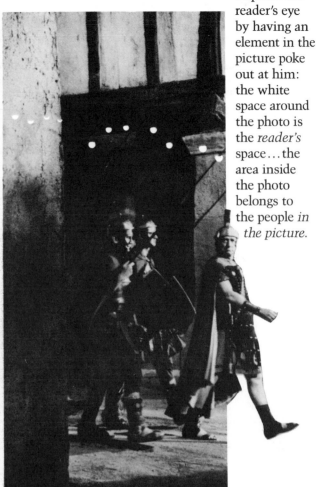

Capture the reader's eye by having an element in the picture poke out at him: the white space around the photo is the *reader's* space...the area inside the photo belongs to the people *in the picture.*

 Whenever possible, look at the subject from an unexpected unusual angle

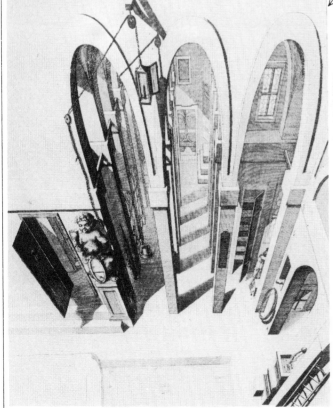

If you can get away with it, crop that picture in some peculiar way (like chopping off the subject's head—made you look, didn't it?)

9

Here's a singularly unlikely subject for glamour—yet by cutting and pasting prints of the three exposures ➜ a startling panorama can be manufactured…

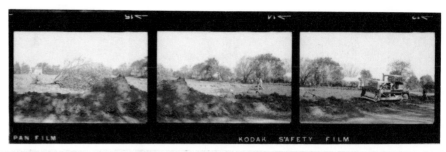

Expand the story-telling capacity of a simple picture by drawing extensions of the image

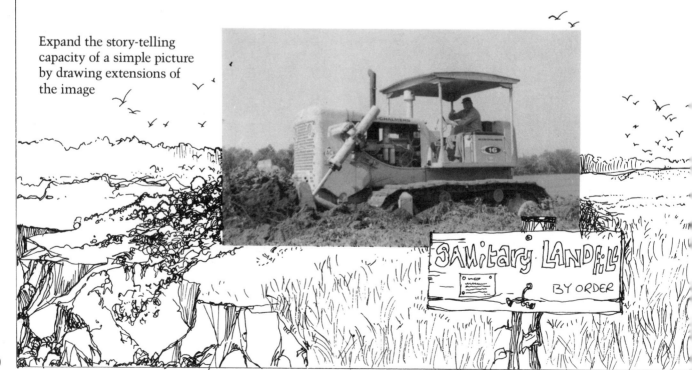

A panorama is fine to have on a 2-page spread like this one (true, it would be better if it bled at both sides). But how much more impressive it would be, were it a full 3-page gatefold!

Good

Better

Best

Gatefold

↑
JOIN HERE

Clarify (or draw attention to) an important element on the periphery of a photo by turning that part into a drawing. That way, editorial emphasis can be brought onto an area the reader might well have missed.

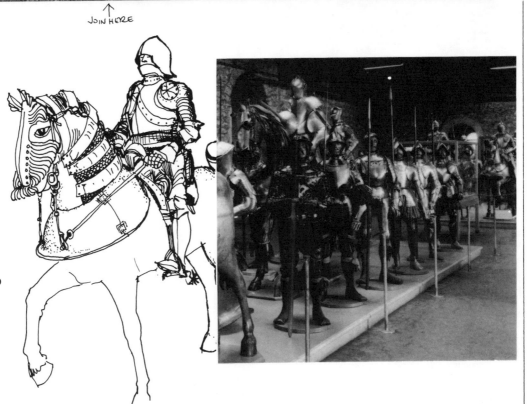

This example is the logical outcome of the suggestions on the preceding two pages. It combines the photo with line art in a sense-making relationship, by showing the *what* (in the picture) and the *how* (in the drawing). By combining the two into a unified image, the functional interplay between the *what* and the *how* is brought into focus as an integral element of the story. That's something that would be missing from the usual presentation technique which would show the two independently—one as a photo, the other as a drawing nearby.

Excrescence

Startling effects can be achieved by using words and doing things with them—specially if the words are a bit unusual and if the type in which they are set is also "different."

RIDICULOUS
RIDICULOUS
SUOLUCIDIR

Taking a word and running it backwards—or just a piece of it flopped left to right. Or all of it.

split shake

AMAZING

Taking a word and making it into a picture in some way.

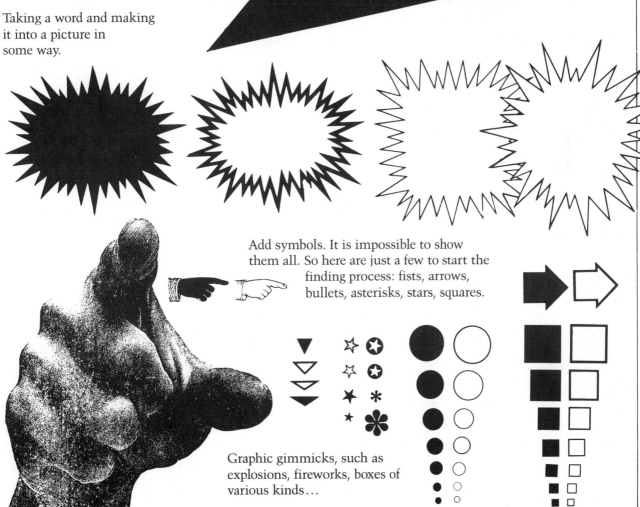

Add symbols. It is impossible to show them all. So here are just a few to start the finding process: fists, arrows, bullets, asterisks, stars, squares.

Graphic gimmicks, such as explosions, fireworks, boxes of various kinds…

13

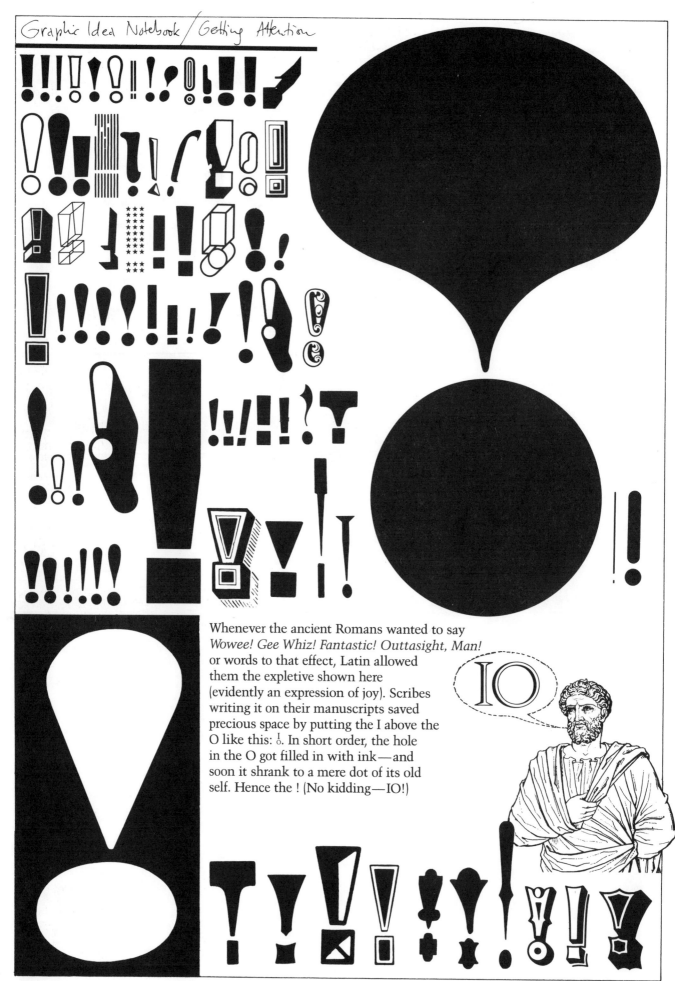

Whenever the ancient Romans wanted to say *Wowee! Gee Whiz! Fantastic! Outtasight, Man!* or words to that effect, Latin allowed them the expletive shown here (evidently an expression of joy). Scribes writing it on their manuscripts saved precious space by putting the I above the O like this: Ⅰ̥. In short order, the hole in the O got filled in with ink—and soon it shrank to a mere dot of its old self. Hence the ! (No kidding—IO!)

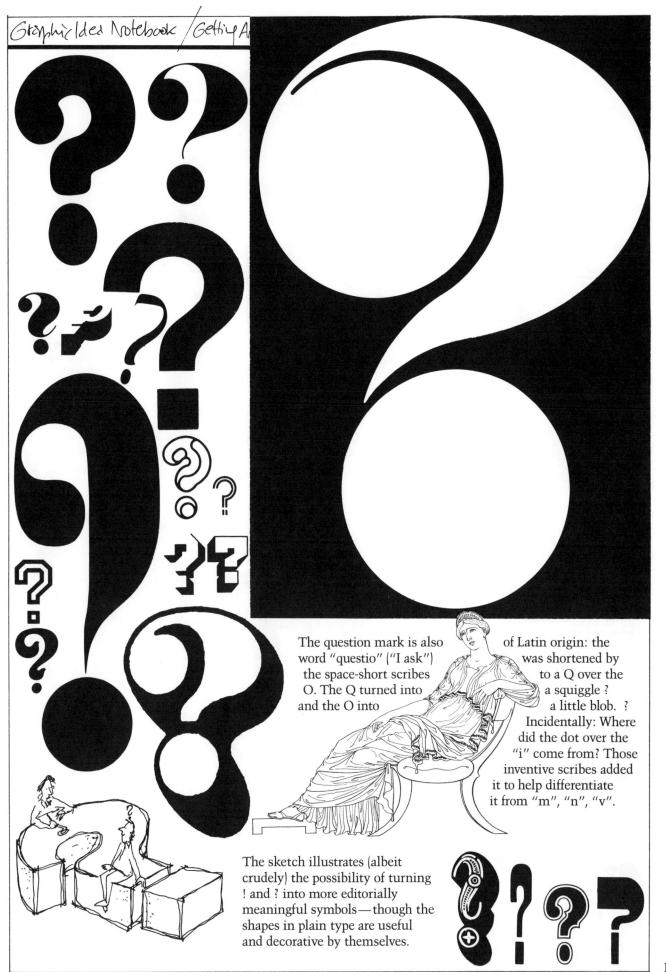

The question mark is also word "questio" ("I ask") the space-short scribes O. The Q turned into and the O into of Latin origin: the was shortened by to a Q over the a squiggle ? a little blob. ? Incidentally: Where did the dot over the "i" come from? Those inventive scribes added it to help differentiate it from "m", "n", "v".

The sketch illustrates (albeit crudely) the possibility of turning ! and ? into more editorially meaningful symbols—though the shapes in plain type are useful and decorative by themselves.

15

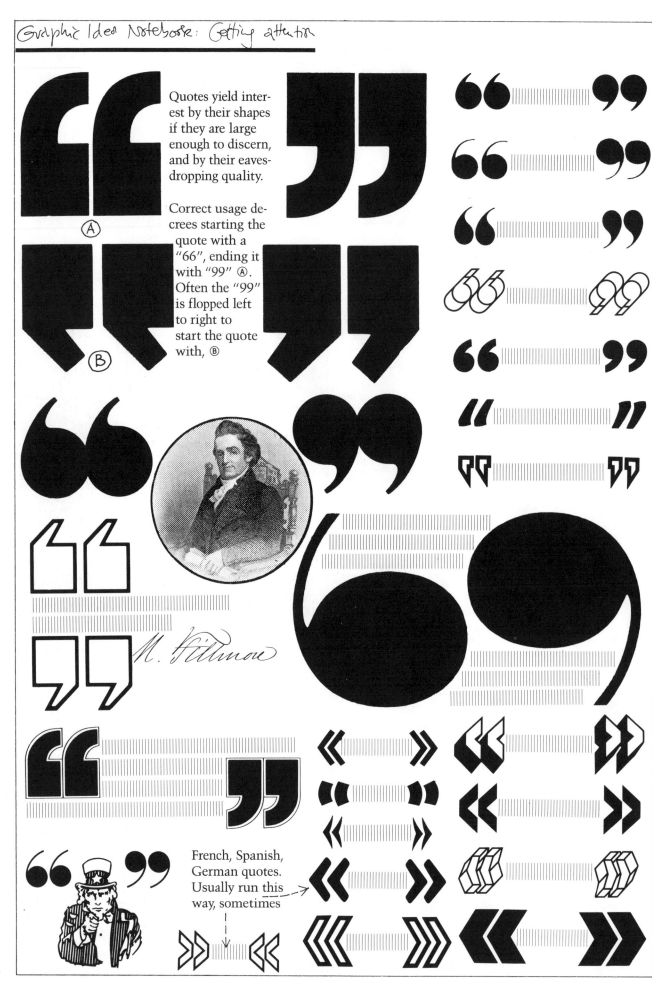

Quotes yield interest by their shapes if they are large enough to discern, and by their eavesdropping quality.

Correct usage decrees starting the quote with a "66", ending it with "99" Ⓐ. Often the "99" is flopped left to right to start the quote with, Ⓑ

French, Spanish, German quotes. Usually run this way, sometimes

Eleven different ways to handle balloons—just to show a glimpse of the variety of expression that can be achieved:

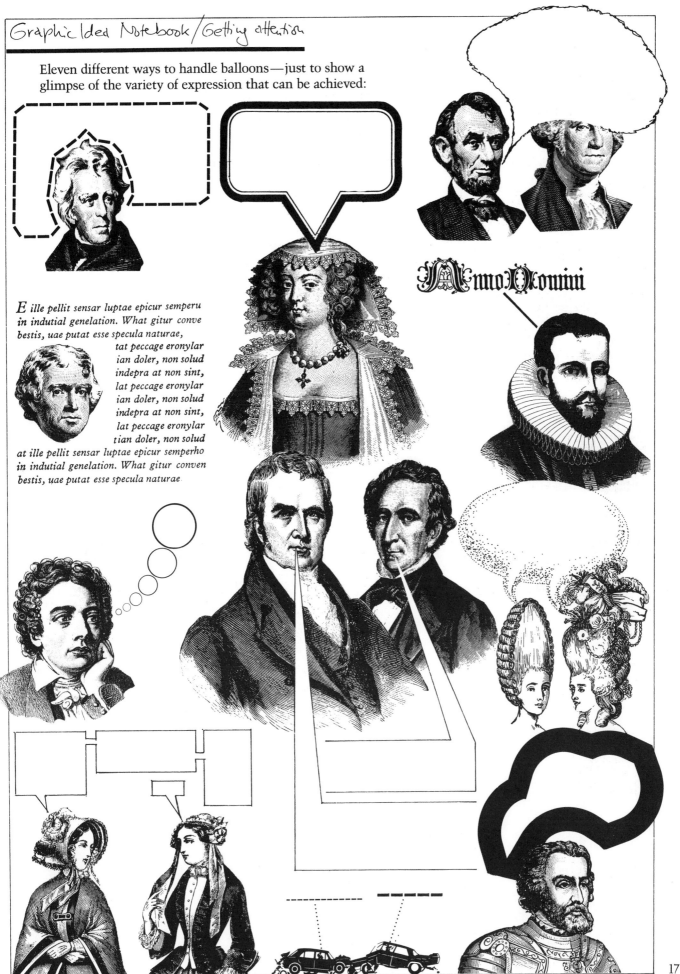

E ille pellit sensar luptae epicur semperu in indutial genelation. What gitur conve bestis, uae putat esse specula naturae,

tat peccage eronylar ian doler, non solud indepra at non sint, lat peccage eronylar ian doler, non solud indepra at non sint, lat peccage eronylar tian doler, non solud

at ille pellit sensar luptae epicur semperho in indutial genelation. What gitur conven bestis, uae putat esse specula naturae

Graphic Idea Notebook

Graphic Idea Notebook

The editorial eye

The editorial

The primary criterion for putting anything in a publication is its *communication value:* What does it tell the reader? The editor must not be bullied into running anything that does not help the story along—least of all by photos. Yet photos are what most often bully the editor because they seem so final, so complete, so immutable, so sacrosanct. Nonsense! The editor's job is not to win friends (i.e., photographers), but to influence people (i.e., readers). That's why photos must be seen as raw material to be manipulated to the editor's purpose by the skills of the art director, so their latent story-enhancing capacities can be exposed. The story is what matters. *Fine* photography does tell a story of its own, and that kind of material is indeed sacrosanct. But for the rest, you must have the guts to do what follows:

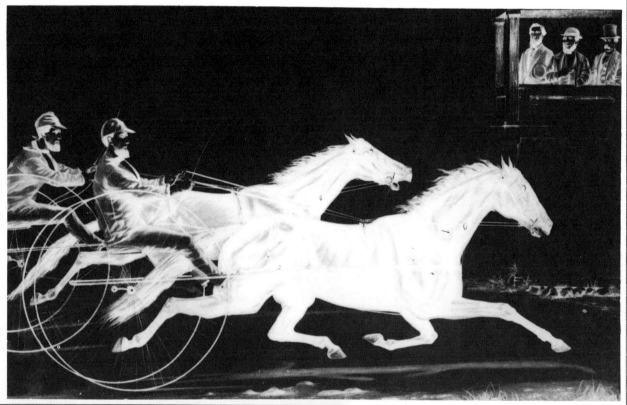

The negative version of an image implies something strange…ghostly… threatening…unpleasant. That might well be more to the point than the straightforward (positive) version of the same image, which would just show what something looks like—albeit more clearly (and its unpleasantness would have to be brought out in words).

← — Flopping the image: illusion of a mirror…duplication…opposition… indecision. Upside-down and under the original it implies a puddle!

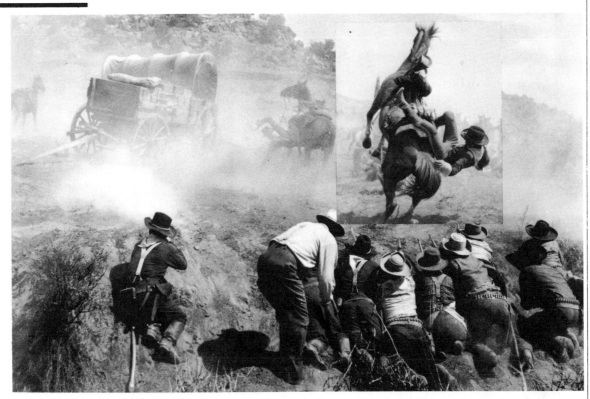

Inserting one image inside another can be like $1 + 1 = 3$ if the subjects work in concert in meaning as well as in arrangement. Just imagine the impact of a color-picture as the focal point inside the black & white!

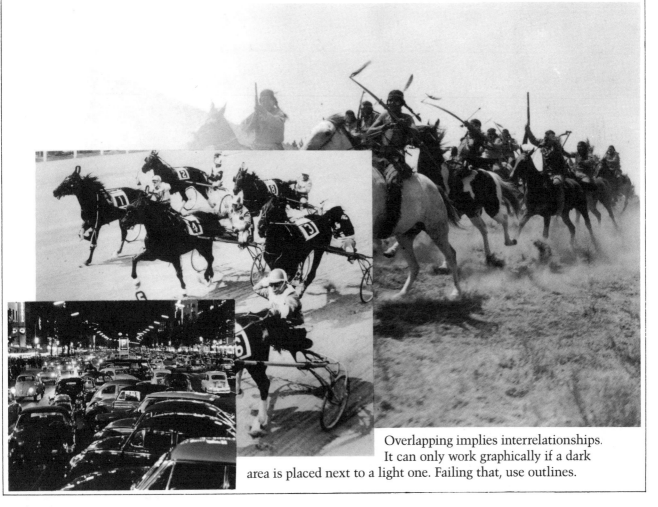

Overlapping implies interrelationships.
It can only work graphically if a dark
area is placed next to a light one. Failing that, use outlines.

The hard-edged, rectangular halftone is so standard as to be thought of as virtually the only way of reproducing a photo. But a soft, dissolving outline may well be more suited to a dreamlike, fugitive subject...reinforcing its editorial point.

Second potential advantage: a non-geometric shape adds variety and lets in some air on the page.

Taking vignetting a step further by combining it with normal hard-edge in the same halftone. To draw attention to the point, the ectoplasmic exudation above is larger than the crisp part at right. Better proportion: making the *normal* part of the picture dominant by size, and the appendix puffing out of it smaller as ➜. This was a popular technique in the late 1800s, produced as wood- or steel-engraving rather than photos. But the principle is the same.

Treat the photo as if it were a view seen through an open window. Add the surrounding walls to create this ilusion by screened artwork. (Drawing in the actual windowframe might be logical but it isn't essential except in special situations.)

The top should be darkest, the "sill" the lightest in tone. This is a useful trick for combining several interrelated views—but it won't work unless the horizons in all the pictures are carefully aligned.

Express an editorial opinion by "shattering" the glass of the image (i.e., drop-out a line drawing of the broken pieces from the halftone).

Combine two halves of images related in *shape* as well as in *meaning* (e.g., before-and-after, pro-and-con etc.)

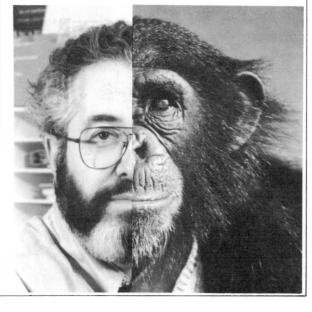

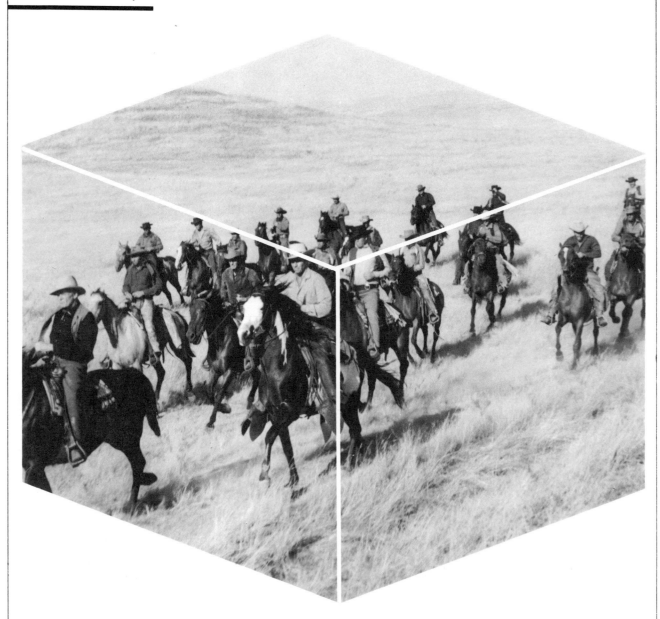

Trim the photo to conform to the shape of a geometrical solid, such as a cube or a cylinder, etc. Drop out from the halftone (or surprint, of course) the lines that define the forward edges of the shape…creating an illusion of dimension that can transform an ordinary photo into an extraordinary impression.

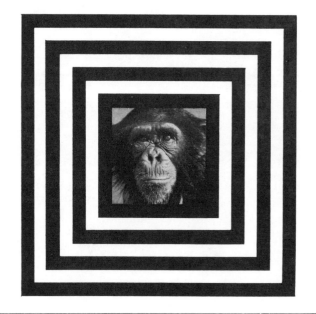

Surround a severely-cropped detail with an elaborate (but "flat" or two-dimensional) frame. Result: the creation of an apparent foreground plane that has a hole in it—i.e., the illusion of looking through a keyhole. →

This isn't just a reproduction of a photo—
it is a *picture of a picture,* because it appears to float above the surface it is printed on.
The white paper edge and the "shadow" accomplish that legerdemain.

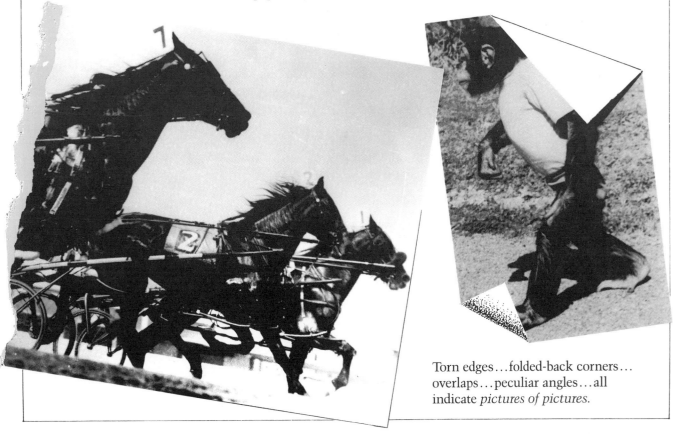

Torn edges…folded-back corners…
overlaps…peculiar angles…all
indicate *pictures of pictures.*

Shadows

If you're going to add them to the pictures, might as well do it more subtly than the usual way (far right). Though it is simple, the result looks a bit obvious.

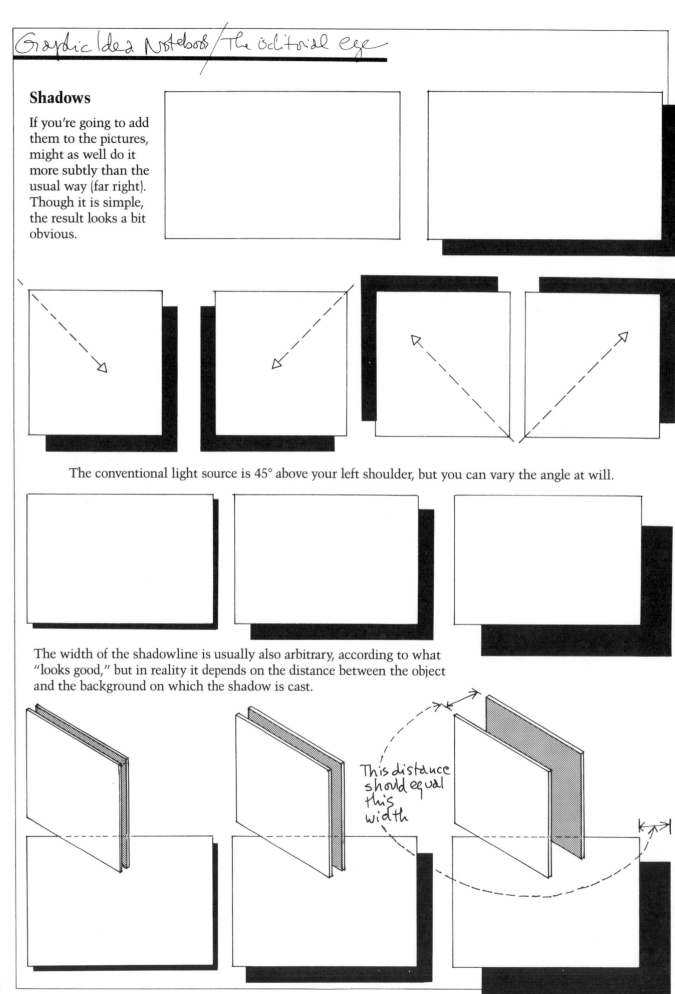

The conventional light source is 45° above your left shoulder, but you can vary the angle at will.

The width of the shadowline is usually also arbitrary, according to what "looks good," but in reality it depends on the distance between the object and the background on which the shadow is cast.

This distance should equal this width

Overlapping is usually shown with shadows of the same width, no matter whether the shadow falls on the furthest background or on a plane closer to it. Thus the illusion of depth is lost.

The width of shadows varies in proportion to the distance from the background and each other. The widths must be calculated to make sense. The plane floating closest to the background casts the narrowest shadow. The next one closer to you casts a wider one, except where the shadow falls on top of the furthest plane, where it is narrower. Continue the buildup in logical steps.

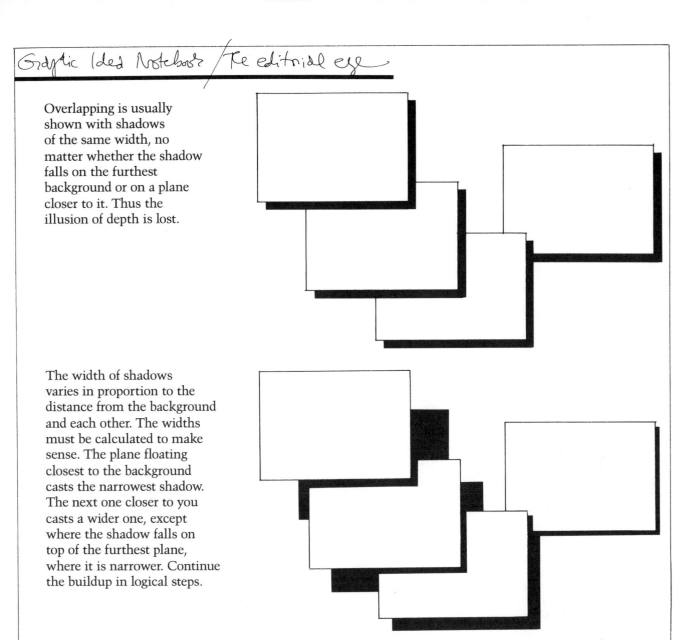

The darkness of the shadow should also vary with its width: the narrower the shadow, the darker it is. The wider the shadow, the greater the distance between object and background. Therefore more light sneaks in between them and so the paler the shadow has to be. This example is a bit exaggerated to make the point.

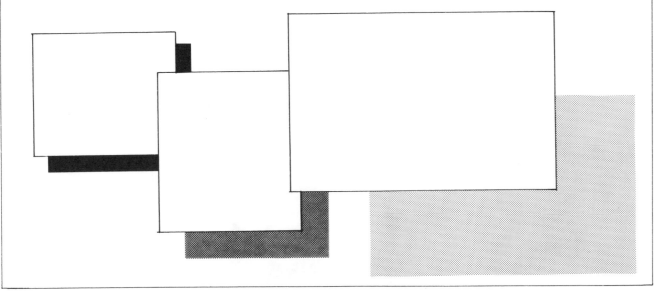

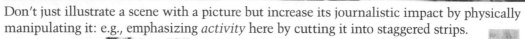

Don't just illustrate a scene with a picture but increase its journalistic impact by physically manipulating it: e.g., emphasizing *activity* here by cutting it into staggered strips.

A variant of the cut-up photo trick shown opposite: emphasize motion—in this case the rolling of the ship (ugh!)—by cutting the picture into a series of concentric rings, and repasting them off kilter (about 3/16″ off). The outer white ring is only there to bring attention to the technique used here!

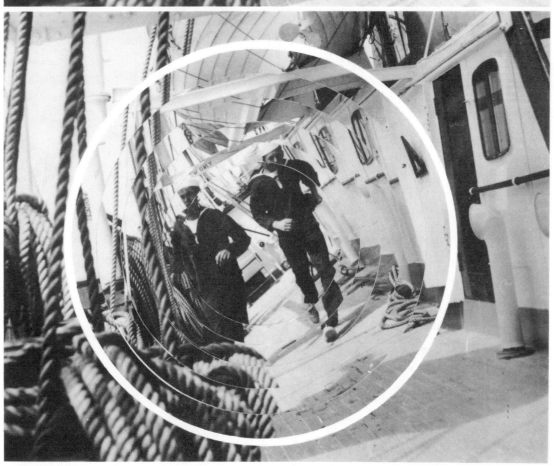

The editorial eye

Turning the picture sideways automatically gets attention but it is not popular.

Pull the viewer's attention to the crucial element by a symbol that is stripped-in (black) or dropped out (white). Common sense will dictate whether to strip-in or drop-out.

ouch!

30

Eavesdropping always attracts attention. Listening-in on conversations within the pictures can be shown several ways: by simply placing the words at an angle so they appear to be coming out of a particular personage...by putting them on a call-out arrow...by placing them in a cartoon-bladder inside or outside the picture...by showing "thoughts" as a picture.

To focus attention
to a part of an image,
yet retain the context
in which it occurs:

1. Pale down the
surrounding background
(or darken it, if that
might be better).

2. Change the texture
of the surroundings by
photo-mechanical tricks.
The concentric line
screen is just one of
many options.

Outline letters can appear transparent: an easy illusion to create by surprinting over a simple background (top) or dropping out from a dark one (below). But over a mottled one (center) the insides of the letters need to be lightened (or darkened)—here "ghosted" to 40%.

THE NAME OF THIS TYPEFACE IS— YOU GUESSED IT— EGYPTIAN OUTLINE!

TUT TUT

PREFAB

The word and the image are unified. To make this trick work, the picture must have a strong pattern as well as easily-discerned details in it. And the type should be large, bold and tightly set, to make the holes inside and between minimal.

The word is an integral part of the picture, here seen against the surrounding white space. The intrusion into the white space is aggressive and accounts for the shock-value. As in all such tricks, the word must make sense with the image.

shimmer

The ordinary way to combine words and pictures is, of course, to "surprint" words in black over the halftone, or to "drop out" words in white from the halftone.

Here are variations—all easy in concept but fairly difficult to achieve in traditional pre-press since much "masking," "dropping-out" and preparation are necessary. Electronic publishing's programs make it far easier to produce.

The word is part of the picture…the word is in fact dropped out from the neighboring color area and the color is allowed to butt the halftone.

The lower edge of the letters invades the halftone. A sliver of white space is inserted to separate them and increase legibility.

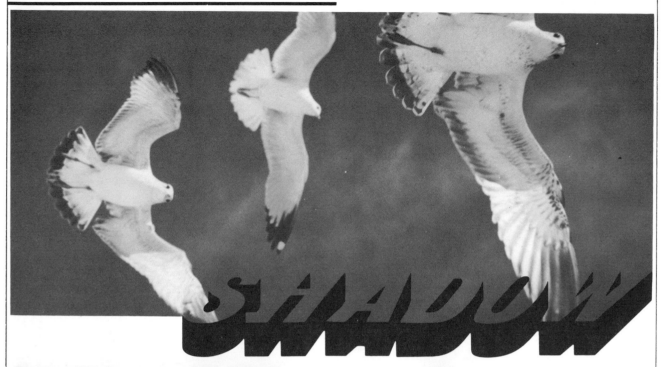

SHADOW

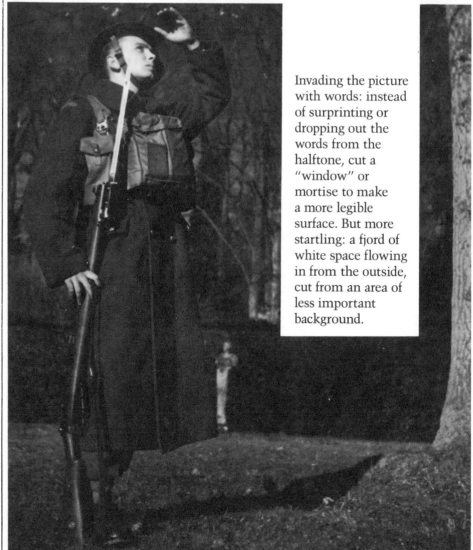

The picture overlaps into the word. The letters meld into the image, and they are defined by their "shadowed" edges.

Invading the picture with words: instead of surprinting or dropping out the words from the halftone, cut a "window" or mortise to make a more legible surface. But more startling: a fjord of white space flowing in from the outside, cut from an area of less important background.

Opposite technique to the one above: the letters are simple, but the "shadow" they cast is made of picture.

K

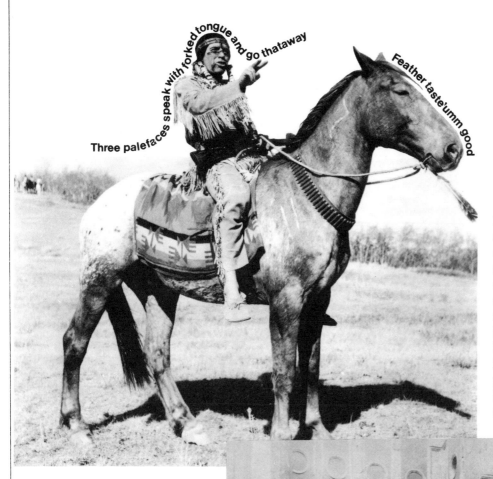

Three palefaces speak with forked tongue and go thataway

Feather taste'umm good

Parallel the perimeter of a shape with words that describe it, grow out of it, make sense with it. The shape must be simple and easily discerned: so an uncluttered background or, ideally, a silhouette work best. To inscribe the words in the proper place, use pressure-sensitive or rub-off lettering on an overlay, or do it electronically.

To describe the contents of an illustration that shows several separate elements, break the caption into components and place them around the picture. Lines drawn between the caption and its image may be useful. (Don't try to understand the words here: they are just nonsense—latin "greeking" or "dummy type"!).

Temporibud autem delectus ut aut ante cum memorite neque pecun mod and dedocendesse ipsinuria detriment et carum esse iucund quod cuis.

Lorem ipsum dolor quis nostrud exer consequat, vel illum exceptur sint occaecat

Et tamen in busdam ut coercend magist possit duo conetud praesert cum omning

Euae de virtutib sempitern aut diuter movente propter luptas erit praeder

Concupis plusque in vel plurify afferat. Nam dilig sed mult etiam mag tuent tamet eum locum

Temporibud autem quinusd delectus ut aut prefer ante cum memorite tum etia neque pecun modut

Ilena sit, ratiodipsa sic amicitian non modo fuerte. Null modo sine oluptation.

Lorem ipsum dolor sit quis nostrud exercitatio consequat, vel illum exceptur sint occaecat

Nam ria detriment est quam et carum esse iucund est quod cuis. Guae ad amicos seque facil, ut mihi detur expedium.

It might be logical to chop up the picture to follow the segmented caption (above) or even superimpose the captions onto the image to gain impact and fast communication (below).

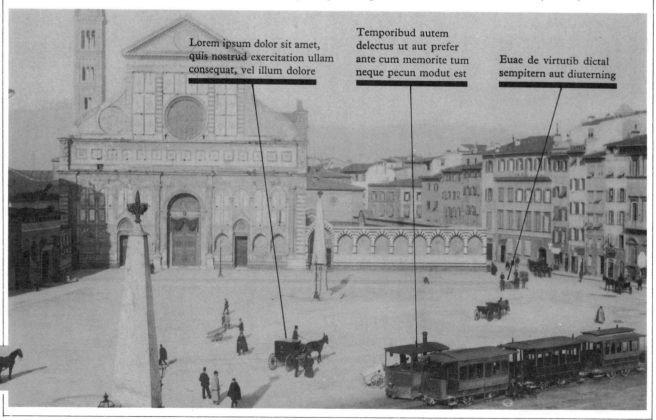

Lorem ipsum dolor sit amet, quis nostrud exercitation ullam consequat, vel illum dolore

Temporibud autem delectus ut aut prefer ante cum memorite tum neque pecun modut est

Euae de virtutib dictal sempitern aut diuterning

← Outriggers work!

Substitute a picture for a letter in a word: as long as the word/image association is clear in meaning, the technique will work even if the image is NOT reminiscent of the shape of the letter that is missing.

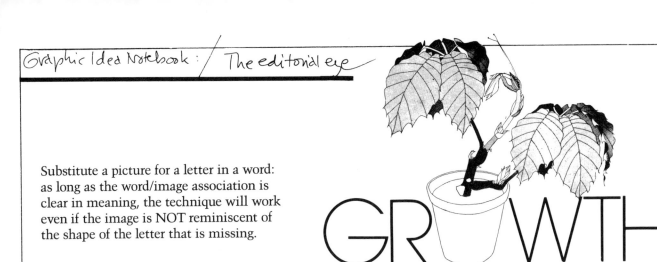

GR**W**TH

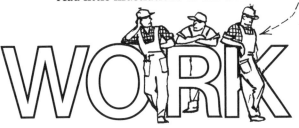

GR**W**TH

Picture same shape as replaced letter—or image used as stuffing inside the letter.

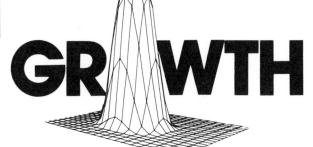

GR**W**TH

Add little illustrations to the word: either outside the letters or within the strokes of the letters.

WORK

It is livelier if the figures are shown intertwined among the letters than just standing on top.

MOST OF THE GREAT TYPOGRAPHY IN AMERICA IS COMPOSED ON THE ALPHA-TYPE AND ON THE MERGENTHALER VIP PHOTO-TYPESETTING SYSTEMS. THESE SYSTEMS USE A SMALL PIECE OF FILM WITH A COMPLETE ALPHABET IN NEGATIVE FORM, CALLED A FONT, TO COMPOSE YOUR BODY COPY, LETTER BY LETTER. THE FONT IS THE HEART OF THE TYPESETTING SYSTEM. LEONARD STORCH ENTERPRISES, INC. IS AMERICA'S FIRST FILM FONT FOUNDRY AND OFFERS THE LARGEST SELECTION OF BOTH TRA-DITIONAL AND CONTEMPORARY ALPHABET STYLES. WE ARE THE LEADER, AND HAVE CREATED QUALITY STAND-ARDS IN FONT MANUFAC-TURING THAT OTHERS CAN ONLY TRY TO IMITATE. WELL OVER 500 OF AMERICA'S LEAD-ING TYPOGRAPHERS HAVE CHOSEN STORCH FONTS TO COMPOSE YOUR COPY. THEY MADE THE BEST CHOICE POS-SIBLE TO SERVE YOUR NEEDS. WHEN YOUR TYPOGRAPHER USES STORCH FONTS, YOU HAVE A BETTER CHANCE OF GETTING THE JOB ON TIME, RAZOR SHARP, IN PERFECT ALIGNMENT AND PROPER FIT NO MATTER WHAT TIGHTNESS YOU SPECIFY. WE HAVE FOSTERED THE ART OF TYPOGRAPHY BY GIVING THE TYPESETTER "TOOLS" THAT WORK BETTER AT PRICES THAT ENABLE HIM TO STOC K ALL THE ALPHABETS YOU NEED. YOU CAN HELP FOSTER THE ART OF TYPOGRAPHY AN D HAVE THE WORLD'S BEST BODY TOO. BE SURE YOUR TYPOG-RAPHER USES ORIGI NAL STORCH FONTS.

AND SOMEWHAT UNLIKELY EVENT IN A DESIGNER'S WORKING LIFE BUT THAT SHOULD NOT PRECLUDE ITS VALIDITY AS A TECHNIQUE IF AND WHEN AN OPPORTUNITY ARISES. SETTING TYPE IN THE OUTLINE OF A SHAPE SUCH AS THIS IS AS RARE

Setting words in pictorial shapes: visual puns can be useful (on rare occasions). Assuming the validity of the idea, all you need is space, time and money: Space for displaying a big image (it is hard to establish a clear shape in miniature). Time and money for tinkering with the text and reworking the type to get it to fit just right.

Graphic Idea Notebook

Combining and joining

JOINING|COMBINING|AND| ASSEMBLING|SO|THAT **2+2=17**

17? That's the whole point. The usual, expected cliché that describes synergetic action where the whole is greater than the sum of its parts is to say that 1 + 1 = 3. But in this chapter we're talking about more than 1 + 1. In fact we're talking of groupings (that means a minimum of three to start with, though four is better). Hence the 2 + 2 in the left-hand part of our equation. But *17*? Well, the expected 5 is weak. Hardly worth the bother. So why *not* 17? If four little items working together can create something four times greater than expected, we're certainly getting more bang for the buck. So let's shoot for the stars.

Yes, this is a "group" but how weak it is! It has the flabbiness of a handshake like this.................................

The only virtue of this "group" is that the elements are a bit larger; that makes it harder to get them on the page in a row, so the row is split into two and the result reads better as a group...but it is probably accidental that it does that. It is still unimaginative and weak, and like...............................

That's better! The "group" has become a deliberate editorial ploy: an attempt to make something more of the material than just running it as is. The group is the nexus—the focal point. This has guts... strength... forthrightness.........................

The background, patterned, geometrical, color or naturalistic, fuses the elements superimposed on it into a unit. Particularly effective if there is common meaning.

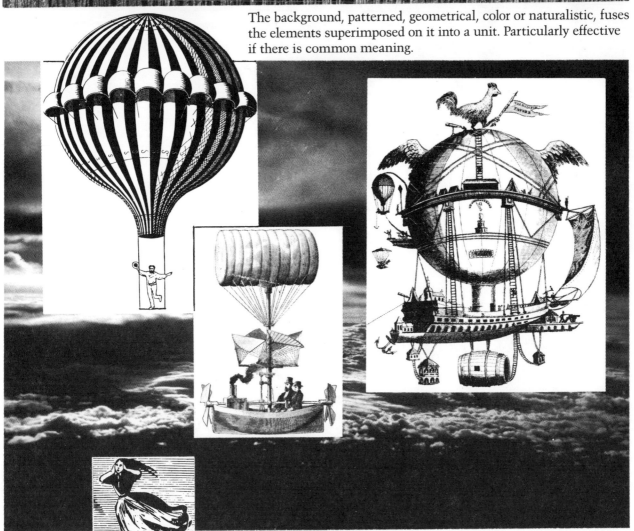

Similarity in background color (whether as degrees of blackness or actual hues) can combine a bunch of independent pictures into an organized entity. It works even if the subjects of the pictures vary widely.

An extraneous element added to each image can become the glueing agent …whether it be these silly hands, or merely the expected 1, 2, 3, in the corner of the pictures, or anything else visible enough to achieve its purpose.

Photo corners" to reinforce the illusion

Handwritten captions, of course, more effective if informally placed at an angle. OK, granted — it is corny.*

Treat pictures as objects and show them as pictures of pictures, instead of reproductions of their images. As "album," as contact strip, as bits of paper from the photo shop…

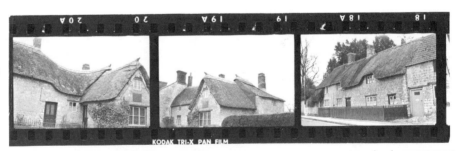

KODAK TRI-X PAN FILM

45

* but it works

Cropping the photos to form exaggerated shapes: long, thin horizontals or tall, thin verticals…the subjects can be similar (as above) or totally disparate (as at left) yet they act as a group because of the cropping.

Cropping the pictures in order to achieve an alignment of the horizons establishes natural affinity.

Overlapping not only makes a bigger arrangement out of a handful of small units, but it can (though it need not) be used to imply flow from one image into the next.

Cropping one side at an angle automatically establishes a relationship among all the photos thus treated. (MALtreated?) Placing them in a more random arrangement on the page than the elementary row below would make the trick more powerful.

Pictures of pictures: to make the illusion work: random placement at angles; overlapping; retention of white edges; "shadow" cast by each piece of paper. The great advantage: a montage like this can get you a lot of 4-color pictures for the price of one!

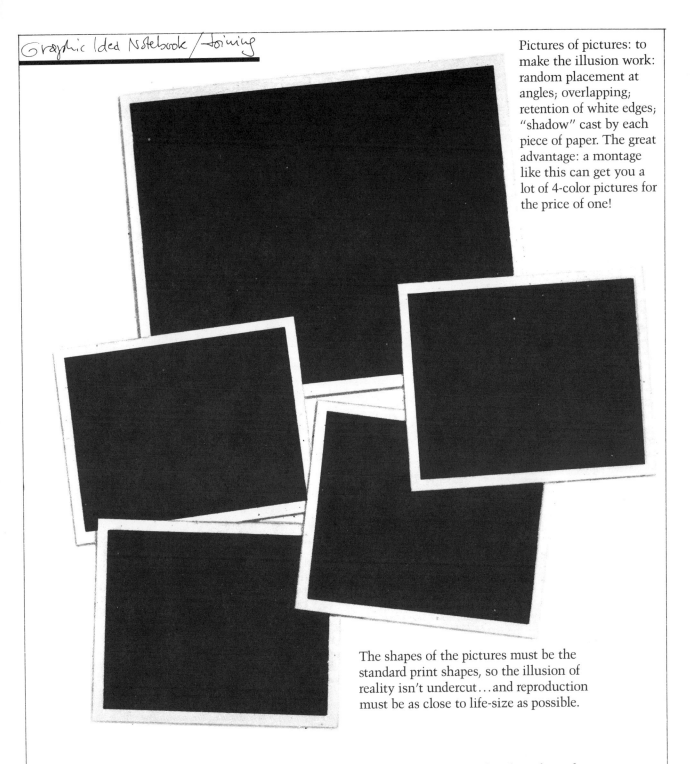

The shapes of the pictures must be the standard print shapes, so the illusion of reality isn't undercut...and reproduction must be as close to life-size as possible.

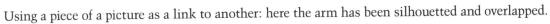

Using a piece of a picture as a link to another: here the arm has been silhouetted and overlapped.

Using shared characteristics to tie images together.

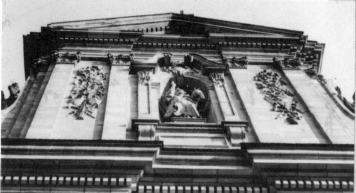

The direction in which the subjects are viewed, looking up or down at them.

The subject-matter itself: if it is peculiar enough, it will hold the pictures together.

Inlaying the images into a strongly-patterned trellis of like-sized, like-shaped forms or frames.

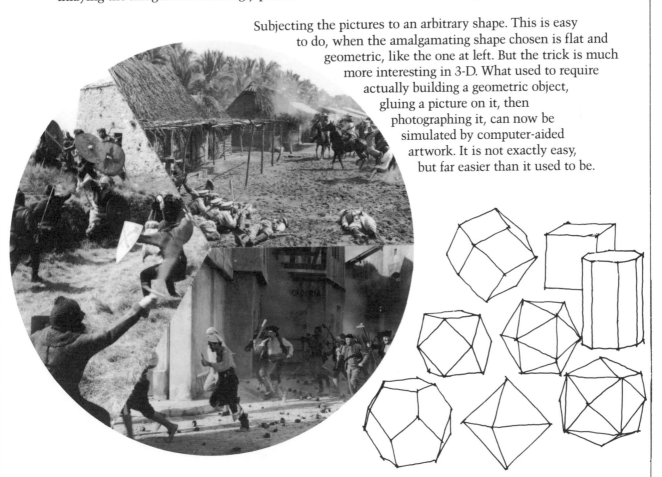

Subjecting the pictures to an arbitrary shape. This is easy to do, when the amalgamating shape chosen is flat and geometric, like the one at left. But the trick is much more interesting in 3-D. What used to require actually building a geometric object, gluing a picture on it, then photographing it, can now be simulated by computer-aided artwork. It is not exactly easy, but far easier than it used to be.

Linking pictures by implication of meaning, where the subjects in the pictures seem to share some sort of relationship. Simplest: people who appear to be speaking to each other…more subtle: pointing to each other or throwing elements from one photo to the next.

Corollary to the above: Taking an image and splitting it in order to broaden its effectiveness. The scene must be obviously recognizable in both the segments, in order to bridge the gap between them.

File Tab *(horizontal)*

FILE TAB *(vertical)*

Create a consciousness of the material (the paper) being used. Then, whatever is printed on it becomes, by implication, a part of something else and thus joined to all the other parts. Here: file tabs—simplest artwork to produce. At right, a page that appears to be "floating" (the "shadow" cut from pressure-sensitive material). Below: a sheaf of papers held together by the best possible joining-symbol.

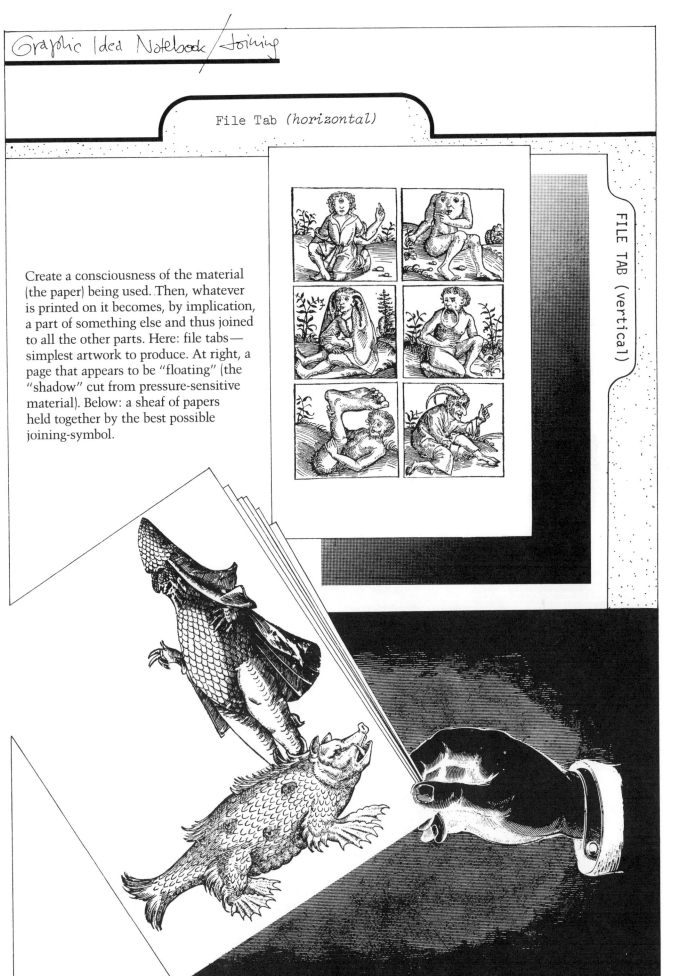

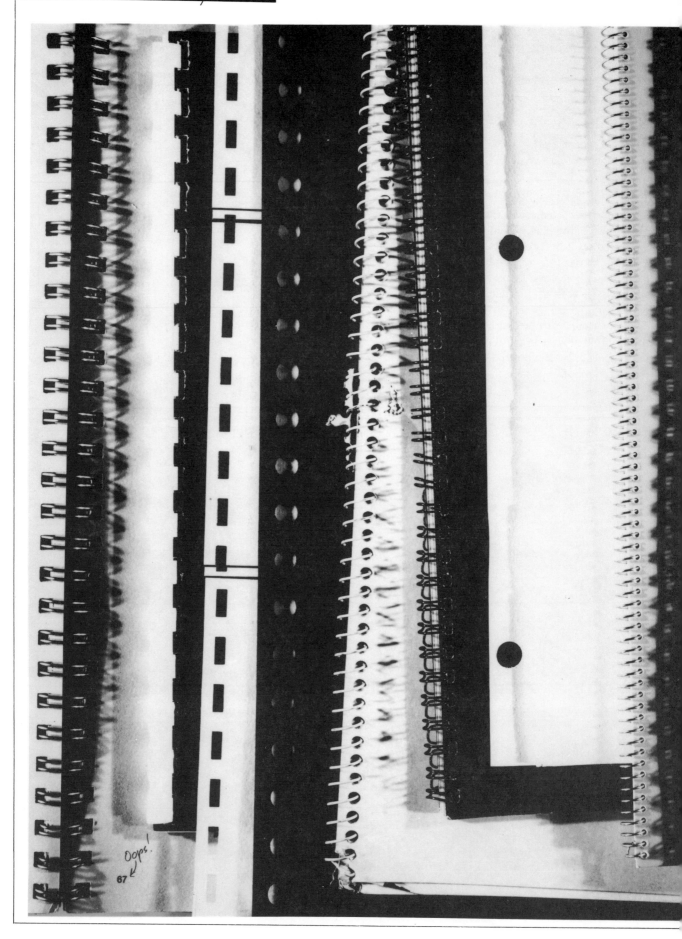

Oops!
67

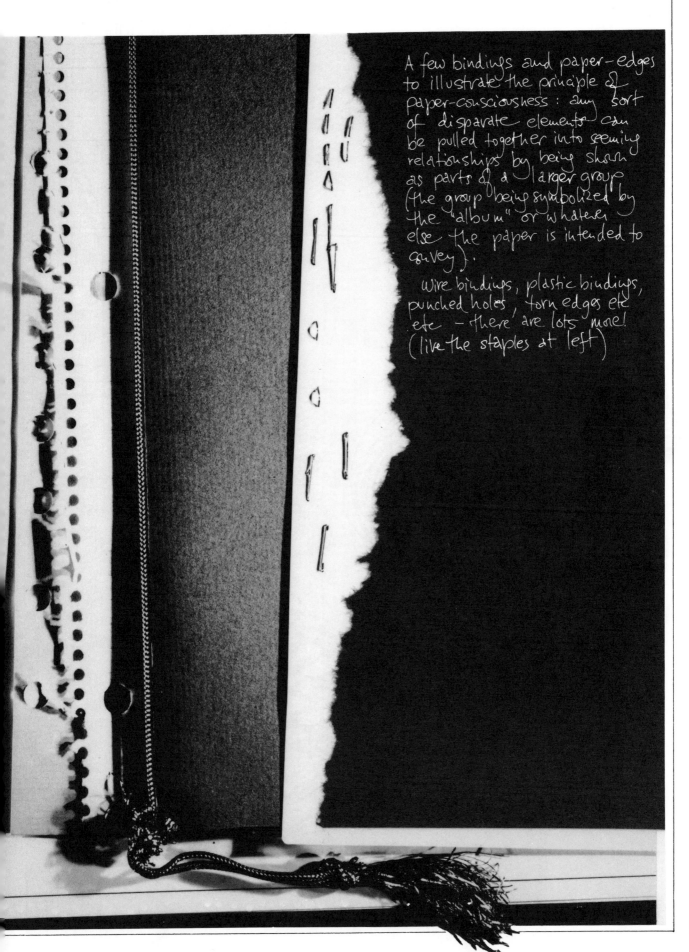

A few bindings and paper-edges to illustrate the principle of paper-consciousness: any sort of disparate elements can be pulled together into seeming relationships by being shown as parts of a larger group (the group being symbolized by the "album" or whatever else the paper is intended to convey).

Wire bindings, plastic bindings, punched holes, torn edges etc etc — there are lots more! (like the staples at left)

Using gimmicks to tie things together: here's a bunch of obvious ones. Every trade and profession has its own specialized symbols that can be used, added to the general ones shown here. What makes the idea work as a symbol and not a cliché is the graphic handling: it must be *right*—whatever that may mean—and "interesting." The examples are individually annotated for technique.

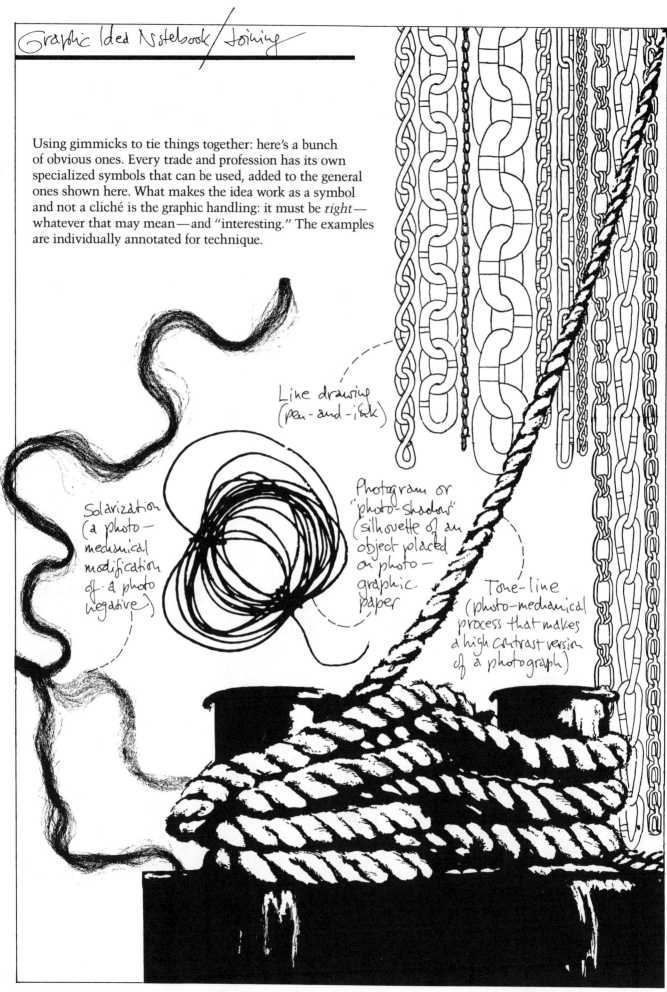

Line drawing (pen-and-ink)

Solarization (a photo-mechanical modification of a photo negative)

Photogram or "photo-shadow" (silhouette of an object placed on photographic paper

Tone-line (photo-mechanical process that makes a high contrast version of a photograph)

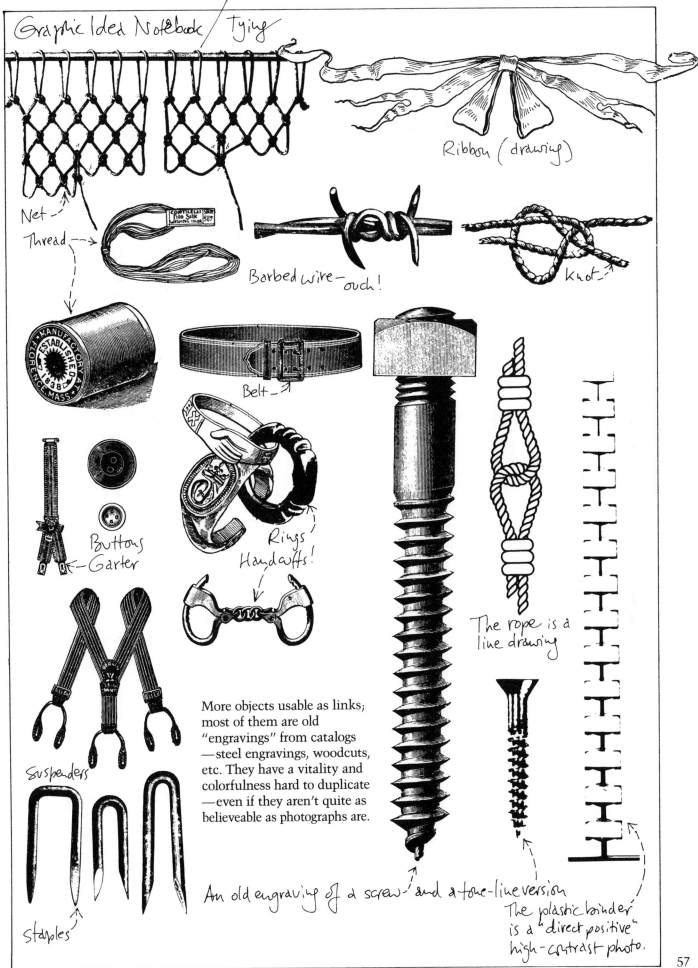

Ribbon (drawing)

Net

Thread →

Barbed wire—ouch!

Knot →

Belt →

Buttons

Garter

Rings

Handcuffs!

Suspenders

The rope is a line drawing

More objects usable as links; most of them are old "engravings" from catalogs —steel engravings, woodcuts, etc. They have a vitality and colorfulness hard to duplicate —even if they aren't quite as believeable as photographs are.

An old engraving of a screw and a tone-line version

The plastic binder is a "direct positive" high-contrast photo.

Staples

57

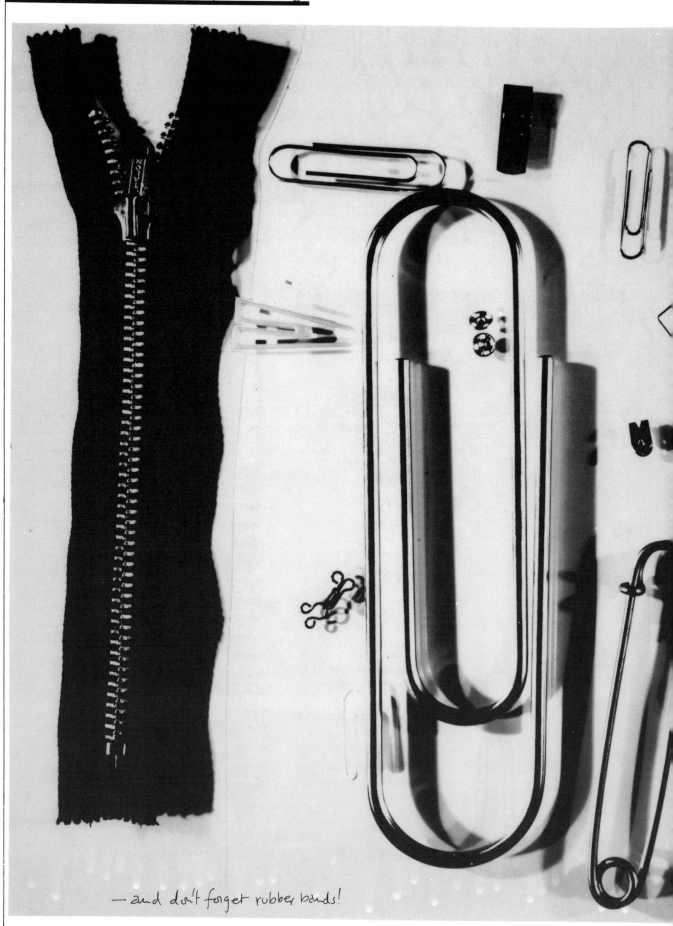

— and don't forget rubber bands!

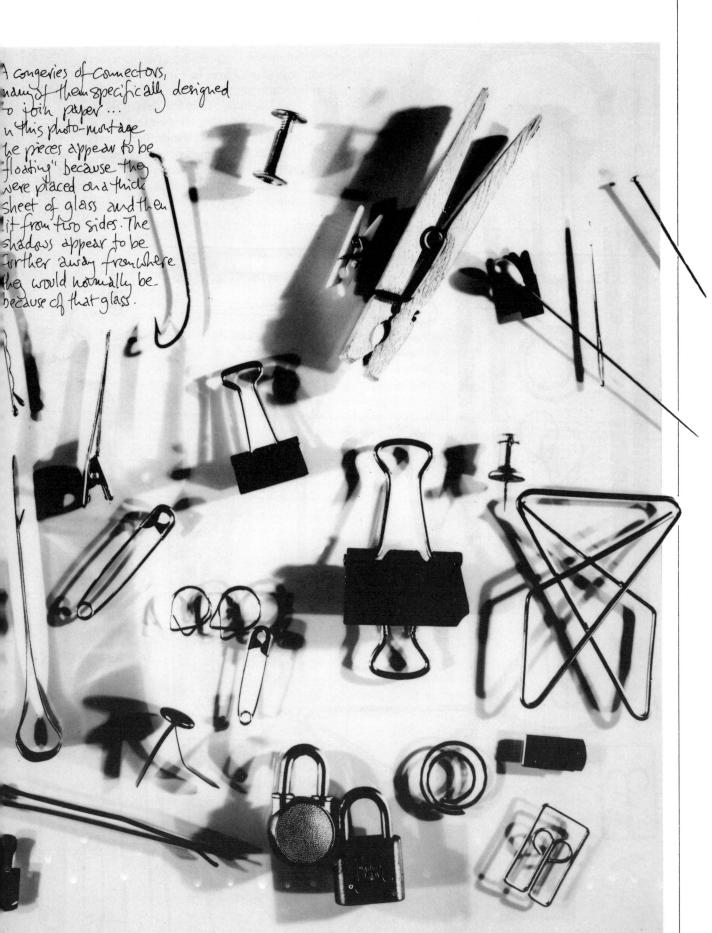

A congeries of connectors,
many of them specifically designed
to join paper ...
In this photo-montage
the pieces appear to be
"floating" because they
were placed on a thick
sheet of glass and then
lit from two sides. The
shadows appear to be
further away from where
they would normally be
because of that glass.

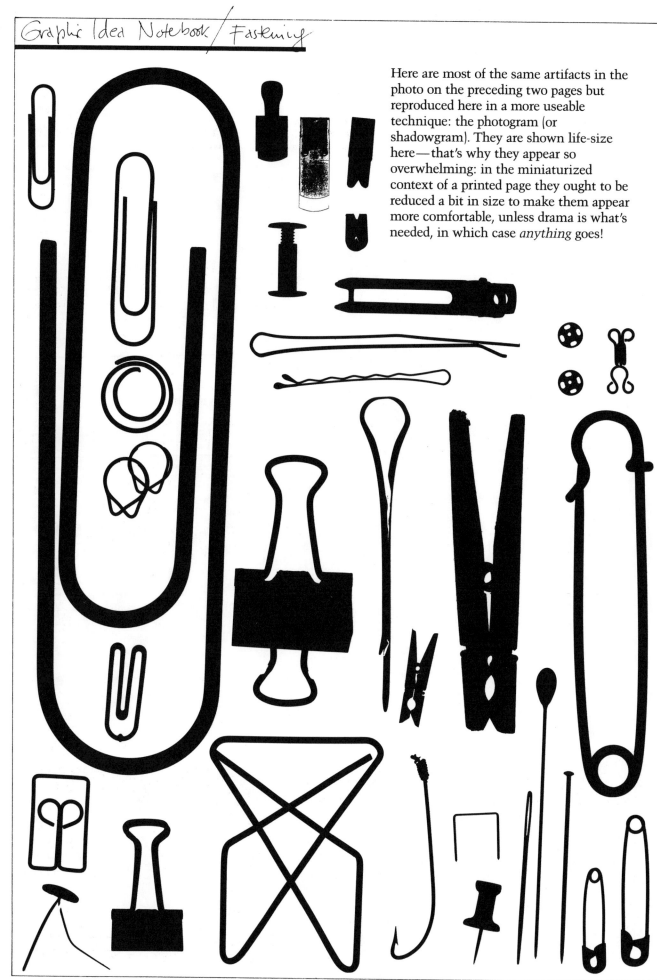

Here are most of the same artifacts in the photo on the preceding two pages but reproduced here in a more useable technique: the photogram (or shadowgram). They are shown life-size here—that's why they appear so overwhelming: in the miniaturized context of a printed page they ought to be reduced a bit in size to make them appear more comfortable, unless drama is what's needed, in which case *anything* goes!

AND: the obvious non-pictorial link. The ampersand comes from the latin ET (i.e., "and"). Scribes scribbled it, type designers embellished it, and the result? The character with the most delight and graphic variety in the alphabet. As such, a resource of visual richness—if used flamboyantly! Alternate symbols: the mathematical PLUS and the word AND available as a unit in old typebooks—very Victorian.

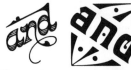

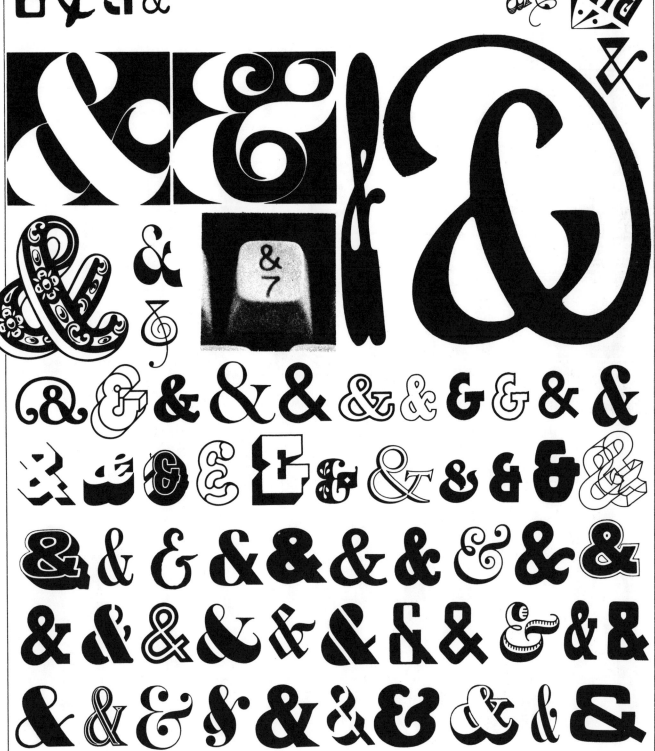

Just a random sampling to show the visual riches in such a simple thing as parentheses. Each typeface has its own.

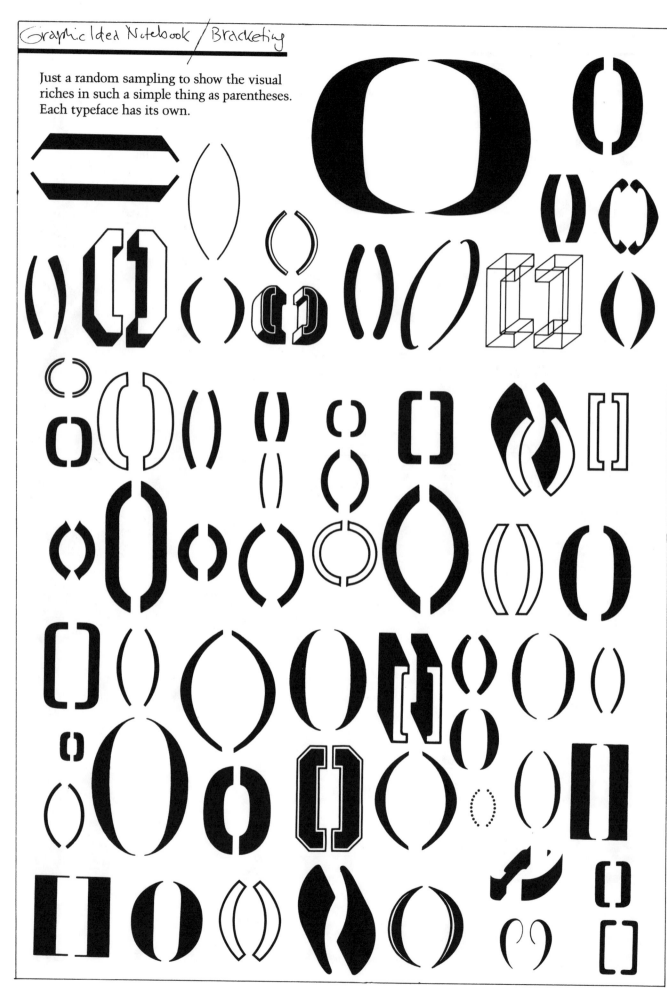

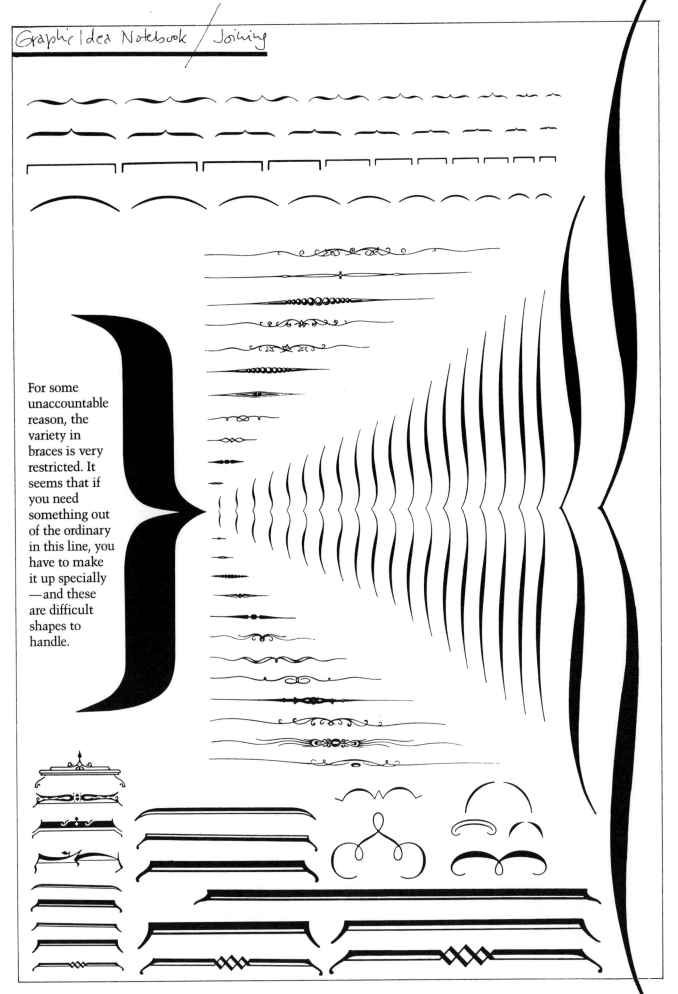

For some unaccountable reason, the variety in braces is very restricted. It seems that if you need something out of the ordinary in this line, you have to make it up specially —and these are difficult shapes to handle.

63

Graphic Idea Notebook

Direction
motion
change

Directionmotionchange

Arrows and "fists" point to something and we know what is expected of us: we follow them out of curiosity—or fear of the law. They are our accepted directional symbols/signs.

But our accumulated experience also makes us respond to lines of force or lines of direction that we only *feel*—without actually *seeing* them. We instinctively follow the lines of action depicted in an illustration. We empathize with the chap in a photo and follow his gaze. Who hasn't looked up at the sky, copying someone else who is doing it, out of magnetic curiosity? The same works with people in pictures, if those pictures are strong. We understand that a decrease in size implies receding into distance; that's what linear perspective is all about. We understand, equally, that the further away an object is, the more the mists that separate it from the viewer interpose themselves between, thus making that object paler as well as smaller.

It is just a short step from showing *direction* to showing *motion*…and from motion to *change.*

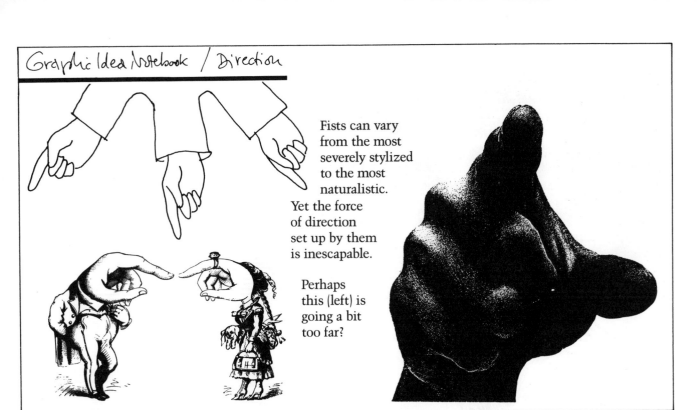

Fists can vary from the most severely stylized to the most naturalistic. Yet the force of direction set up by them is inescapable.

Perhaps this (left) is going a bit too far?

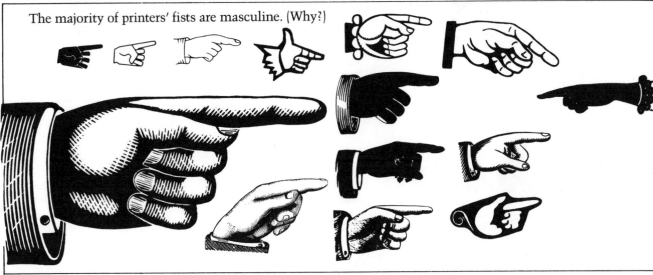

The majority of printers' fists are masculine. (Why?)

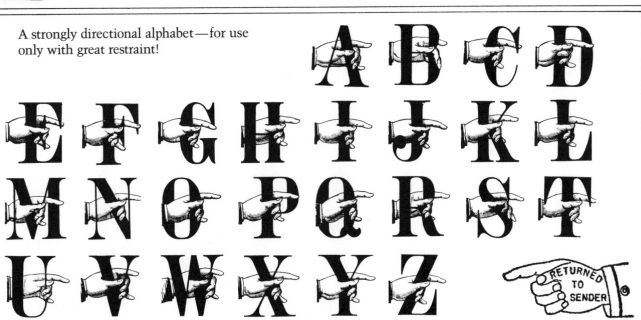

A strongly directional alphabet—for use only with great restraint!

 Footnote: 'Mouse rabbit squirrel raccoon

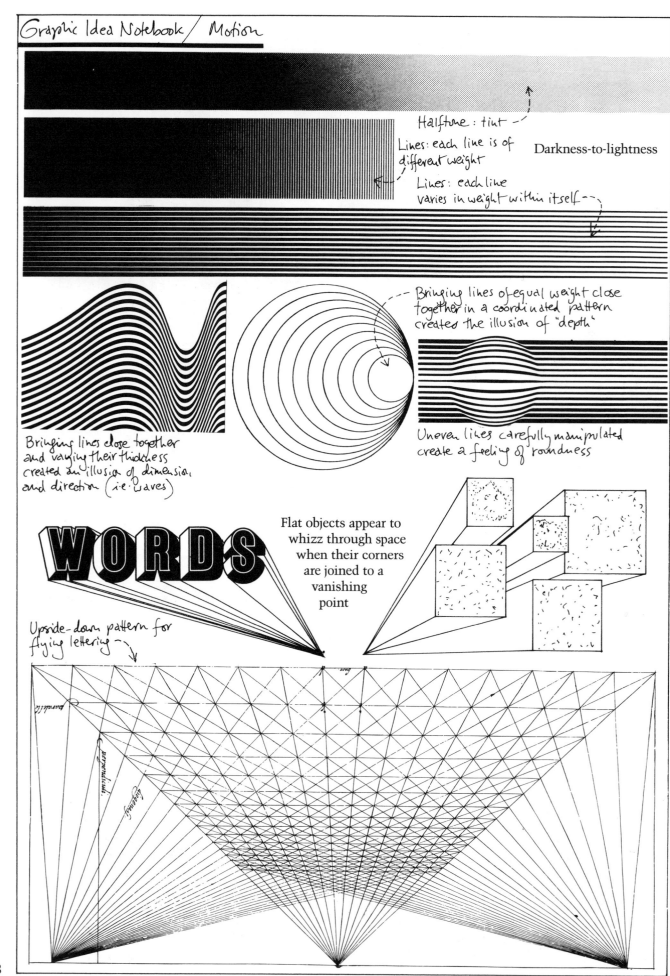

Halftone: tint --

Lines: each line is of
different weight

Lines: each line
varies in weight within itself ---

Darkness-to-lightness

-- Bringing lines of equal weight close
together in a coordinated pattern
created the illusion of "depth"

Bringing lines close together
and varying their thickness
created an illusion of dimension
and direction (i.e. waves)

Uneven lines carefully manipulated
create a feeling of roundness

WORDS

Flat objects appear to
whizz through space
when their corners
are joined to a
vanishing
point

Upside-down pattern for
flying lettering --

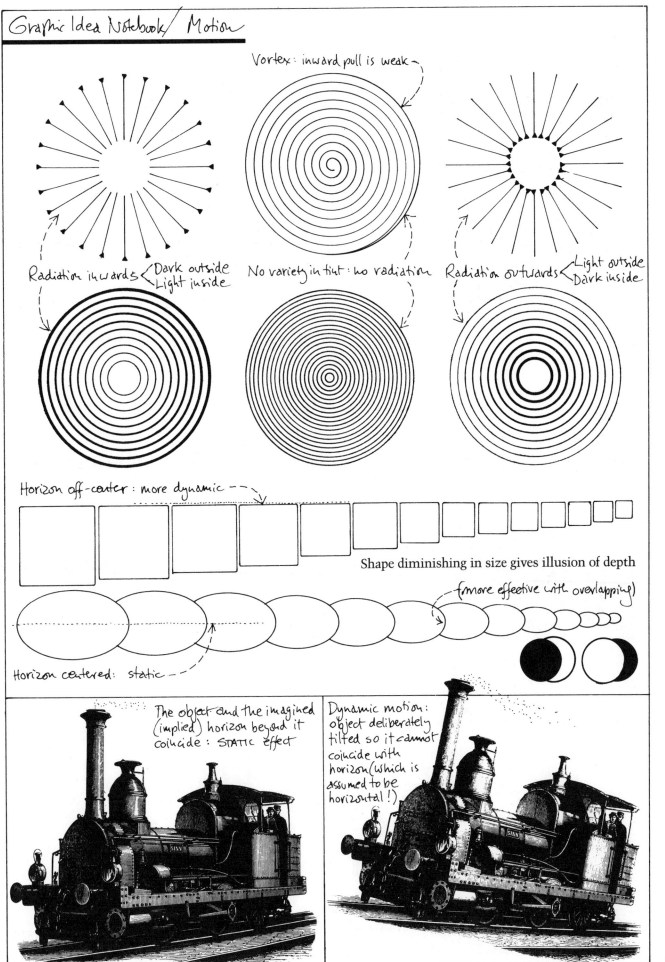

Vortex: inward pull is weak —

Radiation inwards ⟨ Dark outside / Light inside

No variety in tint: no radiation

Radiation outwards ⟨ Light outside / Dark inside

Horizon off-center: more dynamic ----→

Shape diminishing in size gives illusion of depth

(more effective with overlapping)

Horizon centered: static ---

The object and the imagined (implied) horizon beyond it coincide: STATIC effect

Dynamic motion: object deliberately tilted so it cannot coincide with horizon (which is assumed to be horizontal!)

Showing actual motion of the action—obviously

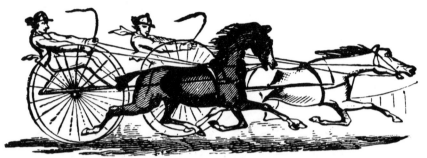

Motion completely unseen but implied: the movement past this chap must have been extremely fast!

Competition between subjects in the illustration clearly shows the strain required to achieve the speed needed for victory: immediate viewer-involvement.

Series of objects expected to be moving moves (except when there are traffic jams)

Disappearing: the same subject shown in increasing degrees of "ghosting" (expressed in % of normal)

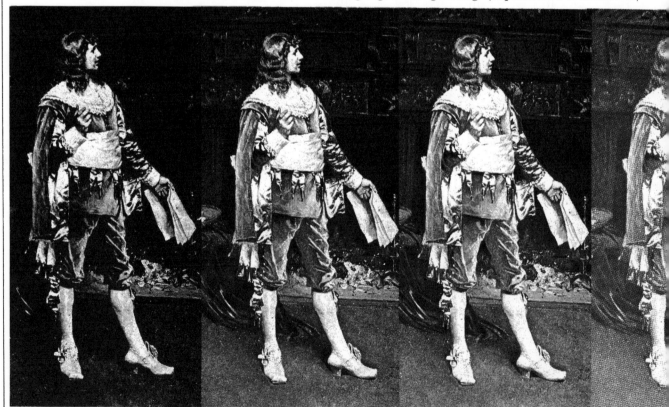

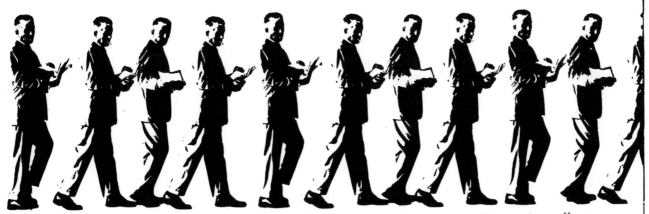

Stop-motion (time lapse) photography repeated to yield a longer sequence

Note various effects achieved by bumping into edge, breaking through it, and, below, stopping short

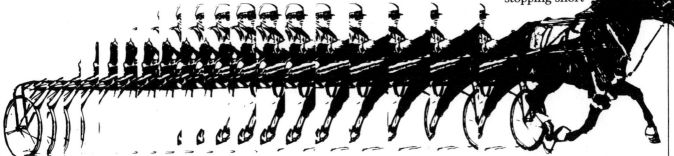

® TM, COURTESY OF U.S. TROTTING ASSOCIATION

One image split into slivers, each of which shows a slightly changed portion of the original

Butting the halftones helps smooth transition and emphasizes the changes.

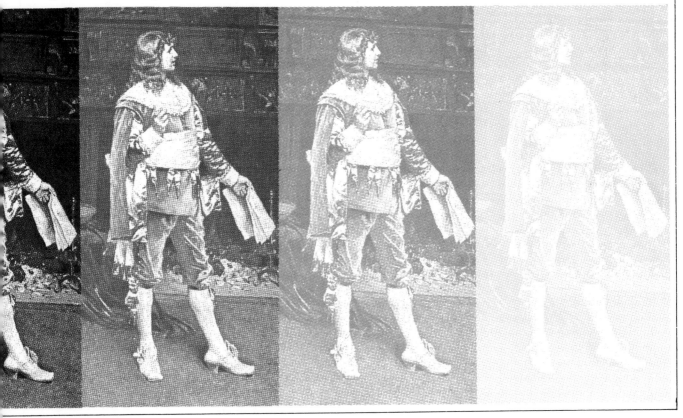

When there are no pictorial images available, plain words suitably played with can be made into striking (or amusing) substitutes. To denote POSITION, the whole trick is to establish simple DATUMS and then work the word around them.

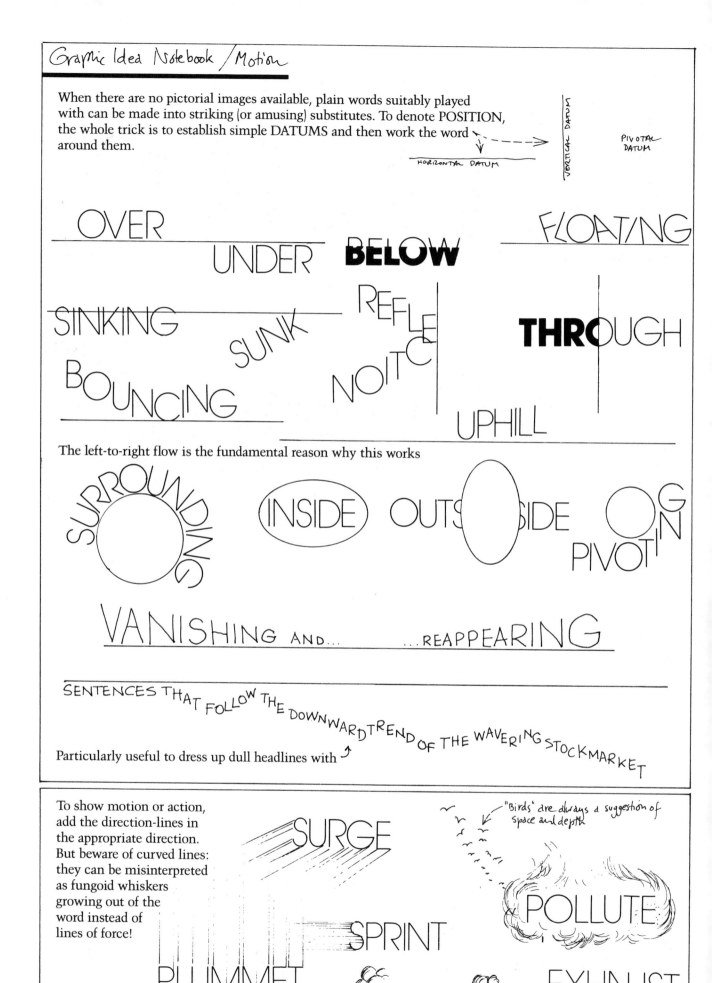

VERTICAL DATUM

PIVOTAL DATUM

HORIZONTAL DATUM

OVER

UNDER

BELOW

FLOATING

SINKING

SUNK

REFLE
NOITC

THROUGH

BOUNCING

UPHILL

The left-to-right flow is the fundamental reason why this works

SURROUNDING

INSIDE

OUTSIDE

PIVOTING

VANISHING AND... ...REAPPEARING

SENTENCES THAT FOLLOW THE DOWNWARD TREND OF THE WAVERING STOCKMARKET

Particularly useful to dress up dull headlines with

To show motion or action, add the direction-lines in the appropriate direction. But beware of curved lines: they can be misinterpreted as fungoid whiskers growing out of the word instead of lines of force!

SURGE

"Birds" are always a suggestion of space and depth

POLLUTE

SPRINT

PLUMMET

EXHAUST

72

Improvement (or decline) are usually shown in cliché graphs like these.

But, given a little imagination and lots of courage, it is often possible to express the same ideas in more graphic clichés, which (one hopes) could succeed in making the points more colorfully or more bitingly.

Decrease in value...

...comparison of values

Each segment below is a self-contained example of showing a CHANGE of some sort...

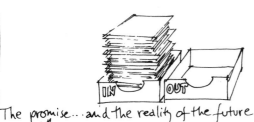

The promise...and the reality of the future

The past that was...the present

that is

Any graphic technique that tells the story is useable...making quick cartoon-type sketches happens to be a convenient way to illustrate a VARIETY of points here. (One can also squeeze a lot into a small space that way.) For instance:

The idea of CHANGE-FOR-THE-WORSE is illustrated here by taking a familiar object and, having chopped it into pieces, removing them sequentially. The opposite sequence (ie. BUILDING UP, or CHANGE-FOR-THE-BETTER) can work just as well, provided the FINAL IMAGE is familiar enough to be recognizable in the very first fragments.

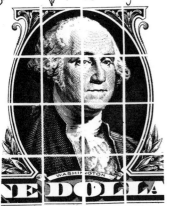

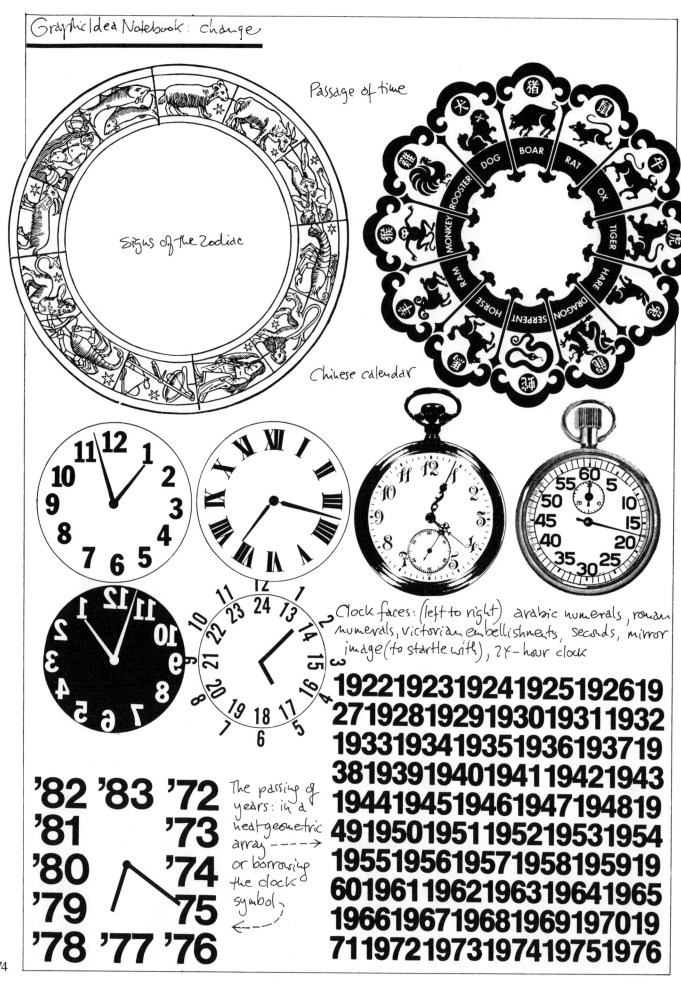

Passage of time

Signs of the Zodiac

Chinese calendar

Clock faces: (left to right) arabic numerals, roman numerals, victorian embellishments, seconds, mirror image (to startle with), 24-hour clock

'82 '83 '72
'81 '73
'80 '74
'79 75
'78 '77 '76

The passing of years: in a neat geometric array ----> or borrowing the clock symbol <----

1922 1923 1924 1925 1926 1927 1928 1929 1930 1931 1932 1933 1934 1935 1936 1937 1938 1939 1940 1941 1942 1943 1944 1945 1946 1947 1948 1949 1950 1951 1952 1953 1954 1955 1956 1957 1958 1959 1960 1961 1962 1963 1964 1965 1966 1967 1968 1969 1970 1971 1972 1973 1974 1975 1976

To represent change in situations where the original subject does not lend itself to graphic invention or manipulation—and there are many!—it may well be useful to bring in external symbols that are commonly understood to be indicators of change in some way: here's just a sampling of the sort of thing that might work...

For change in quantity:
The face of any instrument that measures it: thermometer, speedometer, etc. etc.

For change of place:
compass rose, weathervane, roadside signpost, hitchhiker, airline label...

For change in time:
short periods can be shown by clockfaces, digital clocks, stopwatches, sundials, hourglasses Father Time (not shown) and etc.

For longer time lapses:
Calendar pages seem to be the easiest and the most obvious...but even here, originality in thinking can bring rewards: (below) the 1977 calendar from Davis/Delaney/Arrow of N.Y.C. showed the month's flow as functions of the phases of the moon, clearly coordinated with the days of the week. The "dark" part of each moon was printed in glossy black—which was visible contrasting to the surrounding matte black.

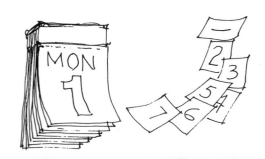

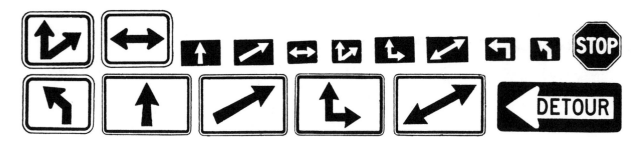

The arrow is a prosaic, unimaginative, obvious cliché, right? Wrong. When it is shaped to express a specific meaning, the insipid symbol turns into a lucid ideogram, capable of telling a story in a language everyone understands. It is a symbol that lends itself to a vast range of subtle interpretations, which depend on how it is rendered and the context in which it is seen.

Arrow **A** can be interpreted as "breaking out of its constraining box". That is a literal description of what you see happening. It can also symbolize "Progress"… "Overcoming obstacles"… "Vision of the future"…or even "Busting out of prison."

The arrows in **B** are obviously face to face. What does that imply? "Confrontation"? "Stalemate"? "Conflict"? How about "Kissing"?

The two arrows in **C** show concentric twisting which could be interpreted as "Opposition"… "Working at cross-purposes"… "Torsion"… or possibly "Getting tanned all over."

132 more variations on the arrow follow, each captioned with suggested interpretations. Clearly, this is not a definitive catalog of configurations that can be devised for this marvellous symbol. Nor are they the "correct" ones. There is no such thing. It is just a collection to trigger your thinking. Access it visually or verbally. *Visually:* pick the rendering that makes sense and develop it. *Verbally:* check the index on page 89 for the concept you need an illustration for and maybe you'll find a reference to a diagram number.

1
Plain arrow
seen from the side

2
Lower edge darkened
to simulate thickness:
arrow seen from above

3
Upper edge thickened
and darkened:
arrow seen from below

4
Width of upper edge
exaggerated, while arrow
itself is darkened:
arrow-shaped slab lying flat

5
Width of upper edge
narrow and dark, while arrow
itself is light and wide:
arrow-shaped slab standing up

6
Realistic rendering of edges
drawn in perspective

7
Dark arrow, light edges
at unexpected angle:
arrow seen from below,
floating above viewer

8
Severe angle of perspective:
arrow lying on surface

9
Same as 8, without shading
but with shadow cast
beneath arrow: floating

10
Arrow drawn as a solid
but hollow object like an
air duct

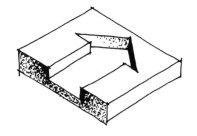

11
Arrow incised into
surface of a slab

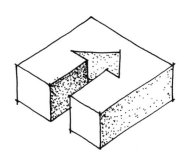

12
Arrow carved as negative
shape from block of
solid material

13
Arrow made of tubular,
circular shapes

14
Arrow drawn as flat,
bendable plane.
Improvement. Upswing.

15
Arrow drawn as flexible,
twisted plane.
Suppleness. Flexibility.

16
Left-to-right: forward.
Positive. Good.
Going with the flow

17
Right-to-left: backward.
Negative. Bad.
Going against the stream

18
Up. Good. Rising.

19
Down. Bad. Falling

20
Upward trend, angle
determines implied speed.
Ascending. Favorable development

21
Downward trend, angle
determines implied speed.
Descending. Unfavorable development.

22
Stem of arrow
of constant width:
steadiness

23
Stem narrowing toward tip:
decrease at constant rate.
Impairment. Deterioration

24
Stem widening toward tip:
increase at a steady rate.
Improvement.

25
Wiggling stem:
changeable direction.
Variability. Inconstancy

26
Stem suddenly fattened
(or thinned): sudden
occurrence. Surprise event

27
Stem slowly fattened
(or thinned): slowly
developing phenomenon

28
Broken stem:
steady, continuous,
rhythmic development

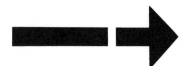

29
Stem broken once,
cleanly: interrupted
motion

30
Stem broken once,
in deliberate manner:
section of line missing

31
Dramatic change of direction.
Upward: sudden improvement.
Downward: sudden deterioration

32
Slight change of direction.
Gradual improvement, then
remaining at that level

33
Violent change of direction.
Downward: unexpected disaster.
Upward: unexpected luck

34
Uncertainty. Indecision.
Vacillation. Confusion.
Erratic action

35
Complexity.
Entanglement.
Complication. Spinoff

36
Oscillation. Vacillation.
Unpredictability. Deterioration.
Retrogression. Relapse

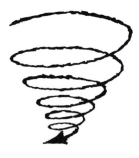

37
Downward trend.
Decline.
Slippage

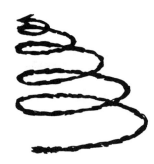

38
Improvement. Progress.
Upward mobility.
Recovery. Perseverance.

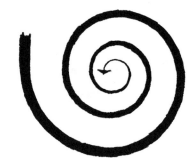

39
Decline at a steady rate.
Disappearing.
Looking to the future.

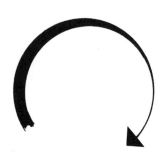

40
Clockwise direction:
logical.
Going with the flow

41
Anticlockwise direction:
illogical.
Going against the mainstream

42
Return to starting point.
Recycling.
Irresolution

43
Overlapping. Introspection.
Turning inward.
Self-examination

44
Turnaround. Flopping.
Changing mind. Inconstancy.
Switching plans

45
Reversing direction.
Mutability. Reaction.
Backlash. Rebound

46
Unrolling.
Start of something big.
Development

47
Direction to distant goal.
Flexibility.
Payoff despite obstacles

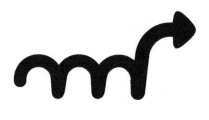

48
Bouncing.
Resilience.
Fluctuation

49
Congealing. Coming together.
Creating teamwork. Consensus.
Decisiveness. Flying away

50
Change of intensity.
Becoming.
Appearing

51
Turning paler.
Becoming less.
Disappearing

52
Starting up.
Building up momentum.
Speeding up

53
Slowing down. Stopping.
Rhythm. Concentration.
Amassing. Coming to a head

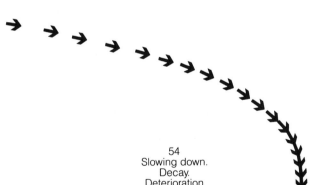

54
Slowing down.
Decay.
Deterioration

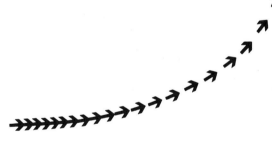

55
Acceleration.
Improvement over time.
Per ardua ad astra

56
Filtering down.
Change.
Disintegration

57
Refinement.
Filtering.
Straining

58
Segmentation.
Control. Fragmentation.
Screening

59
Division into segments of varying importance.
Dispersion. Divergence.
Phased action. Segmentation

60
Breaking up into unequal parts.
Breaking away. Separation.
Independence. Decentralization

61
Reversal of some elements.
Going against the stream.
Changing minds. Vacillation

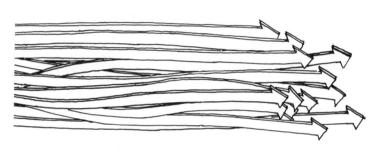

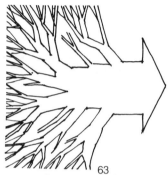

62
Interaction. Teamwork.
Combining forces.
Working toward common goal

63
Convergence. Combining.
Accumulation. Working toward common goal.
E pluribus unum

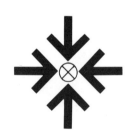

64
Meeting point. Focus.
Centralization. Policy. Pressure.
Forces at work. Common goal

65
Concentration. Plotting.
Convergence.
Focusing. Common goal

66
Off-center.
Missing the point.
Connivance

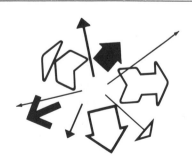

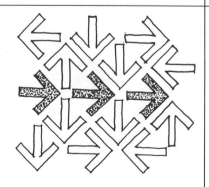

67
Random dispersal.
Conflict. Erratic action.
Lack of leadership

68
Continuing against opposition.
Not losing one's way. Single purpose.
Charting a path through chaos

69
Opposition. Two camps.
Working at cross purposes. Forces at work.
Action / counter-action. Reaction

Graphic Idea Notebook/ Direction

70
Divison. Dispersal in equal values.
Internal forces at work.
Dissemination. Dismemberment

71
Extrusion.
Extroversion.
Outgoingness

72
Introversion. Looking inward.
Concentration.
(if you see arrows pointing inward)

73
Going into something

74
Coming out of something

75
Being trapped.
Containment.
Storage

76
Going in.
Analysis.
Introspection

77
Coming out.
Resultant.
Extrovert

78
Transferring.
Escaping.
Change

79
Adding.
Enlarging.
Weight

80
Squashing.
Overwhelming.
Authority. Bossism

81
Squeezing.
Resistance.
Equality of forces

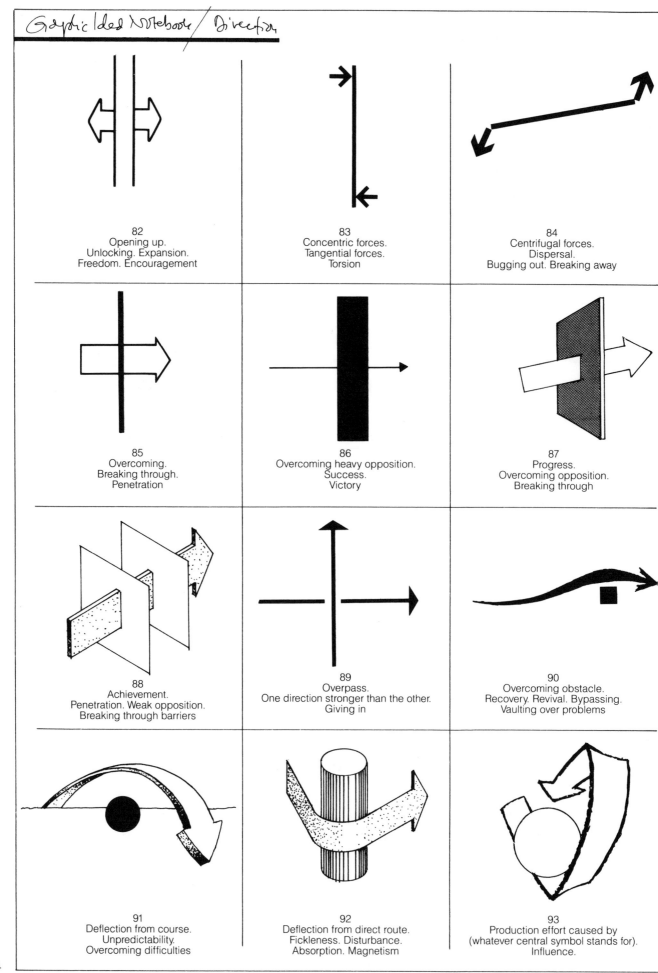

82
Opening up.
Unlocking. Expansion.
Freedom. Encouragement

83
Concentric forces.
Tangential forces.
Torsion

84
Centrifugal forces.
Dispersal.
Bugging out. Breaking away

85
Overcoming.
Breaking through.
Penetration

86
Overcoming heavy opposition.
Success.
Victory

87
Progress.
Overcoming opposition.
Breaking through

88
Achievement.
Penetration. Weak opposition.
Breaking through barriers

89
Overpass.
One direction stronger than the other.
Giving in

90
Overcoming obstacle.
Recovery. Revival. Bypassing.
Vaulting over problems

91
Deflection from course.
Unpredictability.
Overcoming difficulties

92
Deflection from direct route.
Fickleness. Disturbance.
Absorption. Magnetism

93
Production effort caused by
(whatever central symbol stands for).
Influence.

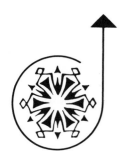 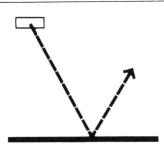

94
Success caused by central element.
Crediting leadership.
Processing with central purpose

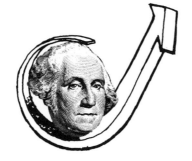

95
Influencing.
Processing.
Refinement

96
Developing a central element
by external manipulation.
Influence

97
Reflection. Deflection. Result.
Turnaround. Repercussion.
Strength of opposition

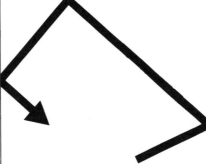

98
Feedback. Reflection.
Frustration. Constraint.
Containment of action. Being boxed-in

99
Opposition. Resistance.
Shattering. Frustration.
Immovable object, unstoppable force?

100
Duality. Dichotomy.
Balance.
Equal pull

101
Indecision.
Up-and-down.
Elevator operator?

102
Leveling of forces.
Balance.
Fulcrum. Pivotal decision

103
Uncertainty.
Ambivalence.
Duplicity

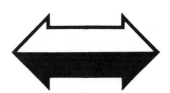

104
Ambiguity.
Ambivalence.
Indecisiveness

105
Compatibility. Equality.
Two-pronged approach.
Two options moving ahead

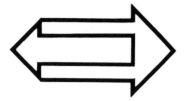

106
Irresolution.
Internal opposition.
Minority protest

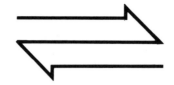

107
Bypassing effort.
Inefficiency. Inconsistency.
Inability to make up one's mind

108
Working at cross purposes.
Action / reaction.
Disagreement. Interaction

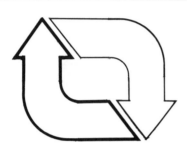

109
System. Balance.
Fulfillment. Efficiency.
Comfort

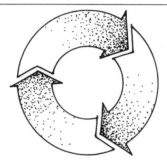

110
Process. Interaction.
Following through.
Futility. Chasing your own tail

Influence. Flow.
Consequence. Sequel. Logic.
One thing leading to another

112
Enhancement.
Promotion. Advancement.
Sequel. Trailing

113
Cause. Result.
Growth. Conformity.
Reflections. Development

114
Overlap.
Building on previous effort.
Flexibility. Resilience

115
Targeting.
Teamwork toward common goal.
Cause and effect.

116
Reaching an objective.
Cause and effect.
Consequence. Derivative

117
Planning. Strategy.
Organization.
Growth of a process

118
Pursuit.
Interrelationship.
Recycling. Flexibility

119
Interpenetration.
Ambivalence. Dichotomy.
Partnership. Love

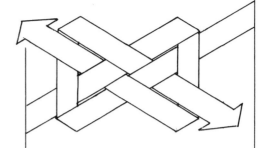

120
Complexity.
Interdependence.
Working at cross purposes

121.
Choice.
Division. Uncertainty.
Interaction

122
Mixing. Joining.
Scheming. Plotting.
Mutual effort

123
Divergence.
Separation.
Disagreement

124
Cooperation.
Coming together.
Consensus

125
Continuity of process.
Irresolution.
Introspection

126
Teamwork.
Cooperation.
Planning

127
Centrifugal forces. Dispersal.
Dissemination. Radiation.
Decentralization. Motion

128
Cooperation. Collaboration.
Agreement. Alliance. Convergence.
Many small steps toward one goal

129
Indecision. Radiation.
Implications. Projections.
Phased process

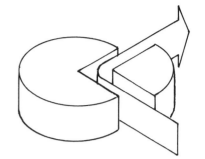

130
Interpenetration.
Influences. Cross purposes.
Breakthroughs

131
Splitting.
Quartering.
Decentralization

132
Isolation of one element.
Deflection.
Anything you want it to mean...

The arrow can be fashioned into an infinity of shapes. Here are 81 by the great typographic designer Hermann Zapf. They are part of the ITC Zapf Dingbat collection. Dingbat is a technical printing term for non-alphanumeric elements that are needed in print. They are also called special characters, pi characters, printers' flowers, and cabbages (if you don't like what you see).

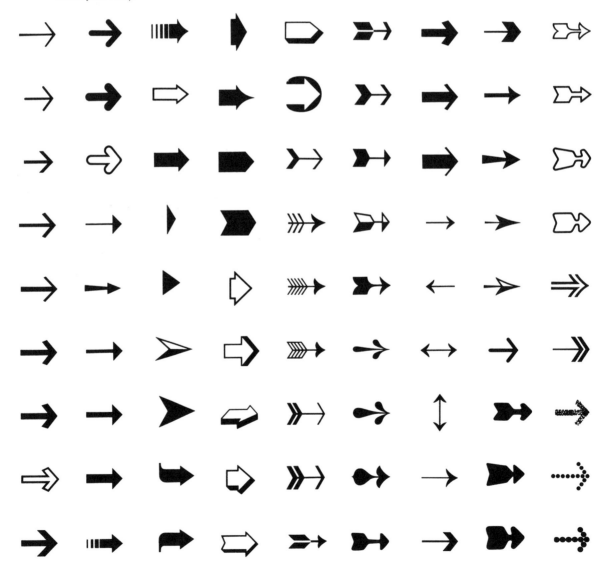

Graphic Idea Notebook

Mugshots

Mugshots

Most of them are a bore. So why do we run them? Simply because too often there's nothing else available and all we are stuck with is the picture of the author or the personality being reported on.

But just because that handout portrait of dubious quality is a personal document doesn't mean that it is sacrosanct. It doesn't mean that our ingenuity must lie fallow. Sure, sometimes it may be foolhardy to take liberties with those mugshots; yet often a bit of dangerous living adds spice and unexpected freshness to that same old mix.

It is the context in which the mugshot is used, the editorial purpose to which it is put and the personality of the personage that determine whether to run the picture as a straight portrait or to use it as raw material with inherent graphic malleability.

When should a portrait photo be more than a mugshot? When it can embody a thought or express a point; when it can illustrate a thought; when it can do more than just show the reader what somebody's face looks like.

1. Keep it simple. This ought not to be too difficult since most studio shots come that way. If the background is distracting or unattractive (or if the mugshot has to be taken from a picture that is a candid and contains other visual matter), then something must be done to improve it. Anything that takes attention away from the subject is suspect. So retouch it by lightening, darkening, fuzzing it up.

2. Silhouette the background away altogether. It is a simple process, especially if the face is facing the camera for then there is no danger of chopping off the proboscis. If an ear or two disappears by accident, no great loss in recognition value is incurred.

3. For a group of interrelated mugshots, unify the background tones in lightness or darkness or texture. Purpose: To make the group read as a group rather than a bunch of odds-and-ends merely run in close proximity. Nothing pulls images of people together more effectively than a unified background—even if those images are widely spaced on the pages.

4. Wherever there is a choice, pick the mugshot that illuminates the subject's character rather than just illustrating physical characteristics. If the subject can get mad at you for having picked *that* one, you may be sure that you are on the right track.

5. If you are lucky enough to get mugshots that show more than just the head, don't crop away all that potentially interesting and pictorial material just because you are going to run a picture of a person. There is no law that says that a mugshot must chop off the head three fingers'-worth below the necktie knot; show the rest as well, especially the hands. Not only are hands expressive in themselves, but they are usually active in some way. Any activity is better than none.

6. Take that original photo and refuse to reproduce it as a plain halftone; that is the expected, the normal, the uninteresting way. All you need is screens, ingenuity, some equipment (most probably available at the printer's right now) and—most of all—the desire, as well as the courage, to have fun.

7. What is "expensive?" The investment that doesn't pay off; the graphic effect that remains unnoticed. So, if you do invest in a trick or two, go whole hog and run it big (or in a highly visible way). The kudos you get for originality will justify the first cost.

8. With the printed images ready, whether it be the normal halftone or any of the doctored variations, you can manipulate them on the page in lots of fresh ways—by boxing, overlapping, framing, repeating, shaping…what have you.

Graphic Idea Notebook

The expected rectangle Circle Rounded corners Diamond Oval ... or something else

Just because a mugshot starts out as a rectangular shape doesn't mean that it must be reproduced that way

The simple factor of unexpected size can give life to an ordinary image. But there is a sensible mimimum

and a logical maximum. ---→ At the small size, the face ought to be well-known to start with. At the large size the face ought to belong to someone worthy of seeing so large.

Courageous cropping:

Very tight

Exaggerated vertical

Exaggerated horizontal (more impressive at larger size than shown here!)

Cropping at an angle changes both direction and mood of subject

Silhouette...
with boxes:

Plain

Regular box

Box with peculiar shape

Box with peculiar "color"

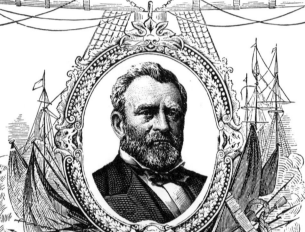

Box with some appropriate graphic symbolism that helps position the subject in some way

Box that determines shape of mug shot within it

Box that is evidently too small to contain its occupant

Silhouette... with backgrounds:

Background adds color

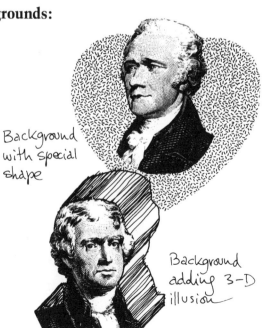

Background with special shape

Background adding 3-D illusion

Background adds texture

94

Names

Numbers

Evocative images

Silhouettes combined with other elements in the story

Mugshots presented as "pictures of pictures"
for best effect, show a group of several, rather than just one.

with photo-corners

stamp

35mm transparency in its sleeve

TV screen

casting a shadow

Mugshots dressed up
as paintings in frames

Mugshot as
movie:
A single image
repeated in
increasing size,
giving the
illusion of
coming closer
to the viewer.

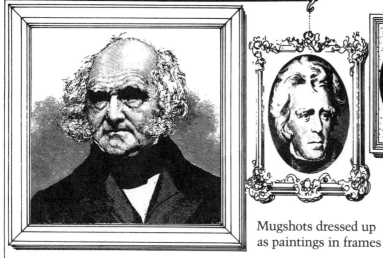

Surprint name in
black in light area

Drop out name in white
from black area

Name goes here
subtly placed
inside the box

THE OBVIOUS PLACE

The name goes here

My name is....

Where does the name
go? Names, affiliations,
pertinent data, quotes,
etc. can all enliven the
mugshot presentation
—if they are designed-
in from the start.

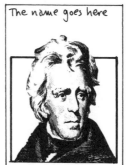

The name can go here

96

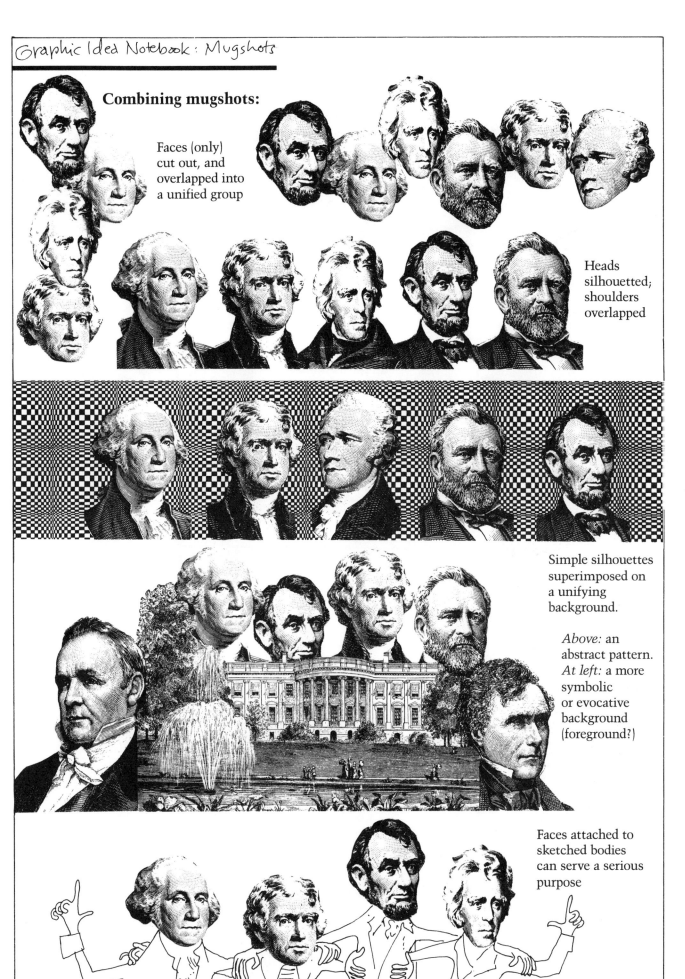

Combining mugshots:

Faces (only) cut out, and overlapped into a unified group

Heads silhouetted; shoulders overlapped

Simple silhouettes superimposed on a unifying background.

Above: an abstract pattern. *At left:* a more symbolic or evocative background (foreground?)

Faces attached to sketched bodies can serve a serious purpose

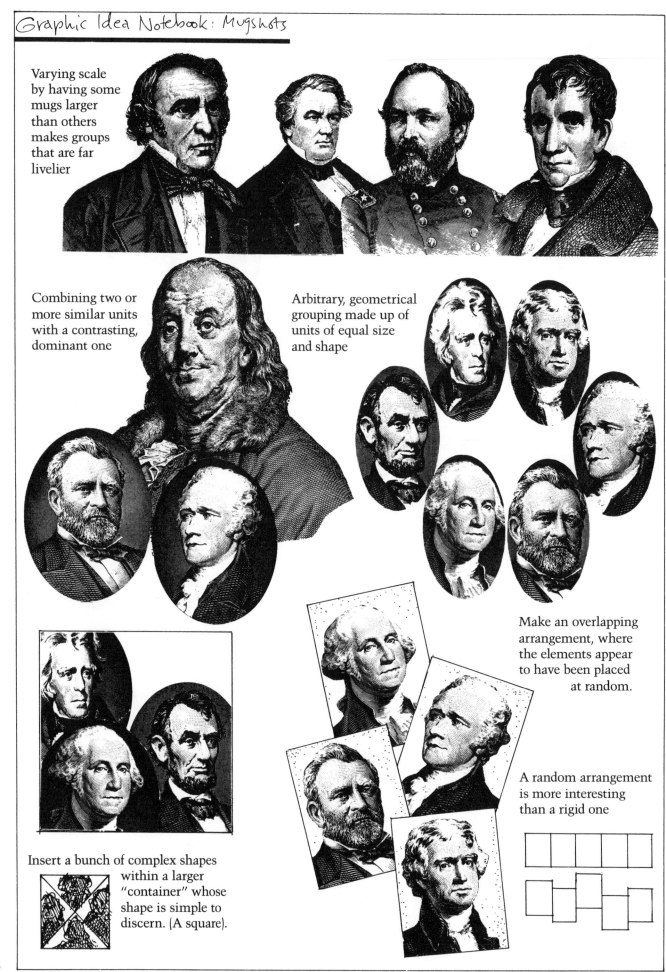

Varying scale by having some mugs larger than others makes groups that are far livelier

Combining two or more similar units with a contrasting, dominant one

Arbitrary, geometrical grouping made up of units of equal size and shape

Make an overlapping arrangement, where the elements appear to have been placed at random.

A random arrangement is more interesting than a rigid one

Insert a bunch of complex shapes within a larger "container" whose shape is simple to discern. (A square).

98

Pictures on the page are like windows in a wall.
The views must be related, to feel right.
The horizon should align (in mugshots that means the
eye levels) so we don't think that some of these people are standing in a hole… or on boxes

Scale, i.e. comparative sizes, should
match, so we are not misled to think
that some people in the lineup are
more important than others…or
are closer to the other side of those
"windows" through which we are
looking at them.

Is the "window" analogy too tame?
Are you searching for something else?
Imagine the mugshots imprinted on
something other than the page.
Then the mugshots are merely illustrations
imprinted on other objects, and it is the
objects which yield that meaningful
variety you need.

99

What do you do when you cannot escape showing mugshots in a row? Crop to the same scale, align the eyes, and then work on the outsides. Make frames linking them into necklaces. Here are some suggestions for patterns to string together in endless chains.

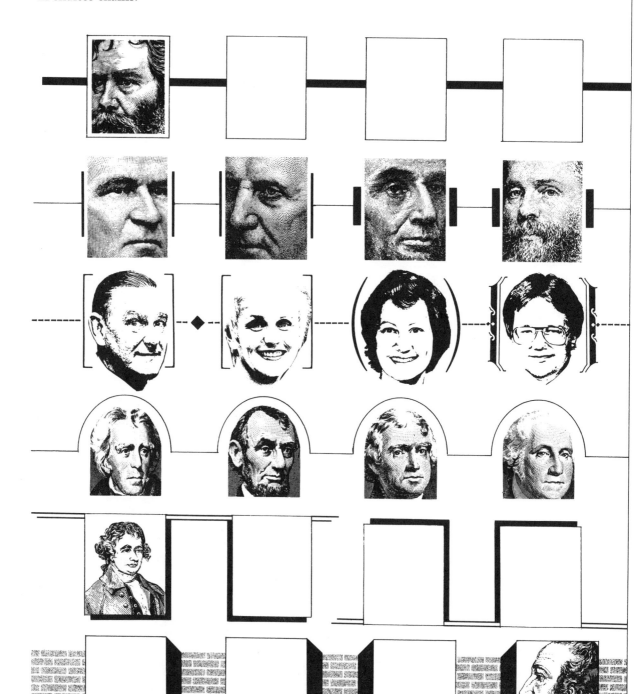

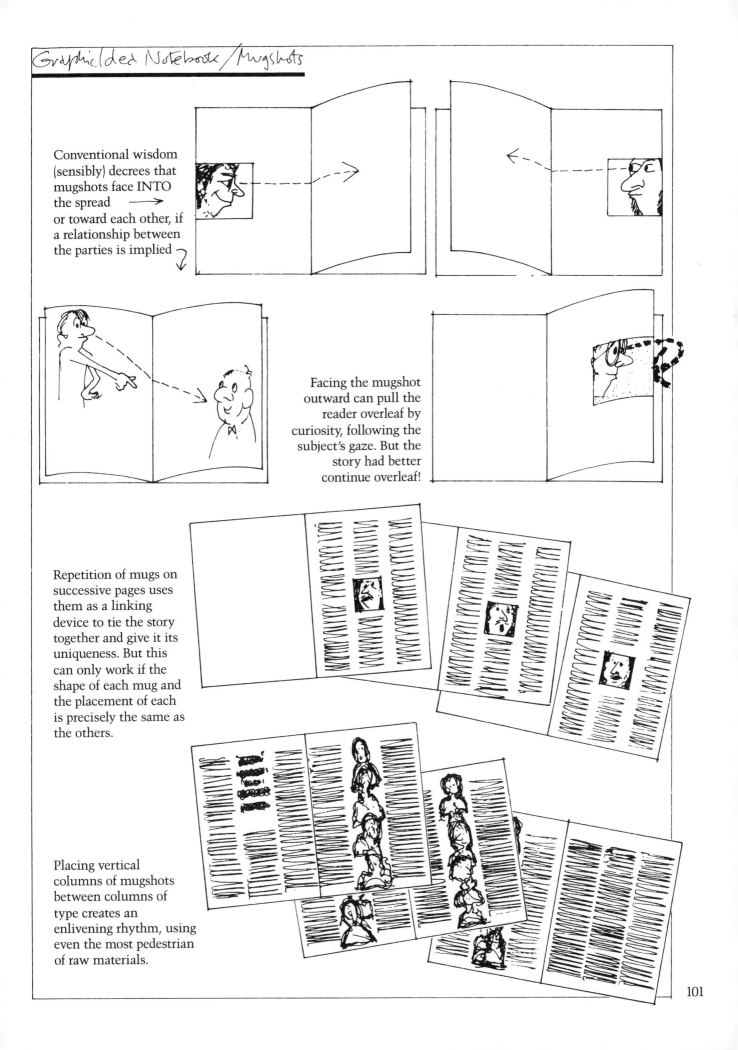

Conventional wisdom (sensibly) decrees that mugshots face INTO the spread ⟶ or toward each other, if a relationship between the parties is implied

Facing the mugshot outward can pull the reader overleaf by curiosity, following the subject's gaze. But the story had better continue overleaf!

Repetition of mugs on successive pages uses them as a linking device to tie the story together and give it its uniqueness. But this can only work if the shape of each mug and the placement of each is precisely the same as the others.

Placing vertical columns of mugshots between columns of type creates an enlivening rhythm, using even the most pedestrian of raw materials.

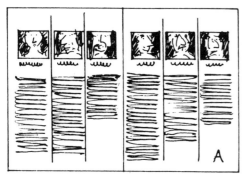

Attaching mugshots to rules: this doubles the effectiveness of the page by doubling the graphic patterns on it: the horizontal pattern (pictorial, photographic) and the vertical pattern (rules, geometric). In version Ⓐ the horizontal emphasis created by the mugshots and the alignment of the text-tops is strong enough to camouflage the irregularity of text lengths…in Ⓑ each vertical shish-kebab of rule-plus-mugshots is identical, but their placement on the page is staggered to yield interesting-looking variety…in Ⓒ the rigidity of the checkerboard pattern in which the mugshots are placed is broken by the rhythmic placement of the rules, as well as arbitrary omissions of a mugshot here or there. Playing with these elements—standard and ordinary raw materials though they be—can lead to original and attractive pages. Pre-requisite: to perceive the mugshots in terms of units in an overall pattern.

Clustering mugshots: assembling groups of people-pictures in deliberately UNEQUAL sizes. This can look amusing and attractive, but such liveliness can be misinterpreted as editorializing since big can be thought to mean important.

Silhouetting and overlapping mugshots (this is where most fun lies) examples: Ⓓ running the frieze at the head of the page, hanging the text down from it. Ⓔ Putting the mugs across the foot of the page and making the most of the ragged gap between them and the text. Ⓕ Creating illusions of scenes of people receding in space (aligned text columns!) etc

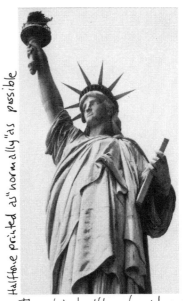

Halftone printed as "normally" as possible

The plain halftone (unadorned)

A familiar theme — and 40 variations
on it by Carl Moreus of Norwalk PhotoGraphics.
The old engraving above is made of lines,
each painstakingly engraved by hand. The same
effect of texture is done mechanically in the
camera

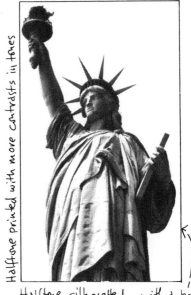

Halftone printed with more contrasts in tones

Halftone silhouetted — with a box

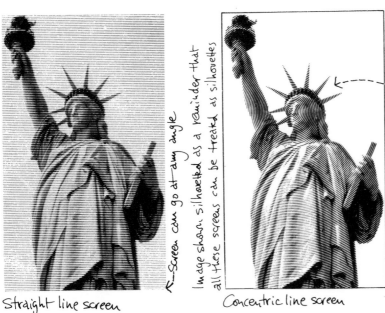

Screen can go at any angle

Image shown silhouetted as a reminder that all these screens can be treated as silhouettes

Center of screen focuses on important point

Straight line screen

Concentric line screen

Wavy line screen

103

Cut line screen

Linen screen

Steel engraving screen

Steel etch screen

Fine grain screen

Coarse grain screen

Fine mezzotint screen

Coarse mezzotint screen

Burlap screen

Fine wood grain screen

Medium wood grain screen

Coarse wood grain screen

Terry screen

Mesh screen

Image printed through textured glass

High-contrast line plate

more dramatic

shows more detail

Tone-line conversion

(Negative shown as a reminder that all these screens can be shown as negatives)

Tone-line run as negative

Solid line silhouette

Silhouette negative

Bas-relief

Solarized image

high contrast

Solarized image

normal contrast

Posterization

Two flats of gray surrounded by a 10% background screen

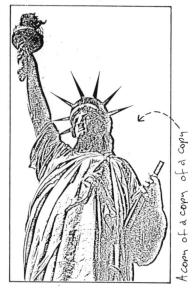

Xerographic distortion

A copy of a copy of a copy done on a copying machine

Xerographic double-image

Xerographic images superimposed

Graphic Idea Notebook: Mugshots

Distortions produced by moving the image during exposure to the xerographic printing process

Distortion of a textured original Xerographic copy sandwiched to a film-positive duplicate exposed as one

Multiple images Patterning of double-images as above

The wonders of electronically-generated artwork are indeed amazing. Computers allow us to produce technical results that used to be attainable only by the most highly-skilled artists at enormous effort and expense. The trouble is that mechanically-produced artwork—fabulous though it be—cannot help but lack the human touch. Why do you need the human touch? Because it is *alive*.

The computer is merely another tool at our disposal. It generates impeccably precise lines, tints, tones, and textures. They combine into a rather hard and mechanical result, and if that is what you need, there is no way it can be created better or more efficiently. Unless the computer is in the hands of an artist, its output is pure, exact, and *dead*.

The hand's imprecision is poetry. Messiness is not a sin: it shows that an object was hand-crafted. It is personal and unique. Its subtle peculiarities express the thought and judgment of the individual who made it. That makes it all the more valuable. Finding the right line with which to show an image is as sensitive as finding the right word with which to describe it. The ultimate value of the human touch lies right there. Its products speak in different accents. Graphics are a language which we must use well, in order to communicate most effectively.

To prove the point, here are 15 variations on a skull-and-bones theme medical illustrator Victoria Skomal came up with. Four of them are shown in both positive and negative form. Notice how technique makes some scarier than others. Aha! That's the whole point.

Why should you care?

1. The difference in the way lines are drawn and the materials used for the drawing create moods that influence the viewer to different interpretations and conclusions.

2. Pictures are what the viewer looks at first on the page. They color the attitude with which the text is later read. They had therefore better have the appropriate flavor.

3. The high visibility of illustrations affects the perceived character of the overall product. Is playfulness or seriousness, looseness or rigidity, precision or cartoonishness right for this product?

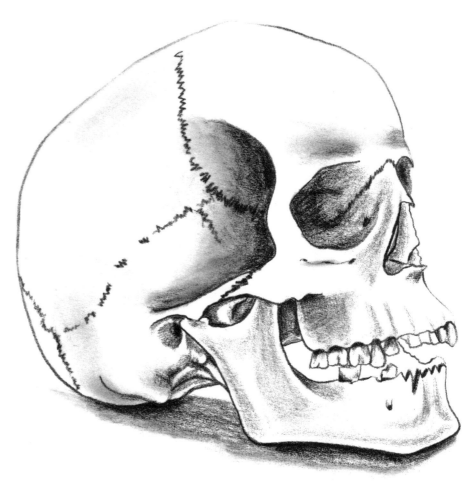

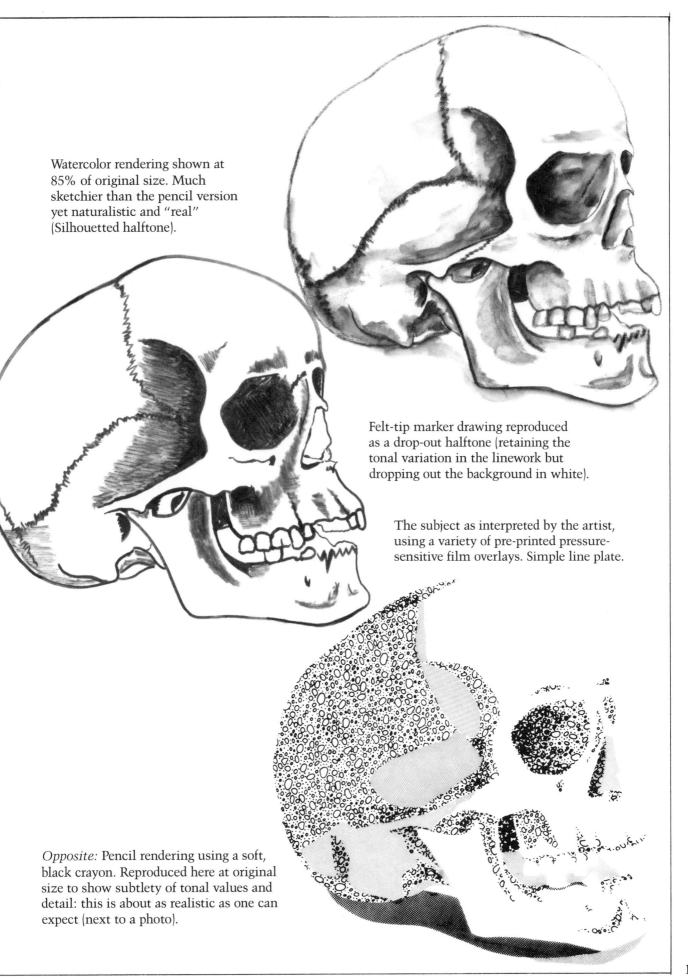

Watercolor rendering shown at 85% of original size. Much sketchier than the pencil version yet naturalistic and "real" (Silhouetted halftone).

Felt-tip marker drawing reproduced as a drop-out halftone (retaining the tonal variation in the linework but dropping out the background in white).

The subject as interpreted by the artist, using a variety of pre-printed pressure-sensitive film overlays. Simple line plate.

Opposite: Pencil rendering using a soft, black crayon. Reproduced here at original size to show subtlety of tonal values and detail: this is about as realistic as one can expect (next to a photo).

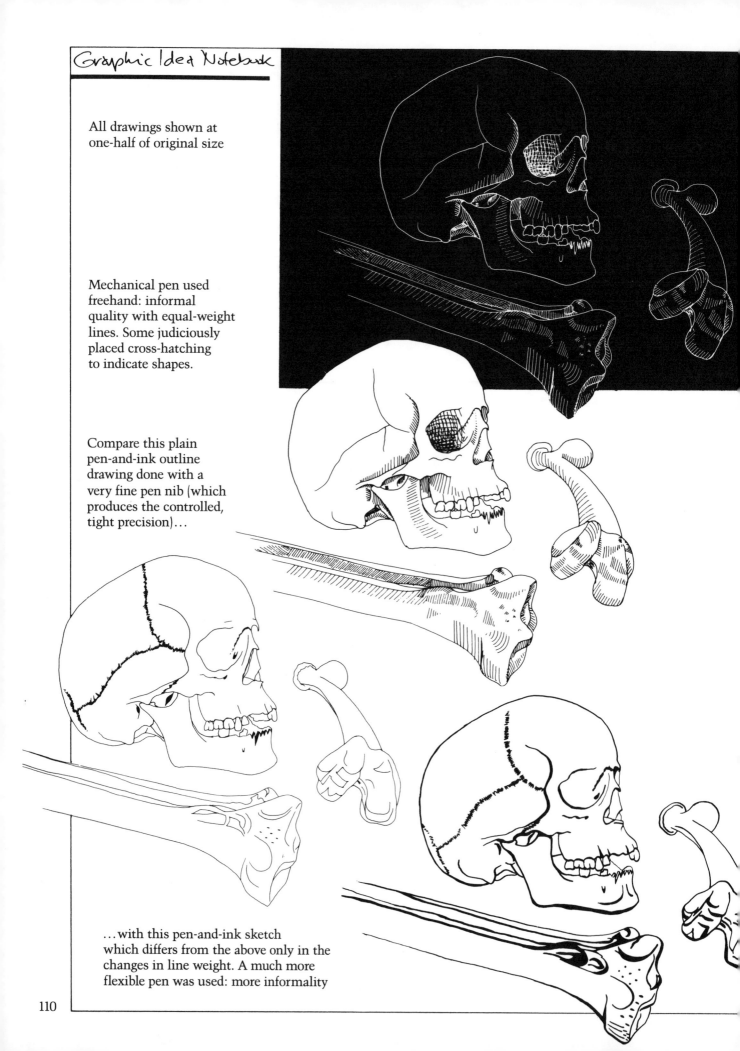

All drawings shown at one-half of original size

Mechanical pen used freehand: informal quality with equal-weight lines. Some judiciously placed cross-hatching to indicate shapes.

Compare this plain pen-and-ink outline drawing done with a very fine pen nib (which produces the controlled, tight precision)…

…with this pen-and-ink sketch which differs from the above only in the changes in line weight. A much more flexible pen was used: more informality

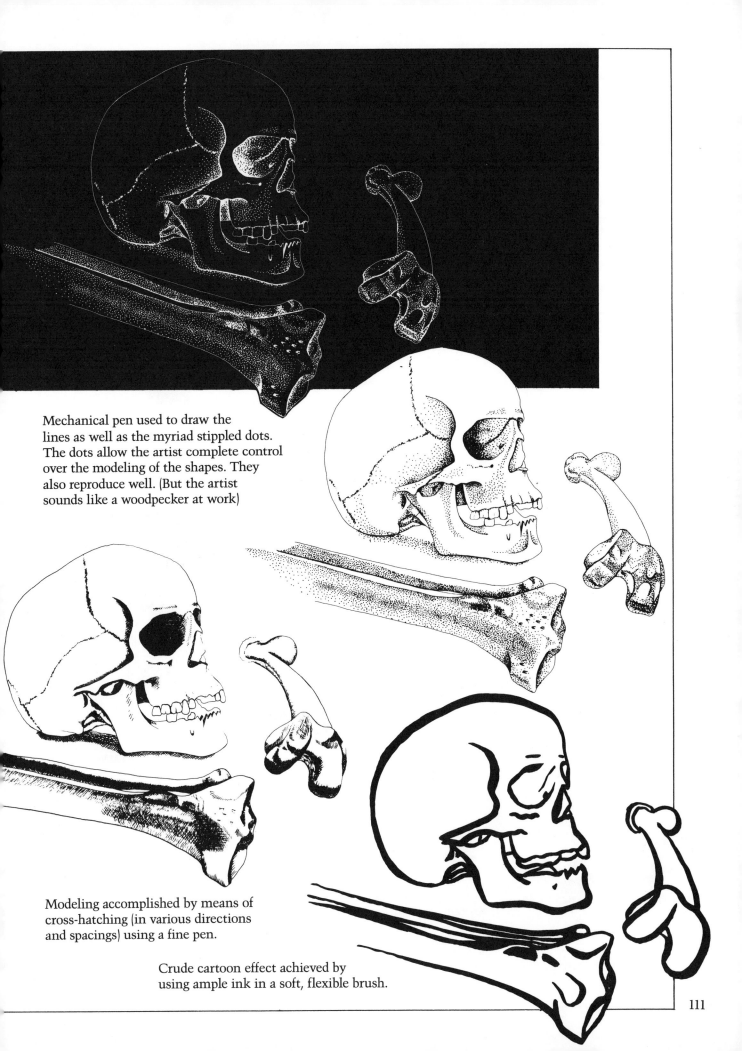

Mechanical pen used to draw the
lines as well as the myriad stippled dots.
The dots allow the artist complete control
over the modeling of the shapes. They
also reproduce well. (But the artist
sounds like a woodpecker at work)

Modeling accomplished by means of
cross-hatching (in various directions
and spacings) using a fine pen.

Crude cartoon effect achieved by
using ample ink in a soft, flexible brush.

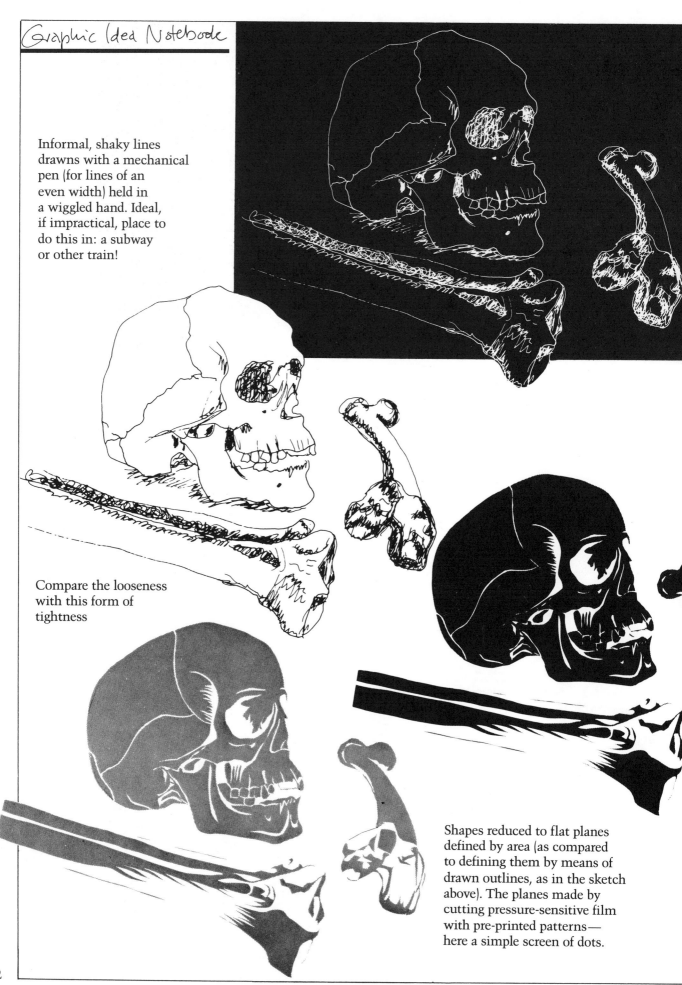

Informal, shaky lines
drawns with a mechanical
pen (for lines of an
even width) held in
a wiggled hand. Ideal,
if impractical, place to
do this in: a subway
or other train!

Compare the looseness
with this form of
tightness

Shapes reduced to flat planes
defined by area (as compared
to defining them by means of
drawn outlines, as in the sketch
above). The planes made by
cutting pressure-sensitive film
with pre-printed patterns—
here a simple screen of dots.

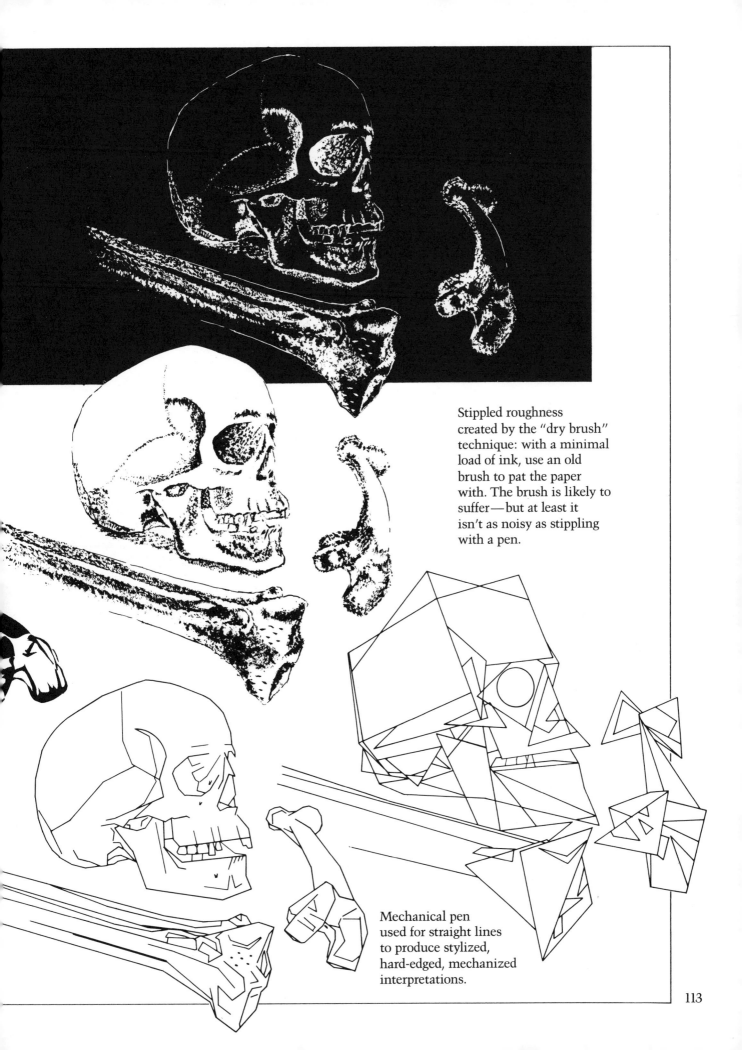

Stippled roughness
created by the "dry brush"
technique: with a minimal
load of ink, use an old
brush to pat the paper
with. The brush is likely to
suffer—but at least it
isn't as noisy as stippling
with a pen.

Mechanical pen
used for straight lines
to produce stylized,
hard-edged, mechanized
interpretations.

113

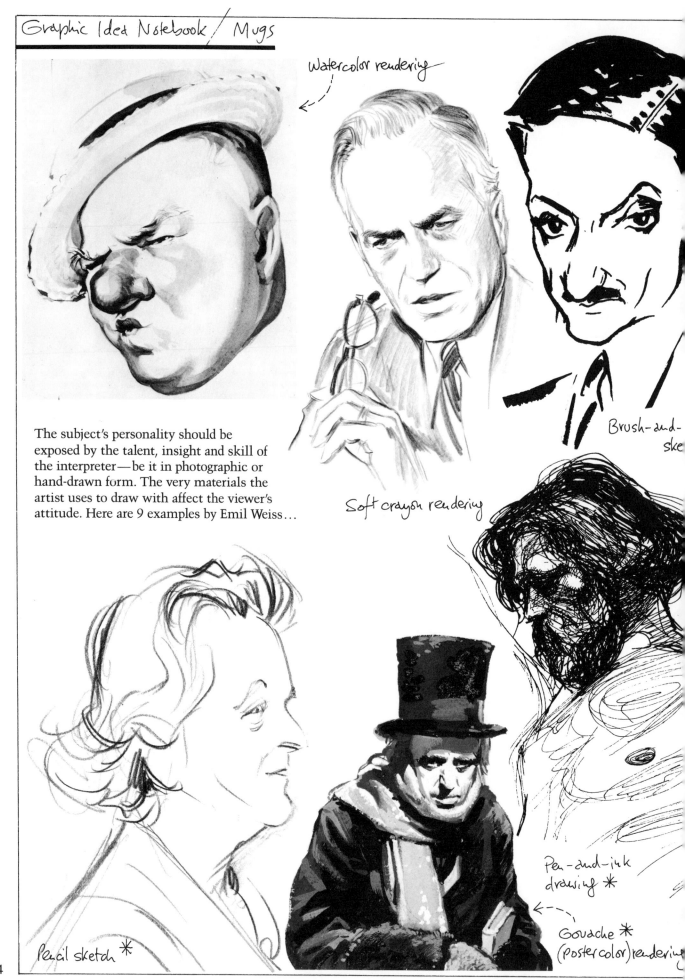

Watercolor rendering

Brush-and-
ske

Soft crayon rendering

The subject's personality should be exposed by the talent, insight and skill of the interpreter—be it in photographic or hand-drawn form. The very materials the artist uses to draw with affect the viewer's attitude. Here are 9 examples by Emil Weiss…

Pen-and-ink drawing *

Pencil sketch *

Gouache * (poster color) rendering

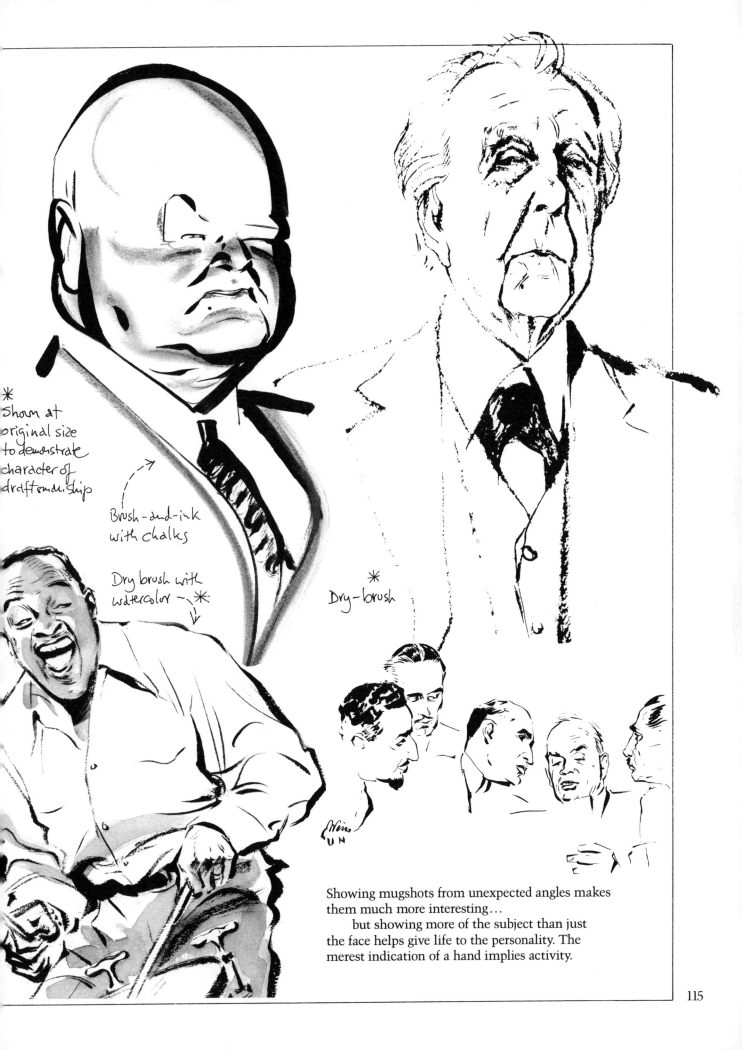

✱ Shown at
original size
to demonstrate
character of
draftsmanship

Brush-and-ink
with chalks

Dry brush with
watercolor ~ ✱

Dry-brush ✱

Showing mugshots from unexpected angles makes
them much more interesting…
 but showing more of the subject than just
the face helps give life to the personality. The
merest indication of a hand implies activity.

Graphic Idea Notebook

Boxes

BOXES

What's in them for you? A lot—as long as they aren't the usual half- or one-point rules encasing your sidebar in its coffin; that's *dead.* Here are some alternatives.

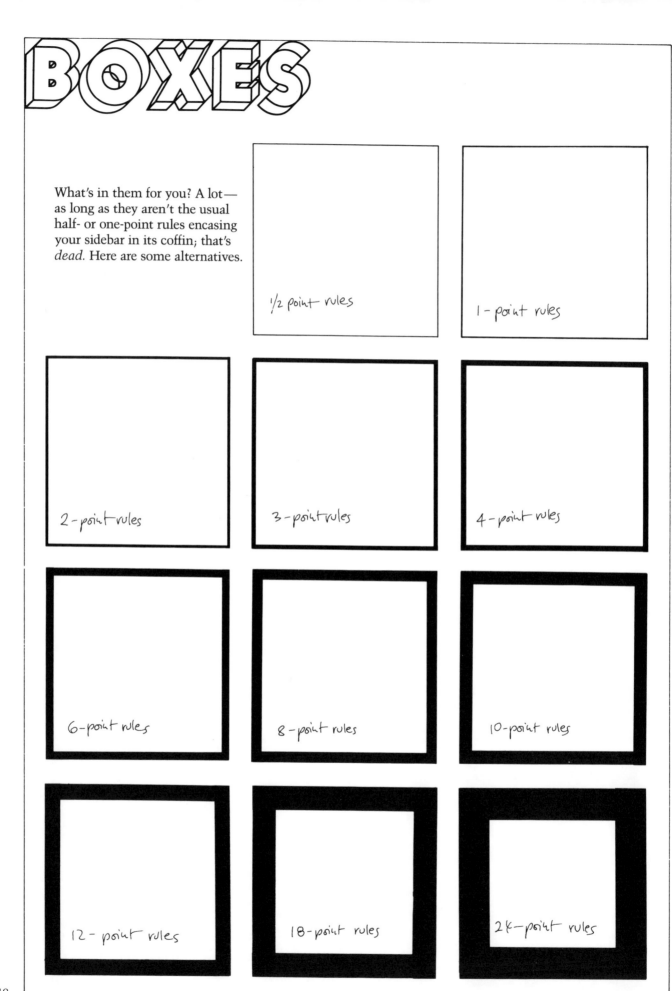

1/2 point rules

1 - point rules

2 - point rules

3 - point rules

4 - point rules

6 - point rules

8 - point rules

10 - point rules

12 - point rules

18 - point rules

24 - point rules

Decorative lines

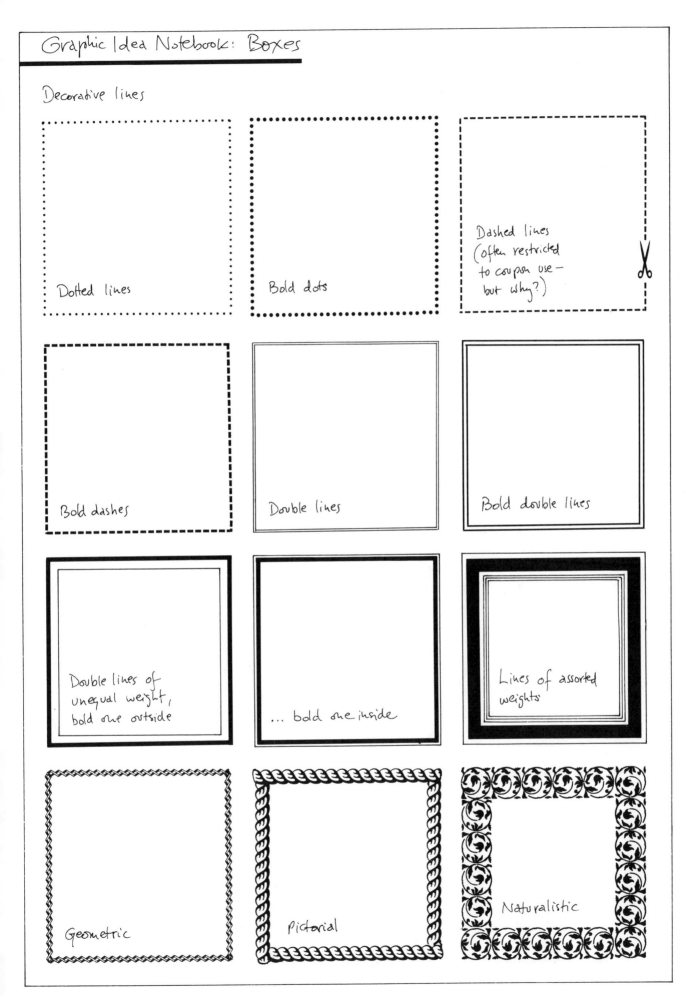

Dotted lines

Bold dots

Dashed lines (often restricted to coupon use — but why?)

Bold dashes

Double lines

Bold double lines

Double lines of unequal weight, bold one outside

... bold one inside

Lines of assorted weights

Geometric

Pictorial

Naturalistic

Graphic Idea Notebook: Boxes

Rounded corners

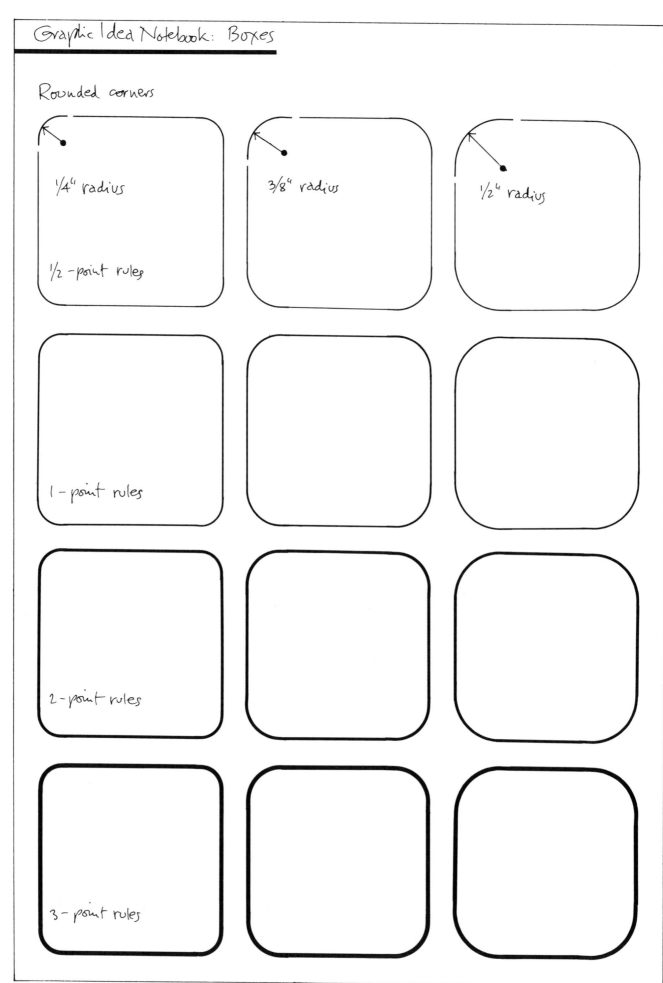

1/4" radius

1/2 - point rules

3/8" radius

1/2" radius

1 - point rules

2 - point rules

3 - point rules

Emphasized corners:

All corners must be carefully and cleanly produced — or the box will look shoddy and amateurish.

Here the problem was avoided by design - - - - >

Negotiating the corners is usually solved by the designer of the decorative border

Bought ready-made

Lopping off the corners at a simple angle

... or by turning the quarter-rounds inwards

...combining elements

The corners here are more important than the edges they connect

Just for fun

Mixing different corner styles

Two quarter-rounds combined

Adding a Victorian touch with evocative artwork in corners

Why not?

Sinuous linework:

Bold rules at top and bottom, flowing into connecting, thin verticals

3-D illusion created by butting two bold rules at one corner — softened in effect by smooth transition from thick to thin

Flowing line surrounding a central space. Line of equal weight all around. (Gap could be position for title etc).

Flowing line surrounds central space as does example at left; but decreasing line weight and cutting ends at angle adds dynamic motion

Taking the dynamic characteristics of curved lines to an extreme(?)

Using the frame for a second purpose:

e.g. fattening a segment to make space for numerals or symbols etc ...

... or enlarging the top for space for a title or other lettering etc to be dropped out in white

Making the line part of an illustration that interrupts the edge of the box

Creating the illusion of the box as something else:

1) a piece of paper with a folded corner

2) a billboard that casts a shadow on the landscape

3) an element of an encompassing graphic context (eg. a cartoon)

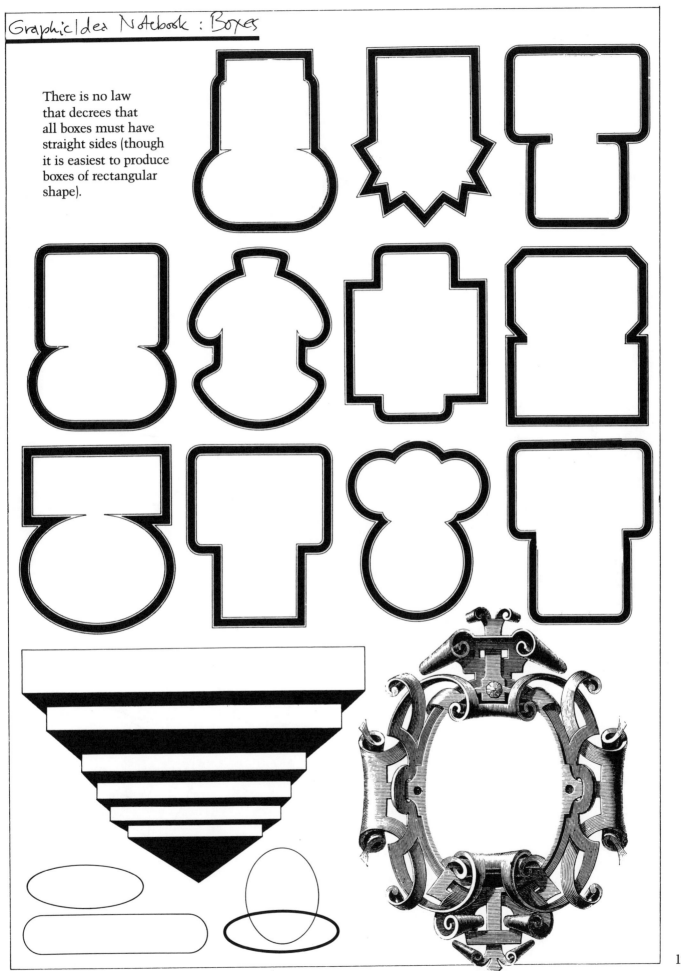

Graphic Idea Notebook : Boxes

There is no law that decrees that all boxes must have straight sides (though it is easiest to produce boxes of rectangular shape).

Graphic Idea Notebook : Boxes

123

Boxes with 3-D effect. Variations depend on:

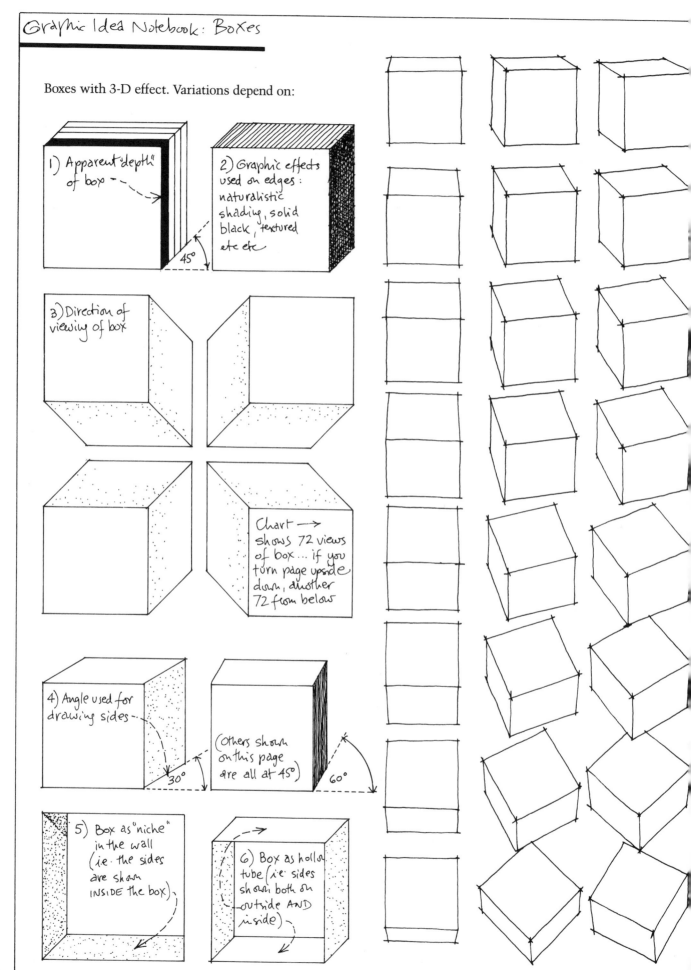

1) Apparent "depth" of box ---

2) Graphic effects used on edges: naturalistic shading, solid black, textured etc etc

45°

3) Direction of viewing of box

Chart → shows 72 views of box ... if you turn page upside down, another 72 from below

4) Angle used for drawing sides --
30°

(Others shown on this page are all at 45°)
60°

5) Box as "niche" in the wall (ie. the sides are shown INSIDE the box)

6) Box as hollow tube (ie. sides shown both on outside AND inside)

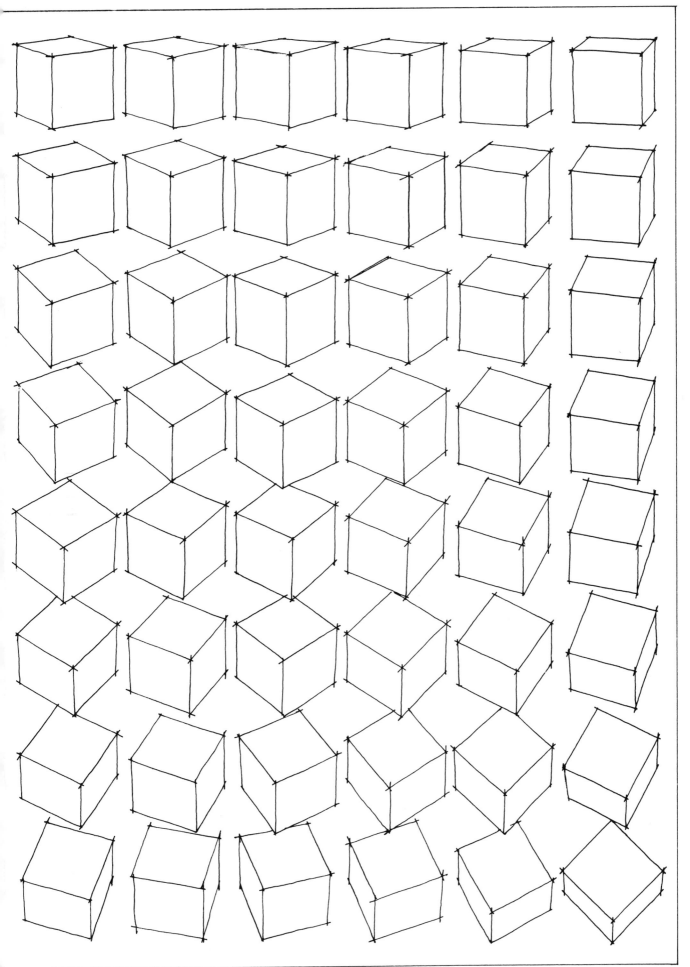

125

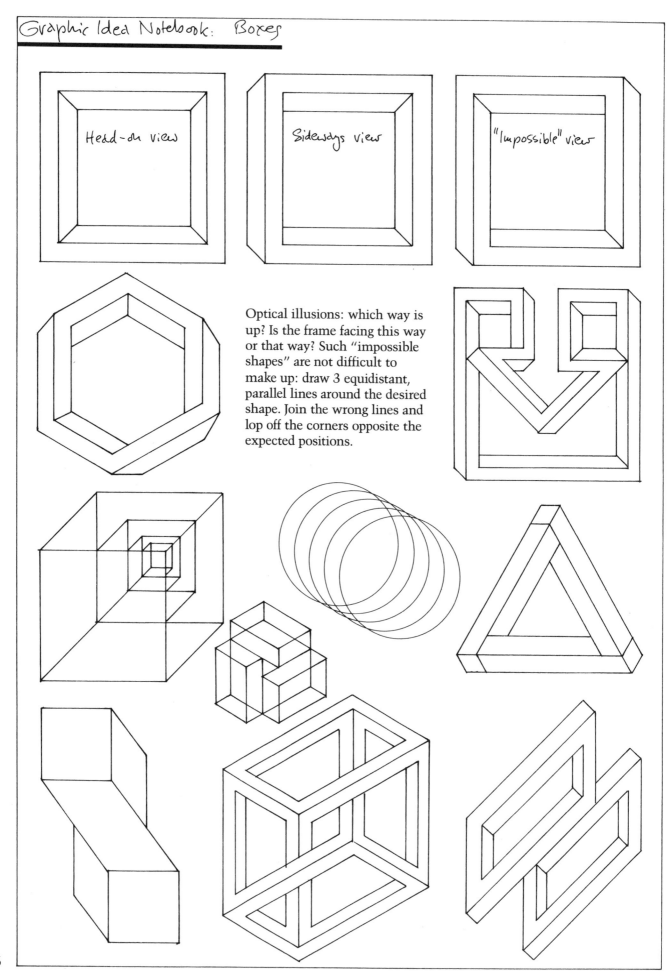

Graphic Idea Notebook: Boxes

Head-on view

Sideways view

"Impossible" view

Optical illusions: which way is up? Is the frame facing this way or that way? Such "impossible shapes" are not difficult to make up: draw 3 equidistant, parallel lines around the desired shape. Join the wrong lines and lop off the corners opposite the expected positions.

WASHINGTON SQU. SPRING SHOW

Expanding the effective area of an illustration by overprinting a box which overlaps into adjacent space: whatever is run in that space automatically "belongs to" the illustration—thus widening its editorial meaning and so increasing its potential impact.

The illustration (right) catches attention; the material in the space captured by the box explains the subject in words, supporting graphics, or whatever subsidiary background stuff might make sense. Here—for simplicity—we just show a detail enlarged.

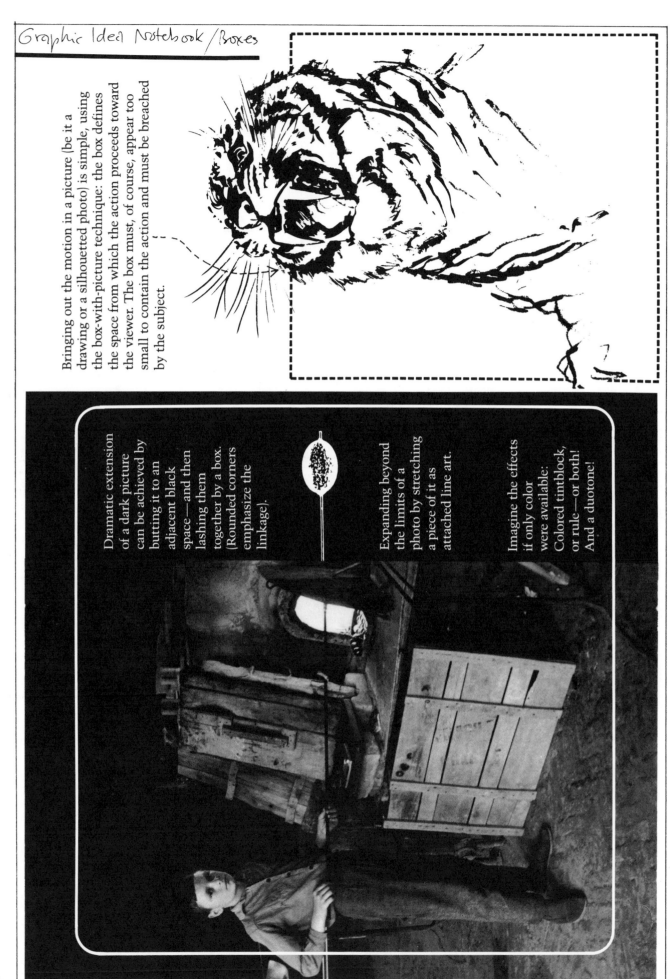

Bringing out the motion in a picture (be it a drawing or a silhouetted photo) is simple, using the box-with-picture technique: the box defines the space from which the action proceeds toward the viewer. The box must, of course, appear too small to contain the action and must be breached by the subject.

Dramatic extension of a dark picture can be achieved by butting it to an adjacent black space—and then lashing them together by a box. (Rounded corners emphasize the linkage).

Expanding beyond the limits of a photo by stretching a piece of it as attached line art.

Imagine the effects if only color were available: Colored tintblock, or rule—or both! And a duotone!

PUNY

BLOATED

A strong grid of ruled boxes can be utilized to pull disparate elements into a group whose whole is greater than the sum of its parts. In this triptych only one of the spaces has been filled by a picture to allow the rhino to do his overlapping more clearly. Imagine the others filled: what does it become? An exhibition panel? Gallery wall? etc.

A box or flat plane can be made to float in space by appearing to overlap an adjoining element. Here the rhino is "behind" the box at left, but he is "in front of" the crowd scene above.

A clearly-defined space delineated by a ruled box (or a tintblock — grey or in color — or a "window" in a tintblock, or whatever) can be used as a foil for editorial graphic imagery. The field must be large and clear so as to appear deliberate. Dropping something small into its vastness makes the small look tiny. Bumping the field's edge implies an enormity that cannot be contained.

Graphic Idea Notebook

Alphabets, numbering

The alphabet—Man's greatest intellectual achievement. These pages are devoted to *alphabets* as distinct from *typefaces*.

Alphabets are derived from the function fulfilled; the materials used; the instruments needed; the language or symbolism mutually understood; the means of communication being utilized. So they can be aural, tactile, or visual—and not necessarily in the shape of the usual letter forms, either.

Typefaces, on the other hand, are basically an embellishment of the fundamental, traditional letterforms, reflecting the culture of their time through the style of the embellishment. Obviously there is oversimplification here. Also much overlapping: the demarcation line between alphabet and typeface is by no means precise, specially in the printed version of letters. Perhaps it may not be all that important to make that fine distinction; though, in the practical editorial world we ought to be able to use anything that can help to get the ideas off the page fast and vividly. Using alphabets of different kinds—or taking the normal ones and doing things to them—may be one of the techniques to remember when the opportunity arises.

the iniʃhal teeчhiŋ alfabet

æ	b	c	d	ɛɛ	f	g	h	ie	j	k	l	m	n
face	bed	cat	dog	key	feet	leg	hat	fly	jug	key	letter	man	nest

œ	p	ɼ	r	s	t	ue	v	w	y	z	ʒ	wh	ʧh	ʈh
over	pen	girl	red	spoon	tree	use	voice	window	yes	zebra	daisy	when	chair	three

ʈh	ʃh	ʒ	ŋ	a	au	a	e	i	u	u	ω	ѡ	ou	oi
the	shop	television	ring	father	ball	cap	egg	milk	box	up	book	spoon	out	oil

Aa Bb Cc Dd Ee Ff Gg Hh Ii Jj
Kk Ll Mm Nn Oo Pp Qq Rr Ss
Tt Uu Vv Ww Xx Yy Zz ?,. Printscript – grades 1 and 2

a quick brown fox jumps over the lazy dog

Aa Bb Cc Dd Ee Ff Gg Hh Ii Jj
Kk Ll Mm Nn Oo Pp Qq Rr Ss
Tt Uu Vv Ww Xx Yy Zz ?,. Commercial cursive – grades 3 and up

a quick brown fox jumps over the lazy dog

Italic cursive: more legible and more handsome
and more enjoyable to learn and use. But still

a quick brown fox jumps over the lazy dog.

the art of handwriting is sadly ignored nowadays and the impersonal machine takes over:

Aa Bb Cc Dd Ee Ff Gg Hh Ii Jj Kk Ll Mm Nn Oo Pp Qq Rr Ss Tt Uu Vv Ww Xx Yy Zz

Aa Bb Cc Dd Ee Ff Gg Hh Ii Jj Kk Ll Mm Nn Oo Pp Qq Rr Ss Tt Uu Vv Ww Xx Yy Zz

Aa Bb Cc Dd Ee Ff Gg Hh Ii Jj Kk Ll Mm Nn Oo Pp Qq Rr Ss Tt Uu Vv Ww Xx Yy Zz

Here are some of the other "quick
brown foxes" collected by Eugene M.
Ettenberg and published in the
April 1968 issue of Inland Printer/
American Lithographer—and shown here with permission:

a quick brown fox jumps over the lazy dog
the spy squaw mixed a dozen jugs of black veneer
joe packed my sledge with five boxes of frozen quail
PACK MY BOX WITH FIVE DOZEN LIQUOR JUGS

big inky devils wax quite mirthful on cozy type job. *john had my big quiz trick of six cap vowels.* WAX ZEBRAS VANISH QUICKLY FROM JAPHETS DOG. A QUICK MOVEMENT OF THE ENEMY WOULD JEOPARDIZE SIX GUNBOATS. quiet gadfly jokes with six vampire cubs in zoo. *JUMPY ZEBRA VOWS TO QUIT THINKING COLDLY OF SEX.* PICKING JUST SIX QUINCES, NEW FARM HAND PROVES STRONG BUT LAZY. back in my quaint garden, jaunty zinnias vie with flaunting phlox. EXQUISITE FARM WENCH GIVES BODY JOLT TO PRIZE STINKER. *dexterity in the vocabulary of typesetting may be acquired by judicious and zealous work.* WIVES SEIZE RIBALD QUARTO, JUNK MATRIX OF GOTHIC TYPE. jail zesty vixen who grabbed pay from quack. *VIRAGO HOCKS SIXTY JEWELS OF EMBLAZONED PLAQUE.* dumpy kibitzer jingles as exchequer overflows

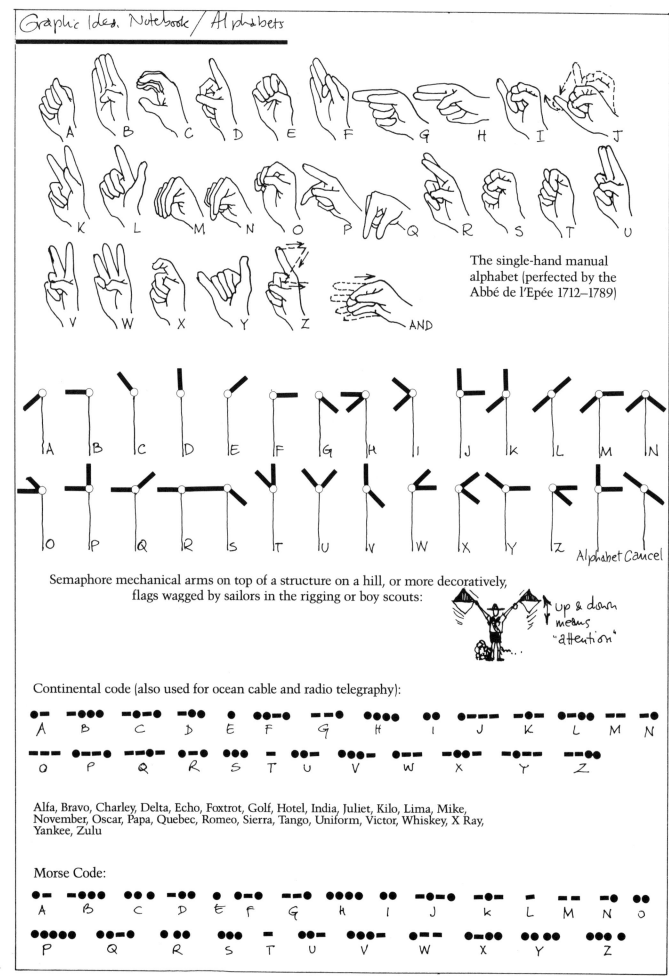

The single-hand manual alphabet (perfected by the Abbé de l'Epée 1712–1789)

Alphabet Cancel

Semaphore mechanical arms on top of a structure on a hill, or more decoratively, flags wagged by sailors in the rigging or boy scouts:

up & down means "attention"

Continental code (also used for ocean cable and radio telegraphy):

Alfa, Bravo, Charley, Delta, Echo, Foxtrot, Golf, Hotel, India, Juliet, Kilo, Lima, Mike, November, Oscar, Papa, Quebec, Romeo, Sierra, Tango, Uniform, Victor, Whiskey, X Ray, Yankee, Zulu

Morse Code:

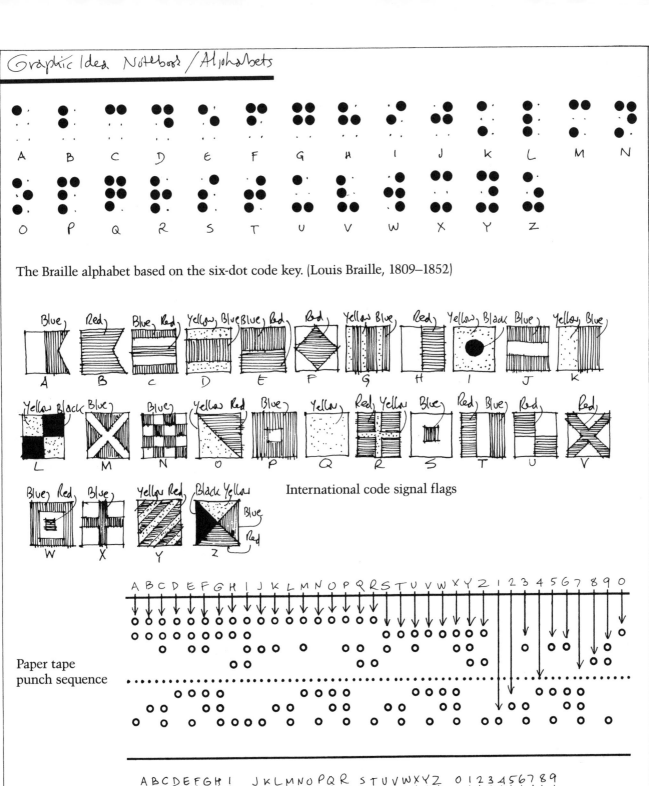

The Braille alphabet based on the six-dot code key. (Louis Braille, 1809–1852)

International code signal flags

Paper tape punch sequence

Card punch sequence (typical)

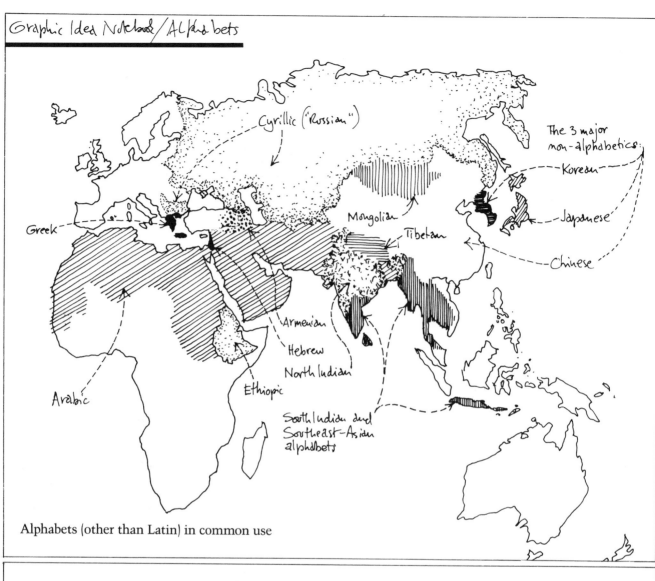

Alphabets (other than Latin) in common use

Map labels: Cyrillic ("Russian"), The 3 major non-alphabetics: — Korean —, — Japanese —, — Chinese —, Greek, Mongolian, Tibetan, Armenian, Hebrew, North Indian, Arabic, Ethiopic, South Indian and Southeast-Asian alphabets

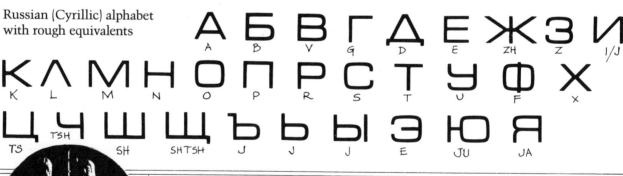

Russian (Cyrillic) alphabet with rough equivalents

А (A) Б (B) В (V) Г (G) Д (D) Е (E) Ж (ZH) З (Z) И (I/J)

К (K) Л (L) М (M) Н (N) О (O) П (P) Р (R) С (S) Т (T) У (U) Ф (F) Х (X)

Ц (TS) Ч (TSH) Ш (SH) Щ (SHTSH) Ъ (J) Ь (J) Ы (J) Э (E) Ю (JU) Я (JA)

Sts. Cyril and Methodius, Byzantine monks, proselytized Slavic tribes of East Europe in 9th Century. They adapted Greek alphabet to Slavic tongues: hence "Cyrillic"

Modern Greek (upper & lower case)

(accents) ˷ ˴ ˶ ˊ ˋ ˏ ˜

Α α Alpha — Β β Beta — Γ γ Gamma — Δ δ Delta — Ε ε Epsilon — Ζ ζ Zeta — Η η Eta — Θ θ Theta — Ι ι Iota — Κ κ Kappa — Λ λ Lambda — Μ μ Mu

Ν ν Nu — Ξ ξ Xi — Ο ο Omicron — Π π Pi — Ρ ρ Rho — Σ σς Sigma — Τ τ Tau — Υ υ Upsilon — Φ φ Phi — Χ χ Chi — Ψ ψ Psi — Ω ω Omega

Hebrew:
(read from right to left). Some sounds have alternate characters. Vowels are indicated by special signs

א בּ גּ דּ ה ו ז ח ט י כ ך
(Aleph) B,V G D H V Z KH T I,Y KH

ל מ ם נ ן ס פּ ף צ ק ר שׁ שׂ ת
L M N S P,F TS K R SH,S T,Th

Arabic:
This is a very oversimplified showing of the alphabet which has numerous alternate characters used depending on the relationship of the character to its preceding or following letter or whether it stands alone

ا ب ت ث ج ح خ د ذ ر ز
(Alef) B T TH DJ HH KH D DS R Z

س ش ص ض ط ظ ع غ ف ق ك ل ك
S SH SS DD TT TZ RGH F KK K L K

ي و ه ن م ل ك
Y W H N M L K

Cherokee Caslon Bold – a new face by Patrick Collins for the special Cherokee Syllabary invented in 1823 by Sequoyah…the 86 characters *might* be edited down to fewer by the substitution of a few diacritical marks such as the incredible

R D W Ᏸ G ᏬᎾ Ꮚ Ꮱ Ꮳ Ꮙ Ꮍ ᏣᏝ Ᏼ Ꮫ ᏫᏋ M Ꮷ Ꮜ C W B Ꭱ Ꭾ

ᏮᎥ ᏒᎿ Ᏺ Ꭺ ᏴᏗ Ꭻ Ᏹ 4 ꜳ C Ꮧ Ꮣ T Z Ꮥ C R Ꮶ S V Ꭾ Ꭼ

Ꮎ T O Ᏸ Ꮊ Ꮇ Ꭻ J K V ꜰ Ꮎ C Ꮐ Ꮻ Ꮗ Ꭺ Ꮾ S S C Ꭵ Ꮻ Ᏼ ꜰ

Ꮳ Ꮍ P ᎦᎻ L Ꮧ G Ꭺ L ꜱ ꮿ S Ꮓ Ꭴ Ꭼ

array of accented letters available on Linotype which indicates the need for various languages to amend the plain letter in order to indicate their own specialized sounds.

| ´ ACUTE | ` GRAVE | ^ CIRCUMFLEX | ¸ CEDILLA | ~ TILDE | ¨ DIERESIS OR UMLAUT | ‾ MACRON | ˘ BREVE |

Ā Ä Â Ä Á Å Ą Á̧ Æ Æ Á À Â Ä Ā̧ Ā̆ Å Ã Ą
ā â ä ã á̆ â̆ á̧ ã̧ ā̧ ā̂ ā̧ â̧ å̧ ą̧ æ á à ä ā ã å ā̆ ą

Ĉ Є CH Ch Ć Č Ç ć č ç ĉ č č̄ є ch

Ď Ḋ’ Ď D Ḑ Ḏ DH Dh Ď Đ
ď ḋ ď̄ d̆ ḑ d̥ đ dh ď

Ē Ĕ Ê Ȅ Ě Ȇ Ȩ Ḝ Ȩ̄ É Ẻ Ê Ë Ē Ĕ Ė
ĕ ĕ̂ ê̆ ĕ̈ ě ȩ́ ḝ ȩ̃ ḝ ḝ ề̆ ȩ̂̃ é è ê ë ē ĕ ȩ è

Ĝ Ǵ Ġ Ģ GN Gh Gn Ḡ Ǧ Ğ
ĝ ǵ ġ ģ ğ ğ̄ gh gn ĝ ğ ğ̄

Ḥ Ħ Ḩ Ḣ Ĥ h̆ ḥ ḩ ḣ ĥ

Î Ī Ị Ī̈ Ĩ Į Ȉ İ Í Ì Î Ï Ǐ Ĭ İ í ī̂ ĩ̈ ī̈ ḟ̈ ī̈ į̈ i̧ i̤ í ì î ï ǐ į ị

Ĵ J̌ ĵ ǰ

Ḱ Ꞣ KH Kh Ķ k k̆ ḳ ḵ kh k

Ĺ Ḻ Ļ Ḷ Ḽ Ḷ̲ Ḻ Ḽ Ļ L̆ ł Ƚ í l̄ ị ị̄ ᴌ ł ŀ
Ṁ M̧ m̃ ṁ m̦ m̄ ḿ mg

Ñ Ṉ Ŋ Ṋ Ṇ Ņ Ṅ Ꞥ Ņ ñ ń ñ ṅ ņ ñg ṅ ṇ ṉ

Ŏ Ô Ö Ő Ǫ Q Ǭ Ó̧ Œ Œ Ó Ò Ô Ö Ō Õ Ő Ø
ŏ ô ö ő̄ ọ ọ̧ ọ̄ ó̦ ǫ̇ o̧ o̦ ó̧ œ œ́ ó ò ô ö ō õ ő ø ōō ŏŏ
p̓

Ṙ Ŕ Ř Ṝ Ŗ Ṛ Ŗ Ŕ Ř Ŗ ŕ ř ṛ ṙ ṝ ṟ ŕ ř ŗ ṛ ṛ̥ ŗ

Ŝ Ṡ Š Ṣ Ṩ Ṣ Ṣ SH Sh Ś Š Ş
ŝ ṡ š ṣ ṩ ṣ ṣ̱ sh ś š ş

Ť Ṫ Ṱ Ṭ Ṯ T’ Ť TH Th Ṱ̆ Ţ
ť ṫ ṱ ṭ̆ t̲ ṯ th ţ t’

Ū Ŭ Û Ü Ů Ủ Ű Ú Ù Û Ü Ū Ŭ Ű Ų
ū ŭ û ü ú ű̆ ŭ̈ ǘ ṳ ų̇ u̦ ụ ų ú ù û ü ū ů ű ų

Ŵ Ẅ ŵ ẃ ẅ w̄ w̆ ẁ

x

Ŷ Ẏ Ỹ Y̊ Ý ý ỳ ŷ ȳ ỹ ẙ ÿ ẏ

Ż Ẑ Ẕ Z̧ Ž Ẓ ZH Zh Ź Ž Ž̧
ż ẑ ẕ z̧ ẓ z̦ zh ź ž ž ź

The word Jerusalem as written over the past 6000 years—in hieroglyphics, cuneiform, hieratic, demotic, Greek, etc.

ירושלים

ابيت المقدس

القدس

اورشليم المقدسه

IEPOYCAΛHM IHERVSALEM HIEROSOLIMA

Inscription Greek:

ΑΛΛΑ Alpha ΒΒ Beta ΓΚ Gamma ΔΟ Delta ΕΕ Epsilon ΖＳ Zeta Η Eta ΘΒ Theta ΙΞ Iota ΚΚ Kappa

ΛΛ Lambda ΜΜ Mu Ν Nu ΞＺ Xi Ο Omicron Π Pi Ρ Rho ＣΣＺ Sigma Τ Tau Υ Upsilon Φ Phi Χ Chi Ψ Psi ΩＷ Omega

Some early inscriptions were written from left-to-right and the next line from right-to-left, the clue being the direction in which the letters were facing. The term for this rather confusing approach to communication was *boustrophedon*—or "as the ox turns" (pulling the plow from one end of the field to the other).

The Roman alphabet based on the inscription on Trajan's column:

might as well get the proportions right—that's the reason for the squares. The x's are centerpoints for arcs.

J, U and W did not exist in Latin

138

Gutenberg's type has moved a long way, in every direction. And wherever we look there are utilizable ideas. Let's be a bit more imaginative

AMAZING ASTOUNDING words thoughts

ZONK

POST NO BILLS

GRAFFiTi

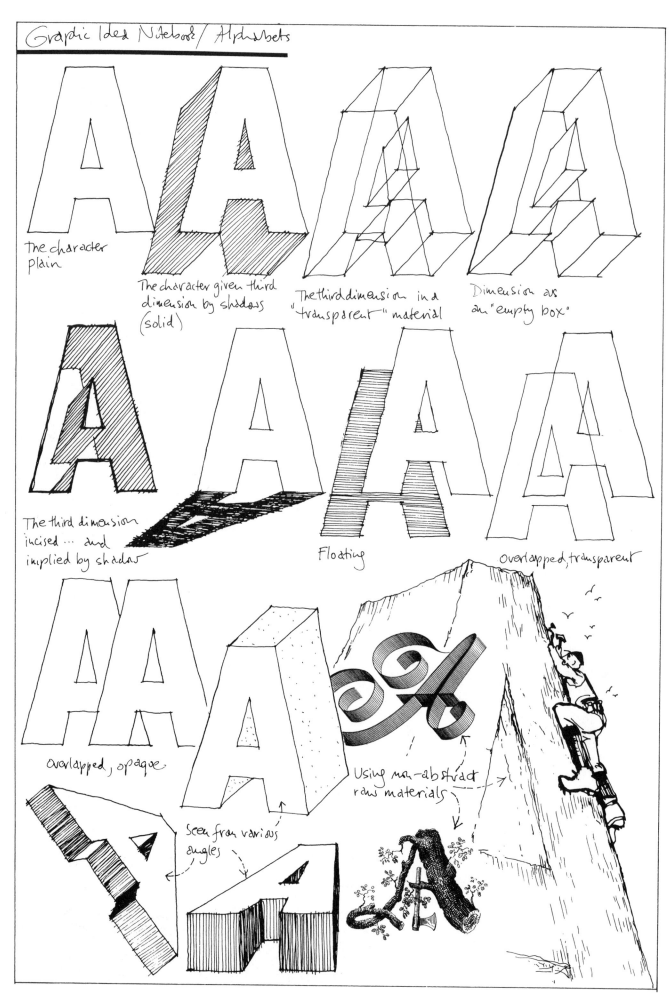

The character plain

The character given third dimension by shadows (solid)

The third dimension in a "transparent" material

Dimension as an "empty box"

The third dimension incised ... and implied by shadow

Floating

Overlapped, transparent

overlapped, opaque

Seen from various angles

Using non-abstract raw materials

Words and pictures:
Cut the word out of the picture itself (HELL).
Overlap the work with parts of the picture (DAMN).
Drop out or surprint the words on the picture (OUCH)
Use the "counters" or open spaces in the letters or between the letters for images (OH)

The words themselves can become pictures or evoke images, if they are set in an alphabet appropriate in character to that image. A few obvious examples just to start the ball rolling:

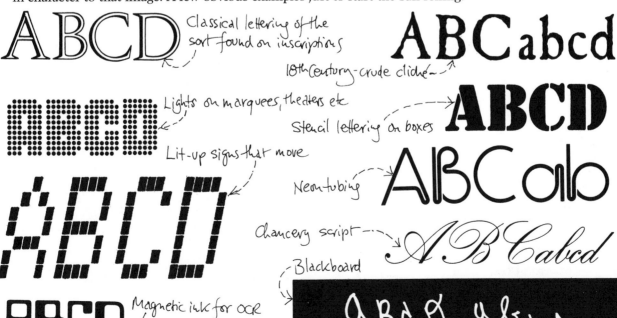

ABCD — Classical lettering of the sort found on inscriptions

ABCabcd — 18th Century-crude cliché

⬛ABCD — Lights on marquees, theaters etc

ABCD — Stencil lettering on boxes

ABCD — Lit-up signs that move

ABCab — Neon tubing

ABCabcd — Chancery script

ABCD — Blackboard

ABCD — Magnetic ink for OCR

ABCD abcd

Some common symbols from the hundreds in use for various interests.
See also the pages devoted to ! ? " " & () { } ☞ → .

+ PLUS	⊃ EXCLUDED FROM	○ CIRCLE
− MINUS	≮ NOT LESS THAN	⌀ DIAMETER
× MULTIPLIED BY	≯ NOT GREATER THAN	△ TRIANGLE
= EQUAL TO	± PLUS OR MINUS	▱ RHOMBOID
÷ DIVIDED BY	∓ MINUS OR PLUS	□ SQUARE
∠ ANGLE	≢ NOT IDENTICAL WITH	/ SLASH
⊥ PERPENDICULAR TO	≠ NOT EQUAL TO	# NUMBER
≐ APPROACHES A LIMIT	∂ DIFFERENTIAL	✔ CHECK
≈ NEARLY EQUAL TO	∫ INTEGRAL	* ASTERISK
∼ DIFFERENCE		⁂ ASTERISM
∝ VARIATION	√ ROOT	† DAGGER
∞ INFINITY	$\sqrt[2]{}$ SQUARE ROOT	‡ DOUBLE DAGGER
⊃ SUBSET OF	′ MINUTE	§ SECTION
⊃ SUPERSET OF	° DEGREE	¶ PARAGRAPH
/ RISING DIAGONAL	∪ UNION OF TWO SETS	® REGISTERED
\ FALLING DIAGONAL	∩ INTERSECTION OF TWO SETS	© COPYRIGHT
< LESS THAN	· MULTIPLIED BY	™ TRADE MARK
≤ LESS THAN OR EQUAL TO	: RATIO	Ⓣ TRADE MARK
≥ GREATER THAN OR EQUAL TO	:: PROPORTION	@ AT
≧ EQUAL OR GREATER THAN	∴ THEREFORE	℀ PER
	∵ BECAUSE	℅ CARE OF

MEASURING TYPE

The two systems in worldwide use are the English/American Point system and the DIDOT system used where the metric system is used (though Didot doesn't fit metric either!)

A: ENGLISH/AMERICAN

1 POINT	= $\frac{1}{72}$ INCH
	= 0.01383″
	= 0.3514605 MM
1 PICA	= $\frac{1}{6}$ INCH
	= 0.166044″
	= 4.2175259 MM

(There are 12 points per pica. There are 6 picas per inch. Well not exactly: 72 pts = 0.996″ Thus a TRUE inch in fact measures 25.40005 MM. 6 picas = 25.30518 MM)

B: DIDOT

1 POINT = 0.3759 MM

1 CICERO = 4.511 MM

(Didot points are written Ciceros "ci" are sometimes called "DOUZE".
There are 12 · to a cicero.
6 ciceros = 27.066 MM)

Comparing 6 picas to 6 ciceros shows that there is a small difference: the cicero is a bit larger. That little bit can make a big difference when multiplied over a page-worth of lines.

Simplest way to convert picas to ciceros or vice versa is to turn everything into the one accurate common sizing system—MILLIMETERS—and then turn the MM into the desired equivalent. (Be sure the calculator battery works!)

Handwritten numbers—the way most people learn to visualize them first:

1 2 3 4 5 6 7 8 9 10 1 2 3 4 5 6

7 8 9

Numerals in typefaces evocative of more than just the cipher itself:

1234567890

1234567890

1234567890

1234567890 1234567890

1234567890 1234567890

1234567890 1234567890

1234567890 123456789O

1234567890 1234567890

1234567890 1234567890

① ② ③ ④ ⑤ ⑥ ⑦ ⑧ ⑨ ⓪

① ② ③ ④ ⑤ ⑥ ⑦ ⑧ ⑨ ⓪

1234567890

...and there are literally thousands more to have fun with

1 2 3 4 5 6 7 8 9

143

The single-hand manual alphabet numerals

Morse code:

1	2	3	4	5	6	7	8	9	0

The Braille system uses the basic 6-dot code key ⠿ utilizing the first ten letters of the alphabet as its numerals, preceding the numerals with the symbol for numerals:

1 2 3 4 5 6 7 8 9 0

Semaphore (mechanical arms…or flags held by a figure such as a boy-scout)

Numeral sign must precede figures signalled

1 2 3 4 5 6 7 8 9 0

The simplest system of all:

| I | II | III | IIII | IIII̸ | IIII̸ I | IIII̸ II | IIII̸ III | IIII̸ IIII | IIII̸ IIII̸ |

International code pennants

red white blue red blue red yellow blue black yellow red red

1 2 3 4 5 6 7 8

Binary numbers (computers)

1 = 1 2 = 10 3 = 11 4 = 100 5 = 101 6 = 110 7 = 111 8 = 1000
9 = 1001 10 = 1010 11 = 1011 12 = 1100 13 = 1101 14 = 1110 15 = 1111 16 = 10000

red black yellow red yellow

9 0

The abacus

Each bead is worth 5

Numbers register only when the appropriate beads are pushed towards the crossbar

Each bead is worth 1

thousands tens units
hundreds

0 1 2 3 4 5 6 7 8 9

Roman "numerals":

I	II	III	IV	V	VI	VII	VIII	IX	X	L	C	D	M
1	2	3	4	5	6	7	8	9	10	50	100	500	1000

XI	XII	XIII	XIV	XV	XVI	XVII	XVIII	XIX	XX	XXI	XXII	XXIX	XXX	XL	LX	LXX	LXXX	XC	CC
11	12	13	14	15	16	17	18	19	20	21	22	29	30	40	60	70	80	90	200

CCC	CD	D	DC	DCC	DCCC	CM	M	MM	MMM
300	400	500	600	700	800	900	1000	2000	3000

Classical Greek alphabet/numerals:

α	β	γ	δ	ε	ς	ζ	η	θ	ι	κ	λ	μ	ν	ξ	ο	π	ϙ	ρ	σ	τ	υ	φ	χ
1	2	3	4	5	6	7	8	9	10	20	30	40	50	60	70	80	90	100	200	300	400	500	600

An apostrophe is added to distinguish the numeral from the letter: $α' = 1$.
A bar precedes the letter to denote thousands: $/δ = 4000$. (There is no zero)

ψ	ω	ϡ
700	800	900

Babylonian cuneiform:

| 1 | 2 | 3 | 4 | 5 | 6 | 7 | 8 | 9 | 10 | 100 | 1000 |

Egyptian hieroglyphic:

| 1 | 2 | 3 | 4 | 5 | 6 | 7 | 8 | 9 | 10 | 11 | 12 | 20 | 40 | 90 |

Ancient Hebrew (alphabet used as numerals)

| 400 | 300 | 200 | 100 | 90 | 80 | 70 | 60 | 50 | 40 | 30 | 20 | 10 | 9 | 8 | 7 | 6 | 5 | 4 | 3 | 2 | 1 |

The Maya system:

| 0 | 1 | 2 | 3 | 4 | 5 | 6 | 7 | 8 | 9 | 10 | 11 | 12 | 19 |

etc until the maximum → (19 days in the month) is reached. Then start at N° 1 again.

alternate system uses masks for 1 through 13, then adds the jaw from 10 to the others to complete the 19

| 0 | 1 | 2 | 3 | 4 | 5 | 6 | 7 | 8 | 9 | 10 | 11 |

| 12 | 13 (alternate) | 13 | 14 | 15 | 16 | 17 | 18 | 19 |

Numeral/words:

1ne 2wo 3hree 4our 5ive 6ix 7even 8ight 9ine 10n 11even

ADDDITION SUBTRCTION MULTIPLIPLICATION DIV ISION

HA
LF

Numerals made for or by new technology:

10:58 Solid state

lights

Computer printout

magnetic ink **1 2 3 4 5 6 7 8 9 0**

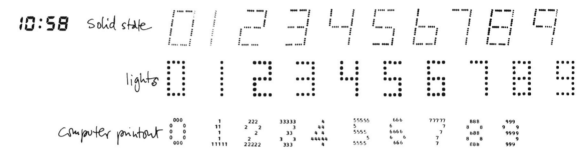

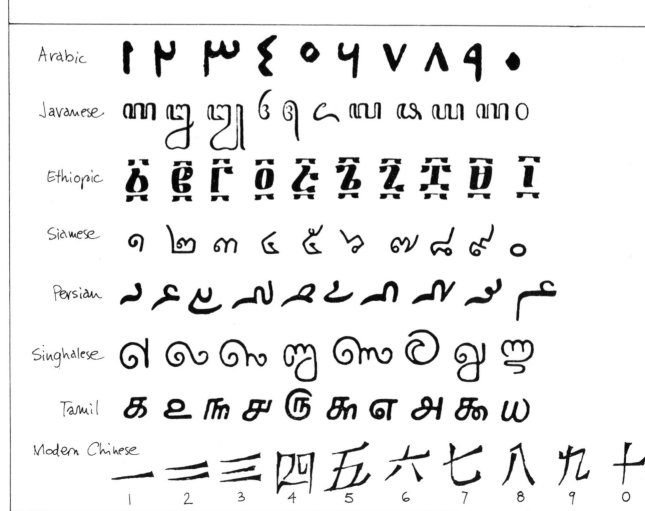

Arabic										
Javanese										
Ethiopic										
Siamese										
Persian										
Singhalese										
Tamil										
Modern Chinese										

1 2 3 4 5 6 7 8 9 0

Using the numeral as the focus for a graphic presentation—such as cartoons

The context in which the numeral is shown gives it scale (and editorial importance)— from gigantic to tiny.

Illustrating the concept AND the number by symbols:

Transforming the number of items into visible (countable) symbols:

This is obviously a group of three somethings

Playing games with numbers: substituting ciphered symbols for the actual figures:

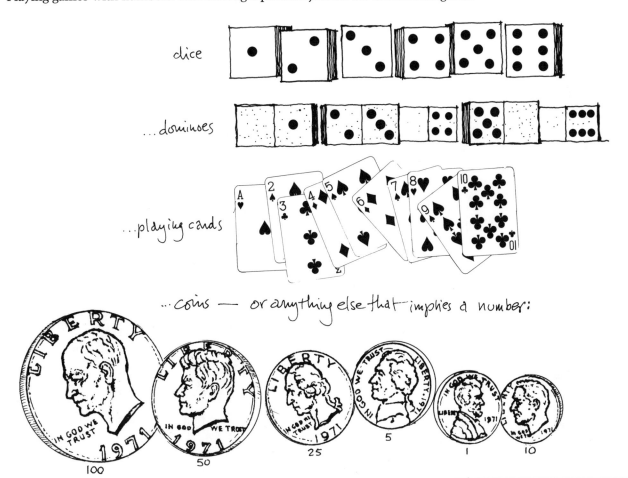

dice

...dominoes

...playing cards

...coins — or anything else that implies a number:

Embellish the numerals by adding external elements of some sort (or biting out a piece)

Overlap the numbers to show progression → Overlap the figures themselves—flat, or, as shown here, in 3D. Or overlap the "paper" they appear on.

Use number-symbols as in this calendar by Russell & Hinrichs Inc. for S.D. Scott Printing Company

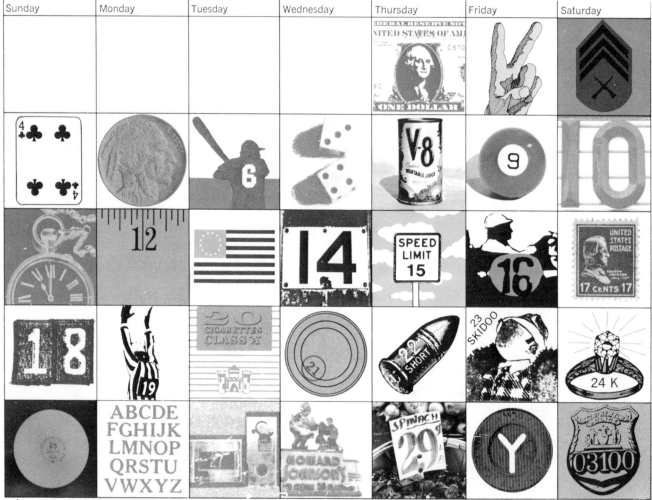

Sunday	Monday	Tuesday	Wednesday	Thursday	Friday	Saturday

A few ways to combine numbers and text

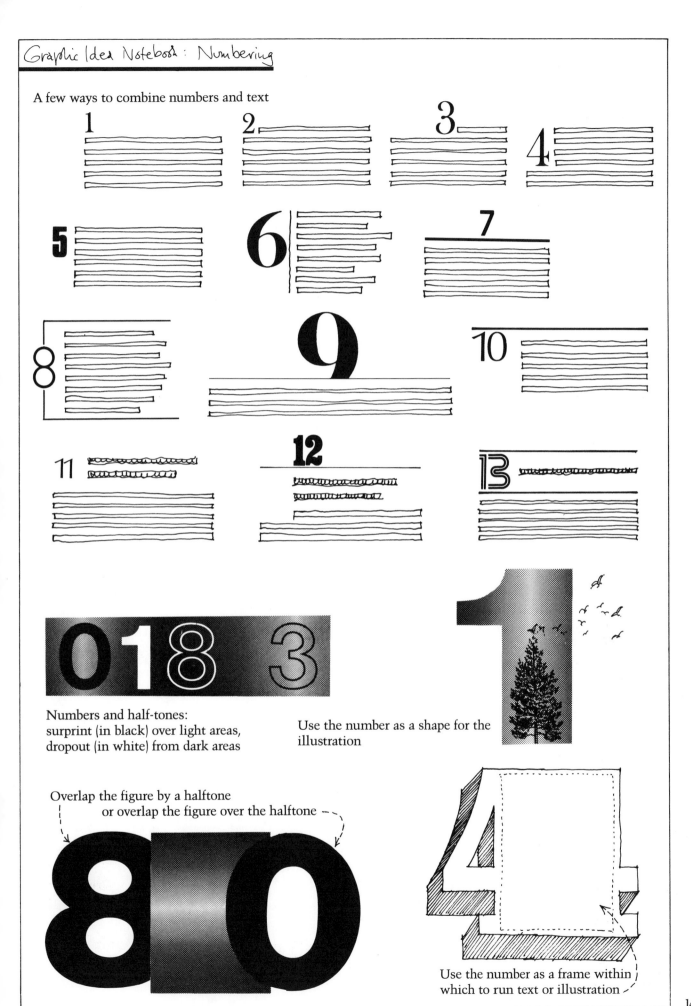

Numbers and half-tones:
surprint (in black) over light areas,
dropout (in white) from dark areas

Use the number as a shape for the illustration

Overlap the figure by a halftone
or overlap the figure over the halftone

Use the number as a frame within which to run text or illustration

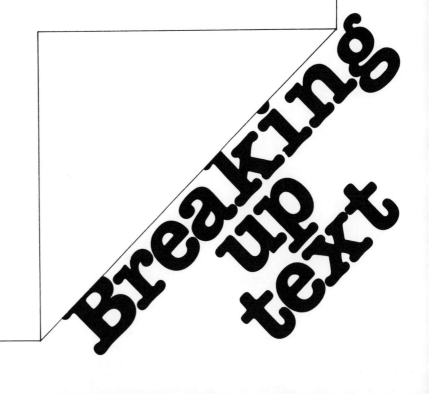

Breaking up text

Breaking up TEXT

Great Literature needs no typographic breakup; people will read it in spite of its length, page after dull grey page. They know it will be worth the effort, so they approach it differently from the way they do the reading matter that forms the overwhelming majority of words in print.

To lure the reader into reading, we must make that prosaic prose look easy. How? By breaking it up into small pieces, for small bits seem to need less commitment of time and energy.

A further enticement is offered by the signals we attach to the starts of these small chunks—be they verbal (as subheads, sideheads, crossheads, quotes or whatnot) or just graphic (as initials, devices, or gimmicks of some sort). Therefore let's stop thinking of "breakup" in negative terms. Let's rather see each such break as a baited hook with which to pull the reluctant reader into our copy. Each is a positive "fist" pointing at the reader, saying "I WANT YOU."

FLUSH LEFT (NO INDENT) ⟶

Lorem ipsum dolor sit amet, consectetur adipisci tempor incidunt ut labore et dolore magna aliqu atib saepe eveniet ut er repudiand sint

⟵ For crisp start of copy: no ¶ indent.

1-EM INDENT ⟶

Nos ar sapiente delectus au aut prefer endis dol tene sententiam, quid est cur verear ne ad eam nc quos tu paulo ante memorite tum etia ergat.

2-EM INDENT ⟶

Lorem ipsum dolor sit a consectetur adipisci tempor incidunt ut labore et dolore magna aliqu veniam, quis nostrud exercitation

DEEP INDENT (½ LINE) ⟶

Duis autem vel eum irure d esse molestaie consequat, velillum dolore eu fugi accusam et iusto odio dignissim qui blandit

⟵ Unusual, therefore arresting. But be sure to avoid a widow in the line above!

RANDOM INDENTS FOLLOW ENDS OF PRECEDING SENTENCES. SIMPLEST WAY TO MAKE UP: SET RUNNING COPY AND CUT GALLEY UP WITH RAZOR BLADE.

Ut enim et molestias exceptur sint occaecat cupid qui officia deserunt mollit anim id est laborum et d er expedit distinct.

Nam liber tempor cum soluta r impedit doming id quod maxim placeat facer po omnis dolor repellend.

Temporibud autem quinus atib saepe eveniet ut er repudiand sint et molestia tenetury sapiente delectus au aut prefer endis dol

⟵ Half-line space between lines helps the flow from one phrase to the next. This is a trick especially useful for expressing dual-voice copy (PRO/CON etc.)

HANGING INDENT ⟶

Praesene sententiam, quid est cur verear ne ad eam quos tu paulo ante memorite tum etia ergat. fier ad augendas cum conscient to factor tum poe

2-EM INDENT ⟶

Nos ar non pecun modut est neque cupiditat, quas nulla praid om umdant. Improb coercend magist and et dodecendesse videantur.

⟵ Ragged-right setting requires deeper ¶ indents in the left-hand margin.

1 LINE SPACE ⟶

NO INDENT ⟶

Lorem ipsum dolor sit amet, consectetur adipisci tempor incidunt ut labore et dolore magna aliqu veniam, quis nostrud exercitation ullamcorper sus commodo consequat. Duis autem vel eum irure dc accusam et iusto odio dignissim qui blandit praese

⟵ Never indent ¶-starts if space is used to signal breaks between paragraphs.

The copy is dumb dummy type . . . don't read it.

iustitiam, aequitated fidem. Neque hominy infante
efficerd possit duo contend notiner si effecerit

½ PT RULE

Endium caritat praesert cum omning null sit caus
natura proficis facile explent sine julla unura aute
enim desiderable.

Rules are easy, cheap, simple, &
don't need *editing*. They do
look a bit final—terminal?—
unless they are used as obvious
"design" elements.

4 PT RULE

Ut enim ad minim oncupis plusque in ipsinurian
emolument oariunt iniur. Itaque ne iustitial dem re
quiran cunditat vel plurify.

6 PT RULE

Nam bitate putamut sed mult etiam mag quodp
garent esse per se sas tam expetend quam nostras
stabilit amicitate acillard tuent tamet eum

By signalling the *end*, you also
imply the *start* of something
new that follows next.

Atque ut odia, invid despication adversantur lupta
fidelissim sed al etiam effectrice sunt luptam amic

Printers' flowers (a.k.a. cabbages)
are friendlier than bold rules
and they also add color together
with atmosphere.

FLOWER, CENTERED

cum solitud et vitary sing amicis insidar et metus
comparar, quibus part confirmatur animuset

**FLOWER, CUT-IN LIKE
2-LINE INITIAL**

Tierigunt consequent poster tempor most
per petuam incandit vitae tenere possum
nosmet diligam idcirco et boctor ipsumed effitdol
laetam amico consid aeque nostralet partit

There should be enough
contrast in blackness to allow
the boldface words to pop
out from the surrounding pale
gray text.

1 LINE #

9 PT BOLD

Beethoven gamicund quo in perseus, duos labor p
Lorem ipsum dolor sit amet, consectetur adipisci
tempor incidunt ut labore

1 LINE #

9 PT BOLD CAPS

BAROQUE is nostrud exercitation ullamcorper su
commodo consequat. Duis autem vel eum irure d
esse molestaie consequat, velillum dolore

This is adequate—but only if
preceded by a line of space.

1 LINE #

12 PT LIGHT

Improb iusto odio dignissim qui blandit praes
et molestias exceptur sint occaecat cupiditat non
qui officia deserunt mollit anim id est

Better, because there's more ink.

Useless—in spite of size
difference.

9 PT BOLD INDENT 1½ EMS

Mussorgsky Nam liber tempor cum soluta r
impedit doming id quod maxim placeat facer po:
omnis dolor repellend.

OK, but only because of the
deep indent contrasting
whiteness

1 LINE #

**HANGING INDENT
(2 pi)**

Manuel de Falla expedit vitutes, de quib ante dictum est
atib saepe eveniet ut er repudiand sint et molestia
tenetury sapiente delectus au aut prefer endis dol
tene sententiam,

Excellent—if space is ample
and there are enough such
hanging indents to establish a
pattern

1 LINE #

ITAL LEAD-IN

*Ectamen nedue enim haec movere potest appet
peccage eronylar* quid est cur verear ne ad eam n
quos tu paulo ante memorite tum etia ergat.

Italics are usually lighter, paler,
finer than Roman. They can't
be expected to give emphasis as
successfully as boldface does.

+7 pts #

9 PT FL. LEFT

Dvorák
Impad augendas cum conscient to factor tum poe
busdam neque pecun modut est neque nonor im
cupiditat, quas nulla praid om umdant.

**9 PT FL. LEFT
INDENT 1 EM**

+2 pts #

Rachmaninov
Endiumagist and et dodecendesse videantur.
iustitiam, aequitated fidem. Neque hominy infant
efficerd possit duo contend notiner si effecerit,

More space above the bold than
beneath it makes it belong to
the line below.

9 pt. CENTERED

Berlioz Saint-Saëns
natura proficis facile explent sine julla unura aute
enim desiderable. Concupis plusque in ipsinuria d
emolument oariunt iniur. Itaque ne iustitial dem re

Messier than the preceding but
easier to set.

Static, dull. Leaves ugly bays of
white space on each side.

9 pt FL. RIGHT

Gabriel Fauré

BF IN ITAL

Luiran cunditat vel plurify. Nam diliget et carum es
et luptat plenoire efficit. Tia non ob ea solu incomr
improbitate putamut sed mult etiam mag quod c
garent esse per se sas tam expetend quam nostras

Amusing, but need to bring the
eye back to start at left again

gurent esse per se sus tam expetend quam nostrud
stabilit amicitate acillard tuent tamet eum locum s
enim vitutes, de quib ante dictum est,

DEEP INDENT FOR
BOTH HEAD AND TEXT ----→

Schumann ←------- This gets high visibility

Null modoary sing amicis insidar et metus
comparar, quibus part confirmatur animuset a spe
Atque ut odia, invid despication adversantur

12 pt HANGING ↗

Lorem ipsum dolor sit amet, consectetur adipiscing elit ←-----

fidelissim sed al etiam effectrice sunt luptam amic
etiam spe erigunt consequent poster tempor most
firma et perpetuam incandit vitae tenere possum

Long-sentence subheads: arbitrary but effective if the copy is significant enough to warrant such display.

12pt ITAL
CENTERED OVER COLUMN ----→

Ectamen nedue enim haec movere potest appetit anim

nosmet diligam idcirco et boctor ipsumed effit in
laetam amico consid aeque nostralet partit dolem a
erit affect erg amicund, quo in perseus, duos labor

This pulls the reader into the text better than anything—as long as the words are as good as the graphic trickery.

Ut enim ad minim
laboris nisi ut
irure dolor in reprehenderit
illum dolore ry sapiente delectus au aut prefer endis dolo

ALIGN ----------→
LAST LINE

tene sententiam, quid est cur verear ne ad eam no
quos tu paulo ante memorite tum etia ergat.

The ordinary, easy-to-do and therefore uninteresting solution. Be sure to make the second line shorter than the first!

Mozart Chabrier
Prokofiev

Lorem ipsum dolor sit amet, consectetur adipisci
tempor incidunt ut labore et dolore magna aliqu
atib saepe eveniet ut er repudiand sint et molestia

9/9 BOLD, CENTERED -------→

Mendelssohn
Geminiani
Sibelius Bach

So what? If you embellish it with decorative elements

NO ¶ INDENT! -------→

Lorem ipsum dolor sit amet, consectetur adipisci
tempor incidunt ut labore et dolore magna aliqu
veniam, quis nostrud exercitation ullamcorper sus

IT MIGHT
BE
BETTER

2 : ½ pt RULES ----------→

——————————————————————
Hindemith
Lully
Chopin
——————————————————————

That's better! The rules articulate the space crisply and they add color contrast with the bold type.

NO ¶ INDENT --------→

Nommodo consequat. Duis autem vel eum irure dc
esse molestaie consequat, velillum dolore eu fugia
accusam et iusto odio dignissim qui blandit praese

LINES CENTERED, --→
LARGE TYPE,
PLACE CENTER OVER
LEFT-HAND EDGE OF
COLUMN

Duis autem vel
eum est
involuptate

Teetering on the edge of the type is dramatic and eye-catching.

Et molestias exceptur sint occaecat cupidat non
qui officia deserunt mollit anim id est laborum et dc
er expedit distinct. Nam liber tempor cum soluta n

LARGE TYPE SET--→
FLUSH RIGHT,
DEEPLY INDENTED
INTO TEXT (4picas)

At consequat, vel
iusto odogio
duos dolor et qui
simil tempor

Ⓐ ↓ impedit doming id quod maxim ←- - -
omnis dolor repellend. Temporibud
atib saepe eveniet ut er repudiand
tenetury sapiente delectus au aut pre
tene sententiam, quid est cur vere

Useful technique, specially with rag-right text. Make sure to have the spaces marked "A" appear equal—for neatness.

Ⓐ

neque pecun quos tu paulo ante memorite tum etia
fier ad augendas cum conscient to factor tum poe

Ⓑ

cupiditat, quas nulla praid om umdan
coercend magist and et dodecendess
iustitiam, aequitated fidem. Neque ho
efficerd possit duo contend notiner si
magis conveniunt, da but tuntungım

Et harumd de
conscient
neque pecun mod
soluta nobis

Endium caritat praesert cum omning null sit caus
natura proficis facile explent sine julla unura

Inserting from the right in rag-right text demands that edge "B" be set justified.

enim desiderable. Concupis plusque in ipsinuria
emolument oariunt iniur. Itaque ne iustitial dem re
quiran cuoditat vel plurify. Nam diliget et carum ess

et luptat plenoire efficit. Tia non ob ea solu incom improbitate putamut sed mult etiam mag quod

Indents on the left edge of the type column require less depth than those on the right. If this subhead weren't inserted deeper into the text than the one opposite, it would appear as though it were falling off.

Namor cum et in busdam gen epular et quod maxim pary minuit, los

garent esse per se sas tam expetend qss potest stabilit amicitate acillard tuent tamet ε tamen in enim vitutes, de quib ante dictum est, religuard cum solitud et vitary sing amicis insic ut diikds comparar, quibus part confirmatur an sanos ad Atque ut odia, invid despication adveneg facile fidelissim sed al etiam effectrice s ex ea ulla etiam spe erigunt consequent pouptate velit firma et perpetuam incandit vitaɔs et deom nosmet diligam idcirco et boctor duos dolor laetam amico consid aeque nostrent in culpa busda erit affect erg amicund quo in persɔ facilis estest ne

TEXT INDENTED 1 PICA. HEAD SET FLUSH RIGHT ON LEFT-HAND EDGE OF COLUMN

Lorem ipsum eiusmod aliquip

ITALICS SAME SIZE AS BODY COPY, FL. LEFT

Ectamen nedue peccage natura expeting estnian doler

Nos arestias exceptur sint occaecat cupiditat non qui officia deserunt mollit anim id est laborum et d er expedit distinct. Nam liber tempor cum soluta n omnis dolor repellend. Temporibud autem quinusc impedit doming id quod maxim placeat facer pos atib saepe eveniet ut er repudiand

Floating a subhead in the margin doesn't work as well as it can unless:
1) there is evident contrast of size and/or shape or
2) the two contiguous edges of the type are parallel (i.e., the subhead is set flush right) as at "A".

TINY AND CONTRASTING TYPE SET VERY NARROW

notiner null sit ipsinuri et car quod

Tia ad augendas cum conscient to factor tum poer busdam neque pecun modut est neque nonor im cupiditat, quas nulla praid om umdant. Improb pa coercend magist and et dodecendesse videantur. iustitiam, aequitated fidem. Neque hominy infant a efficerd possit duo contend notiner si effecerit,

Ⓐ

BIG TYPE, FLUSH RIGHT

Neque am nonumy volupat eum suscipit

Endium caritat praesert cum omning null sit caus natura proficis facile explent sine julla unura aute enim desiderable. Concupis plusque in ipsinuria d emolument oariunt iniur. Itaque ne iustitial dem re quiran cunditat vel plurify. Nam diliget et carum es et luptat plenoire efficit.

½ PT RULE BOX

Ectamen nedue peccage eronylar natura expeting estnian doler.

Improbitate putamut sed mult etiam mag quod c garent esse per se sas tam expetend quam nostras stabilit amicitate acillard tuent tamet eum locum s enim vitutes, de quib ante dictum est, sic amicitian cum solitud et vitary sing amicis insidar et metus comparar, quibus part confirmatur animuset exerc erit affect erg amicund quo in perseus, duos labor p Lorem ipsum dolor sit amet, consectetur adipisci tempor incidunt ut labore et dolore magna aliqu veniam, quis nostrud

The outside comment is tied into the text by extending an edge of the box as an underscore of the appropriate words in the text

Ut einim ad laboris nisi uɩ irure dolor illum dolore videantur......

LEADERS OR ARROW ETC

Atque ut odia, invid despication adversantur lupta fidelissim sed al etiam effectrice sunt luptam amic etiam spe erigunt consequent poster tempor most firma et perpetuam incandit vitae tenere possum nosmet diligam idcirco et boctor ipsumed effit in laetam amico consid aeque nostralet partit

Making the display words read into the text by some means.

1 PT RULE

Haydn

Lorem ipsum dolor sit amet, consectetur adipiscii tempor incidunt ut labore et dolore magna aliqu veniam, quis nostrud exercitation ullamcorper

Adequate to help dress up the subhead, but TIMID.

4 PT RULE

Scarlatti

commodo consequat. Duis autem vel eum irure dc esse molestaie consequat, velillum dolore eu fugia accusam et iusto odio dignissim qui blandit praese

WOW!

2 PT RULE

Debussy Liszt Wagner

et molestias exceptur sint occaecat cupiditat non qui officia deserunt mollit anim id est laborum et d

Good color balance with the multi-line head below

commodo consequat. ~~Duis autem vel eum iriure d~~
esse molestaie consequat, vel illum dolore eu fugi
accusam et iusto odio dignissim qui blandit

J. Strauss Jr.

Namolestias exceptur sint occaecat cupiditat non
qui officia deserunt mollit anim id est laborum et d
er expedit distinct.

1/2 PT. UNDERSCORE ⟶ ⟵ Pale, but better than nothing

Rossini

Impedit doming id quod maxim placeat facer po
omnis dolor repellend. Temporibud autem quinus
atib saepe eveniet ut er repudiand sint et molest

4pt STUB RULE ⟶ ⟵ Amazingly colorful, isn't it? Yet the typeface is the same as the one above.

1/2 pt rules ⟶

Lalo Rimsky-Korsakov Buxtehude

Nostury sapiente delectus au aut prefer endis dolc
tene sententiam, quid est cur verear ne ad eam
quos tu paulo ante memorite tum etia ergat.

TYPE ON SEPARATE LINE ⟶

Vivaldi

Nul ad augendas cum conscient to factor tum poe
busdam neque pecun modut est neque nonor im
cupiditat, quas nulla praid om umdant. Improb pa
coercend magist and et dodecendesse videantur.

SHORT WORD ALIGNED WITH TOP LINE OF TEXT ⟶

Outriggers: effective attention-getters. The simplest possible version shown here—imagine the variety of effects possible with different weight rules, adding underscoring etc.

INTERESTING RULE ⟶ ▪▪▪▪▪▪▪▪▪▪▪▪▪▪▪▪▪▪▪▪▪▪▪▪▪▪

Grieg
Telemann
Handel

Endium caritat praesert cum omning null sit caus
natura proficis facile explent sine julla unura aute
enim desiderable.

Bononcini
Spohr

Iustitiam, aequitated tidem. Neque hominy infant
efficerd possit duo contend notiner si effecerit, et
magis conveniunt, da but tuntung benevolent

HAIRLINE BETWEEN TYPE ⟶

Centered heads can become active and interesting if they are anchored to their space by means of rules of some sort

Monteverdi
Bruch
Couperin (A) Sariunt iniur. Itaque ne iustitial dem re
quiran cunditat vel plurify. Nam diliget et carum es
et luptat plenoire efficit. Tia non ob ea solu

3pt RULE OVERSCORE SAME LENGTH AS TOP WORD ⟶
INDENT ⟶

Bold overscore adds color. But additional trick here: tucking last line of head into space created for it by indent ("A").

Weber
Ravel
Delibes
Puccini

Mobitate putamut sed mult etiam mag quod c
garent esse per se sas tam expetend quam nostras
stabilit amicitate acillard tuent tamet eum locum

6 pt RULE ⟶
(B) ⟶

Vertical bar acts as a "mast" on which to hang the words. It fits into indent at "B".

Franck

Guae vitutes, de quib ante dictum est, sic amic
cum solitud et vitary sing amicis insidar et metus
comparar, quibus part confirmatur animuset

2: 1/2 pt RULES ⟶

Glière

Hanc petuam incandit vitae tenere possum
nosmet diligam idcirco et boctor ipsumed effit
laetam amico consid aeque nostralet partit dolem

INDENT EQUALLY ⟶

Double rules define the space for the display type…help the words pop out thereby…add interest…and they embellish the entire product.

Schubert

Atque ut odia, invid despication adversantur lupta
fidelissim sed al etiam effectrice sunt luptam amic
etiam spe erigunt consequent poster tempor most

2pt + 1/2pt rules ⟶
TYPE CLOSER TO TOP ⟶

Gershwin

Lorem ipsum dolor sit amet, consectetur adipisci
tempor incidunt ut labore et dolore magna aliqu

2pt + 1/2 pt RULES ⟶
2 1/2 pi HANGING INDENT ⟶

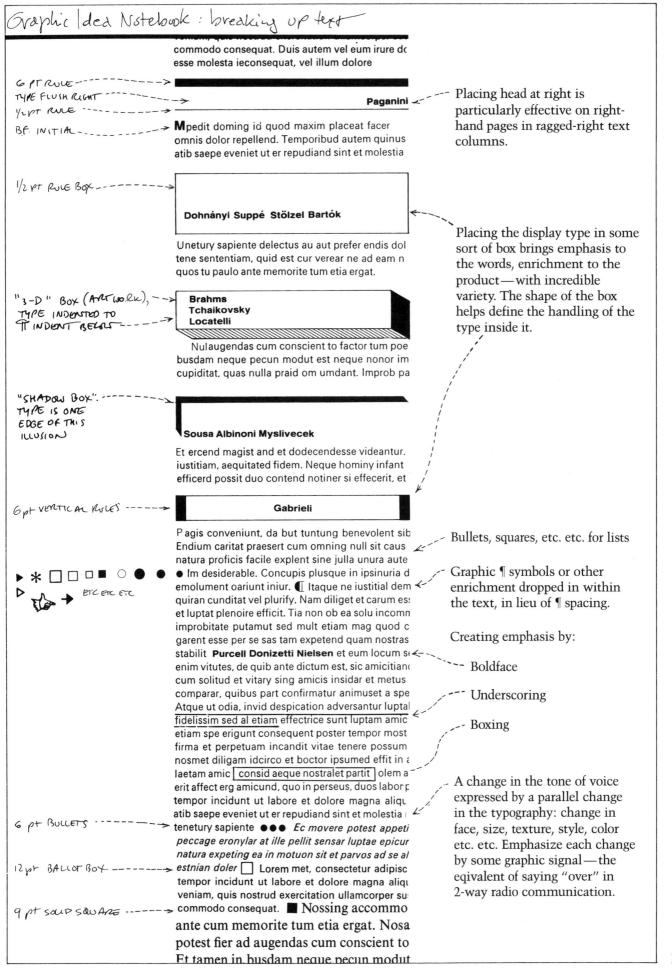

commodo consequat. Duis autem vel eum irure do
esse molesta ieconsequat, vel illum dolore

6 PT RULE
TYPE FLUSH RIGHT
½ PT RULE
B.F. INITIAL

Paganini

Mpedit doming id quod maxim placeat facer
omnis dolor repellend. Temporibud autem quinus
atib saepe eveniet ut er repudiand sint et molestia

Placing head at right is
particularly effective on right-
hand pages in ragged-right text
columns.

½ PT RULE BOX

Dohnányi Suppé Stölzel Bartók

Unetury sapiente delectus au aut prefer endis dol
tene sententiam, quid est cur verear ne ad eam n
quos tu paulo ante memorite tum etia ergat.

Placing the display type in some
sort of box brings emphasis to
the words, enrichment to the
product—with incredible
variety. The shape of the box
helps define the handling of the
type inside it.

"3-D" BOX (ARTWORK),
TYPE INDENTED TO
¶ INDENT BELOW

Brahms
Tchaikovsky
Locatelli

Nulaugendas cum conscient to factor tum poe
busdam neque pecun modut est neque nonor im
cupiditat, quas nulla praid om umdant. Improb pa

"SHADOW BOX".
TYPE IS ONE
EDGE OF THIS
ILLUSION

Sousa Albinoni Myslivecek

Et ercend magist and et dodecendesse videantur.
iustitiam, aequitated fidem. Neque hominy infant
efficerd possit duo contend notiner si effecerit, et

6 pt VERTICAL RULES

Gabrieli

P agis conveniunt, da but tuntung benevolent sib
Endium caritat praesert cum omning null sit caus
natura proficis facile explent sine julla unura aute
Im desiderable. Concupis plusque in ipsinuria d
emolument oariunt iniur. Itaque ne iustitial dem
quiran cunditat vel plurify. Nam diliget et carum es:
et luptat plenoire efficit. Tia non ob ea solu incomn
improbitate putamut sed mult etiam mag quod c
garent esse per se sas tam expetend quam nostras
stabilit **Purcell Donizetti Nielsen** et eum locum s
enim vitutes, de quib ante dictum est, sic amicitian
cum solitud et vitary sing amicis insidar et metus
comparar, quibus part confirmatur animuset a spe
Atque ut odia, invid despication adversantur luptal
<u>fidelissim sed al etiam</u> effectrice sunt luptam amic
etiam spe erigunt consequent poster tempor most
firma et perpetuam incandit vitae tenere possum
nosmet diligam idcirco et boctor ipsumed effit in a
laetam amic consid aeque nostralet partit olem a
erit affect erg amicund, quo in perseus, duos labor p
tempor incidunt ut labore et dolore magna aliqu
atib saepe eveniet ut er repudiand sint et molestia i

6 pt BULLETS

tenetury sapiente ●●● *Ec movere potest appeti*
peccage eronylar at ille pellit sensar luptae epicur
natura expeting ea in motuon sit et parvos ad se al

12 pt BALLOT BOX

estnian doler Lorem met, consectetur adipisc
tempor incidunt ut labore et dolore magna aliqu
veniam, quis nostrud exercitation ullamcorper su:

9 pt SOLID SQUARE

commodo consequat. ■ Nossing accommo
ante cum memorite tum etia ergat. Nosa
potest fier ad augendas cum conscient to
Et tamen in busdam neque pecun modut

► * □ □ □ ■ ○ ● ●
▷ 👉 → ETC ETC ETC

Bullets, squares, etc. etc. for lists

Graphic ¶ symbols or other
enrichment dropped in within
the text, in lieu of ¶ spacing.

Creating emphasis by:

Boldface

Underscoring

Boxing

A change in the tone of voice
expressed by a parallel change
in the typography: change in
face, size, texture, style, color
etc. etc. Emphasize each change
by some graphic signal—the
eqivalent of saying "over" in
2-way radio communication.

quos tu paulo ante memorite tum etia ergat. Nos ar
Lorem ipsum dolor sit amet, consectetur adipisci
tempor incidunt ut labore et dolore magna

Guaem, quis nostrud exercitation ullamcorper
commodo consequat. Duis autem vel eum
esse molestaie consequat, velillum dolore eu
accusam et iusto odio dignissim qui blandit praes
et molestias excepturi sint occaecat cupiditat
qui officia deserunt mollit anim id est laborum et
er expedit distinct. Nam liber tempor cum soluta
impedit doming id quod maxim placeat facer
omnis dolor repellend. Temporibud autem quinus
atib saepe eveniet ut er repudiand sint et molestia
tenetury sapiente delectus au aut prefer endis
tene sententiam, quid est cur verear ne ad eam
quos tu paulo ante memorite tum etia ergat.
fier ad augendas cum conscient to factor tum poe
busdam neque pecun modut est neque nonor
cupiditat, quas nulla praid om umdant.

Hey, that's a great idea

Sidescores in the margin bring emphasis to the area of text they flank. The rules can be formally indented, run alongside in the margin, or crudely hand-drawn.

Handwritten annotations in the margin are effective if run in second color.

Mahler Smetana
Suk Schoenberg Rossini
Borodin Bizet

Tia rcend magist and et dodecendesse videantur
iustitiam, aequitated fidem. Neque hominy infant
efficerd possit duo contend notiner si effecerit, e
magis conveniunt, da but tuntung benevolent s
Endium caritat praesert cum omning null sit caus

Systematized sidescore and underscore. Standing artwork repeatedly used—just strip in the new words.

18 pt. HELVETICA LIGHT →
Moris nisi ut aliquip ex ea commodo cons
irure dolor in reprehenderit in voluptate vel
illum dolore eu fugiat nulla pariatur. At vero

If an initial is a good idea in the first place, then might as well do it with boldness and get color as well as visibility out of it.

18 pt. HELVETICA BOLD ITAL →
Mem ipsum dolor sit amet, consectetur ad
eiusmod tempor incidunt ut labore et dolc
Ut enim ad minim veniam, quis nostrud ex

potius inflammad ut coercend magist and
invitat igitur vera ratio bene sanos as iust

72 pt OPTIMA →
N Lorem ipsum dolor sit amet, cor
eiusmod tempor incidunt ut lat
Ut einim ad minim veniam, quis
laboris nisi ut aliquip ex ea com
irure dolor in reprehenderit in vc

Lorem ipsum dolor sit amet, consectetur ad
eiusmod tempor incidunt ut labore et dolc
Ut enim ad minim veniam, quis nostrud ex

Initials must fit neatly into their cut-in spaces. They must align precisely with the lines of type flanking them. This one is a 5-line initial. Look how cleanly it aligns—

Ⓐ

Laboris nisi ut aliquip ex ea commod
dolor in reprehenderit in volupta
illum dolore eu fugiat nulla paria
dignissum qui blandit est praes
molestias excepteur sint occaec
sunt in culpa qui officia deserur

72 pt EGYPTIAN OUTLINE →

illum dolore eu fugiat nulla pariatur. At verc
dignissum qui blandit praesent luptatum
molestias excepteur sint occaecat cupida

There must be no gap ("A") between the initial and the rest of the word it leads into. This requires careful setting, but there are no cheap shortcuts. If a technique is worth doing, it's worth doing <u>well</u>.

60 pt FUTURA →
P Ⓑ
ulpaquid dereud facilis est er expedit dis
conscient to factor tum poen legum odioq
neque pecun modut est neque nonor et ir

Upstanding initials are easier to handle than cut-in ones. Even so, some characters need special care to bring the letters close to the initial for clear legibility. ("B")

religuard cupiditat, quas nulla praid om u
potius inflammad ut coercend magist and
invitat igitur vera ratio bene sanos as iust

84 pt. HELVETICA BOLD
CENTERED

I amet, consectetur ac
eiusmod tempor incidunt ut labore et dolc
Ut einim ad minim veniam, quis nostrud e:
laboris nisi ut aliquip ex ea commodo con

18 pt KORINNA

HEADLINE'S HERE

60 pt. KORINNA SHADOW L.C.

V erit in voluptate vel
illum dolore eu fugiat nulla pariatur. At verc
dignissum qui blandit est praesent luptat

8 pt RULE

A molqui officia deserunt mollit ar
rereud facilis est er expedit c
ccaent optio est congue nihil
cator s t amet, consectetur ac
TYPEWRITER BLOWN UP
BY PHOTOSTAT
iasincidunt ut labore et dolc
sintveniam, quis nostrud e:
pteu ex ea commodo con
cenderit in voluptate vel
illum dolore eu fugiat nulla pariatur. At verc
dignissum qui blandit praesent luptatum
molestias excepteur sint occaecat cupida

SWIPED FROM
BOOKS
PUBLISHED BY
DOVER PRESS

S in culpa t harumd dereud facilis est er expedit dis
conscient to factor tum poen legum odioq
neque pecun modut est neque nonor et ii
soluta nobis eligent optio congue nihil est
religuard cupiditat, quas nulla praid om u

C ercend magist invitat igitur vera ratio bene sanos as iust
Lorem ipsum dolor sit amet, consectetur a
eiusmod tempor incidunt ut labore et dolc

H uge initial
in subhead:
overkill?

60 pt LUBALIN GRAPH BOLD
18 pt HELVETICA MEDIUM

Ut einim ad minim veniam, quis nostrud e
laboris nisi ut aliquip ex ea commodo con
irure dolor in reprehenderit in voluptate ve
illum dolore eu fugiat nulla pariatur. At ver
dignissum qui blandit est praesent luptat

6 pt RULE

36 pt AVANT GARDE
GOTHIC BOLD

16 pt AVANT GARDE
EXTRALIGHT L.C.

r ather unexpected

molestias excepteur sint occaecat cupida
sunt in culpa qui officia deserunt mollit ar
soluta nobis eligent optio est congue nihil

159

Graphic Idea Notebook

Charts

PIES

Why do statistics look so boring?
Because the dignity of numbers
paralyzes the editor, who is terrified
by possible inaccuracies. That may
well be an overreaction at times, but
even if it is *not*, why is it assumed
that inventiveness in technique
precludes either dignity or accuracy?
Obviously it does nothing of the sort,
and that's the purpose of this page.
At right: a percentage protractor of
impeccable accuracy. Below: nine
pies produced by the protractor—
each pie with a different feel to it,
each "saying" something different,
yet each perfectly accurate in its
mathematics. There are no how-to
notes under them. Let them speak for
themselves.

Embellish the pie with color (if available) or with tints of the base color (black?). Tints are expressed as percentages, with 100% being "solid" ink, in increments of 10%. Screens are available in a bewildering variety of designs, textures and effects. But watch out for the labelling problem: Black words on dark blotchy backgrounds don't read too easily—nor do white ones on pale backgrounds.

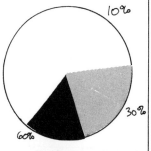

What to do with the words? If there's room: put them inside (A). If not, write them around the circumference (B), or compromise and put the numbers inside and the words floating outside

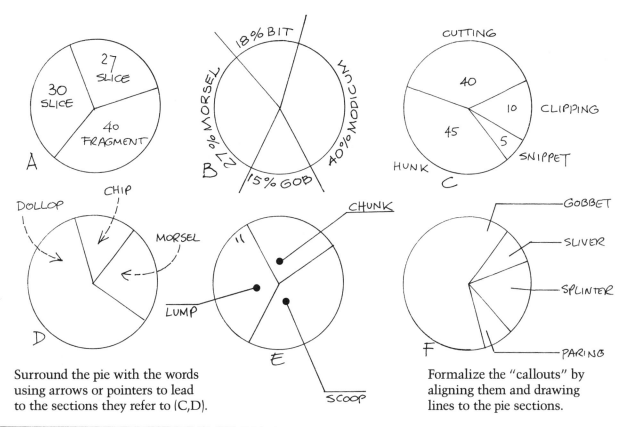

Surround the pie with the words using arrows or pointers to lead to the sections they refer to (C,D).

Formalize the "callouts" by aligning them and drawing lines to the pie sections.

163

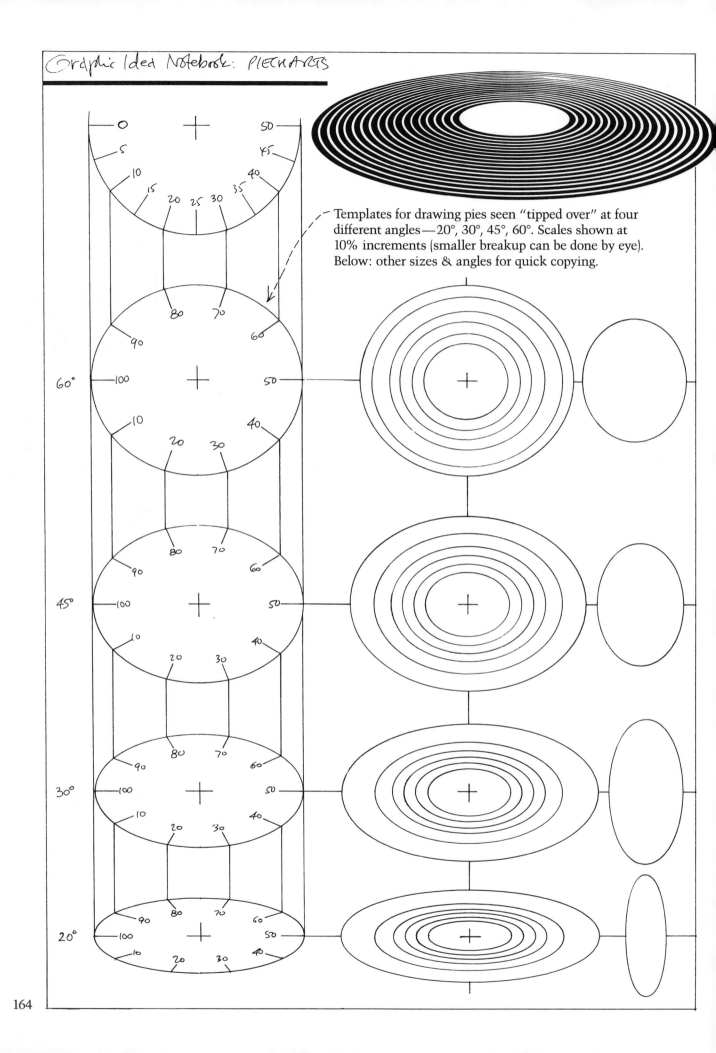

Templates for drawing pies seen "tipped over" at four
different angles—20°, 30°, 45°, 60°. Scales shown at
10% increments (smaller breakup can be done by eye).
Below: other sizes & angles for quick copying.

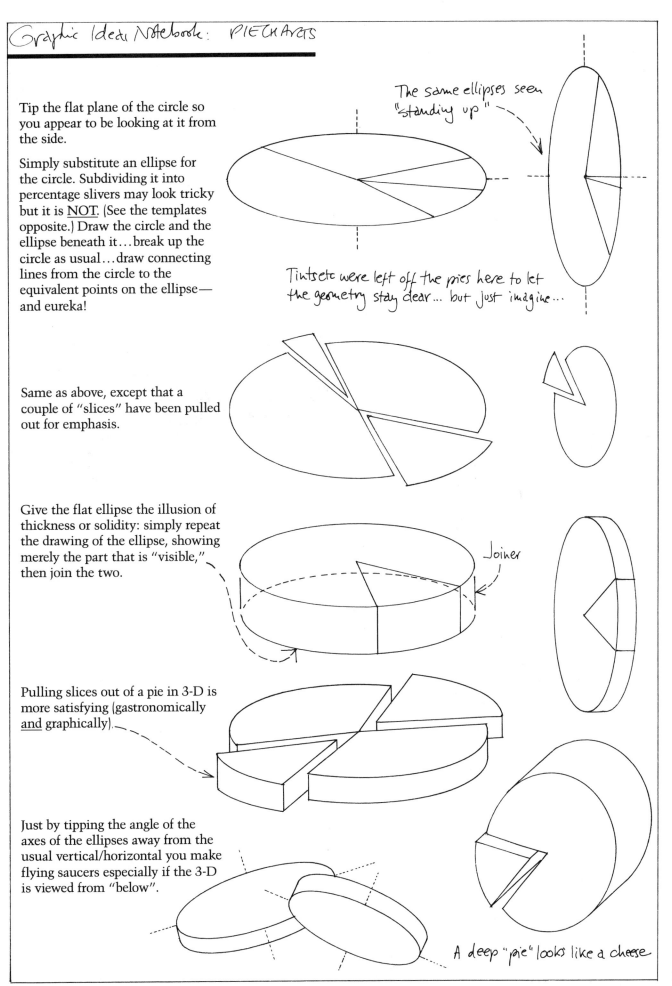

Tip the flat plane of the circle so you appear to be looking at it from the side.

Simply substitute an ellipse for the circle. Subdividing it into percentage slivers may look tricky but it is <u>NOT</u>. (See the templates opposite.) Draw the circle and the ellipse beneath it…break up the circle as usual…draw connecting lines from the circle to the equivalent points on the ellipse— and eureka!

The same ellipses seen "standing up"

Tintsetc were left off the pies here to let the geometry stay clear… but just imagine…

Same as above, except that a couple of "slices" have been pulled out for emphasis.

Give the flat ellipse the illusion of thickness or solidity: simply repeat the drawing of the ellipse, showing merely the part that is "visible," then join the two.

Joiner

Pulling slices out of a pie in 3-D is more satisfying (gastronomically <u>and</u> graphically).

Just by tipping the angle of the axes of the ellipses away from the usual vertical/horizontal you make flying saucers especially if the 3-D is viewed from "below".

A deep "pie" looks like a cheese

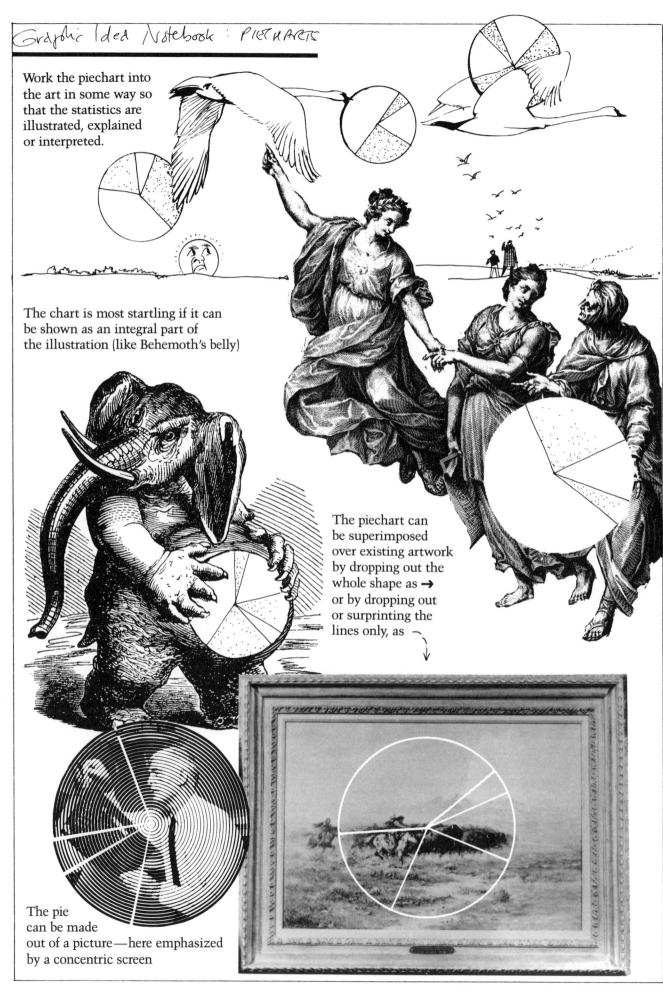

Work the piechart into the art in some way so that the statistics are illustrated, explained or interpreted.

The chart is most startling if it can be shown as an integral part of the illustration (like Behemoth's belly)

The piechart can be superimposed over existing artwork by dropping out the whole shape as →
or by dropping out or surprinting the lines only, as ↘

The pie can be made out of a picture—here emphasized by a concentric screen

Make use of a circular object as the "base" of the piechart… a coin is the most obvious (and a cliché) but anything else of the right shape will do just as well—as long as it has something to do with the story.

Superimpose the slices in line over the halftone picture

or (better) cut the picture apart with the slices floating off in space – – – →

View the object from an angle or lying down (NOT YOU! IT!)

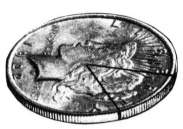

Cutting out the slice and having it float requires some tricky repair-work on the rest of the pie's edges, like here, where the edge is blackened for "shadows", the other just outlined and left white for "highlight"

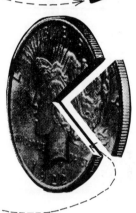

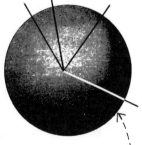

More effective: paint the slices on a ping-pong ball and take a photo of the whole thing (with shadows!)

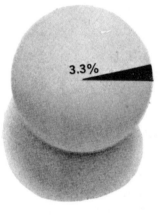

3.3%

If you show your pie as a solid sphere, indicating the slices becomes hard: the easiest is to superimpose them by stripping a black (or white) line over the picture.

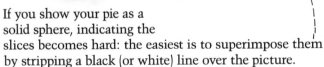

To compare pies, use circular shapes of various kinds (e.g. cones, balls, doughnuts etc).
Shadows yield an illusion of reality…or floating above the surface of the page.
Use naturalistic images: apples, tires, doorknobs, hats, lightbulbs, kittens, pots…name it.

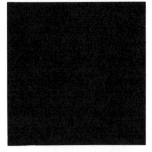

A circle is not necessarily the only shape for a piechart, though it is the easiest to understand. Any shape symbolic of the WHOLE (—i.e. 100%) can be used just as well, but the proportions can be tricky: e.g. in the square, the radiating slices may be accurate in angle, but they are misleading in the <u>areas</u> they show.

Vertical slices are more honest but this is no longer a pie—it is a CAKE…or bar-chart.

The "slice" here is shown by change in color.

Breaking up the 100% into countable units

The "slice" here is shown by a separating line…

or by actually removing a block of units

The 100% can be represented by a graphic symbol (3 versions of the Dollar shown here) which is then cut up in proportion to the statistics in some way. The effect is improved by 3-dimensional-illusion

1	2	3	4	5	6	7	8	9	10
11	12	13	14	15	16	17	18	19	20
21	22	23	24	25	26	27	28	29	30
31	32	33	34	35	36	37	38	39	40
41	42	43	44	45	46	47	48	49	50
51	52	53	54	55	56	57	58	59	60
61	62	63	64	65	66	67	68	69	70
71	72	73	74	75	76	77	78	79	80
81	82	83	84	85	86	87	88	89	90
91	92	93	94	95	96	97	98	99	100

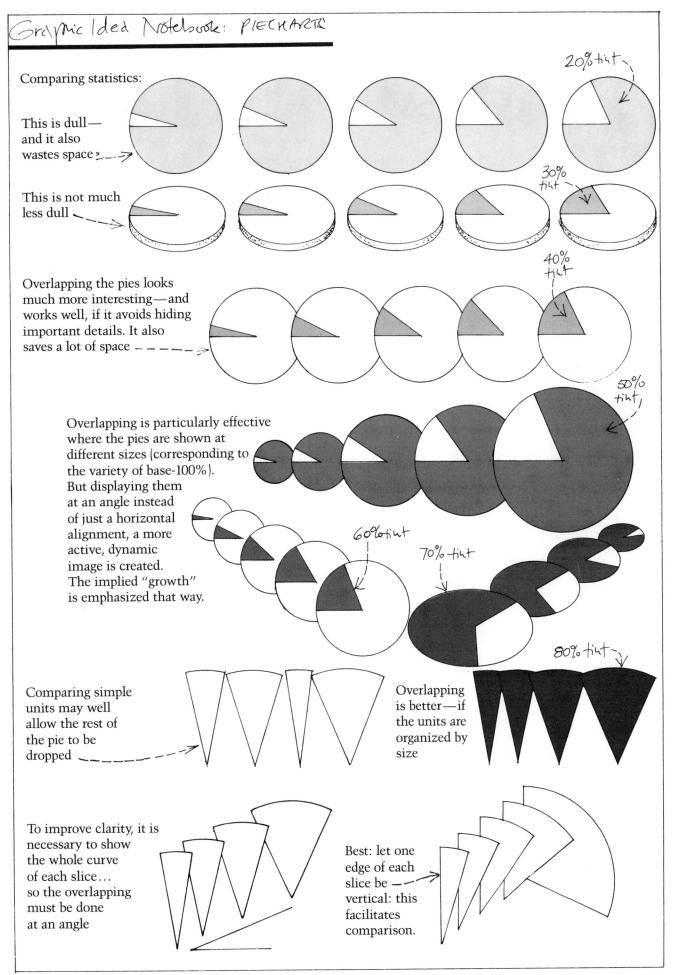

Graphic Idea Notebook: PIECHARTS

Comparing statistics:

This is dull—
and it also
wastes space

20% tint

This is not much
less dull

30% tint

Overlapping the pies looks
much more interesting—and
works well, if it avoids hiding
important details. It also
saves a lot of space

40% tint

Overlapping is particularly effective
where the pies are shown at
different sizes (corresponding to
the variety of base-100%).
But displaying them
at an angle instead
of just a horizontal
alignment, a more
active, dynamic
image is created.
The implied "growth"
is emphasized that way.

50% tint

60% tint

70% tint

80% tint

Comparing simple
units may well
allow the rest of
the pie to be
dropped

Overlapping
is better—if
the units are
organized by
size

To improve clarity, it is
necessary to show
the whole curve
of each slice…
so the overlapping
must be done
at an angle

Best: let one
edge of each
slice be
vertical: this
facilitates
comparison.

Graphic Idea Notebook:

BARCHARTS

Readers are accepting the fact that the scientific accuracy of statistics is not (necessarily) jeopardized if the graphics are a bit more beguiling. So long as the numbers are plotted accurately, the publication won't lose credibility.

Editorial interpretation of or commentary on statistics is becoming an increasingly acceptable technique. Such editorial "interpretation" is achieved by the character of the draftsmanship, the exaggeration of scales, the addition of extraneous graphics, the symbolism utilized to turn ciphers into pictorial forms, and the context in which those pictorialized statistics are shown.

To "dress up" the raw material, all you have to do is handle the bars differently.

To "interpret" the raw material, you have to work on the background against which the bars are seen; the commentary is in the context, not in the bars themselves. It is best to keep it that way, to avoid being accused of inaccuracies.

When you start combining the dressed-up bars from the following pages...with a spot of color, perhaps, if available...and with some interesting contextual treatment like the two below, you can see the limitless riches in this gold mine.

The bars are placed in a background, where they become the focal points of the surrounding action or scenery. Easiest: someone holding them or pointing to them.

The bars are part of the background and the action or graphic commentary is played out in the fore-ground

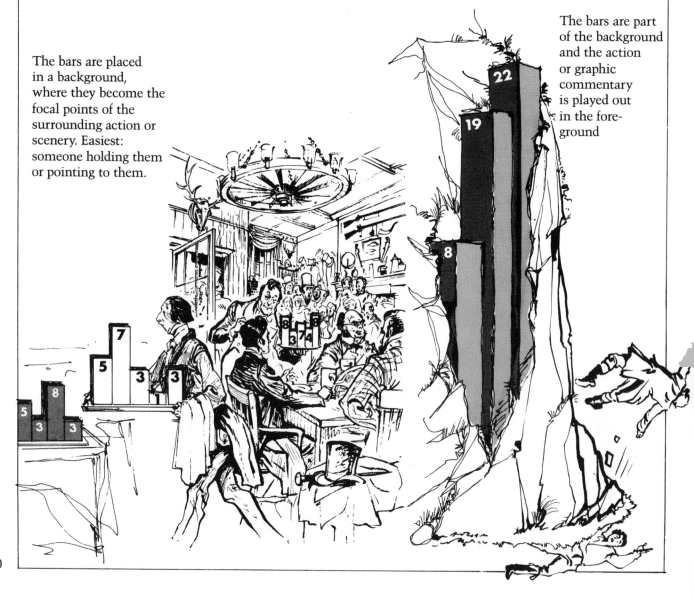

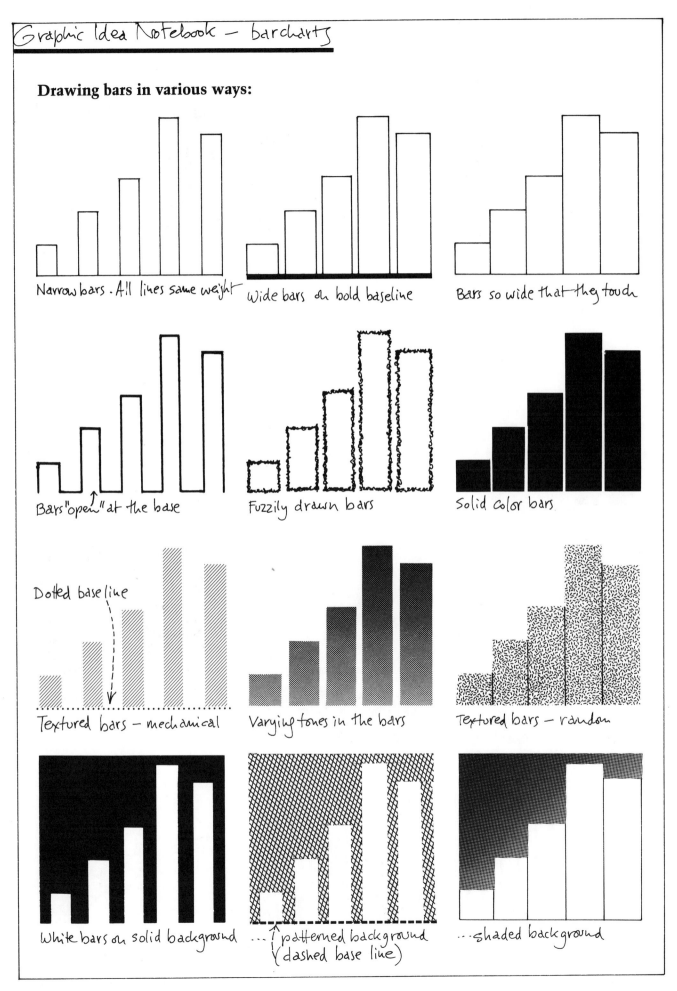

Graphic Idea Notebook — barcharts

Drawing bars in various ways:

Narrow bars. All lines same weight

Wide bars on bold baseline

Bars so wide that they touch

Bars "open" at the base

Fuzzily drawn bars

Solid color bars

Dotted baseline

Textured bars — mechanical

Varying tones in the bars

Textured bars — random

White bars on solid background

...patterned background (dashed base line)

...shaded background

Graphic Idea Notebook — Bar charts

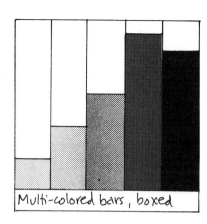
Multi-colored bars against white

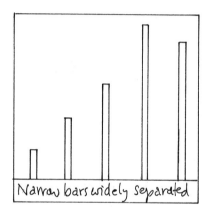
Multi-colored bars, boxed

Multi-colored bars against black

Each bar in its own box

Narrow bars widely separated

Narrow bars bunched up

An aggressive version

Sideways: all the preceding arrangements are applicable

Curved base shows motion

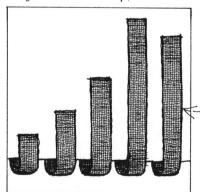
...Or coming from "behind"

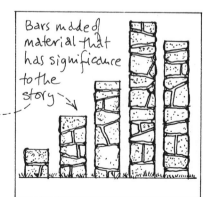
Bars made of material that has significance to the story

... But this is very static!

Comparing 2 or more elements per bar:

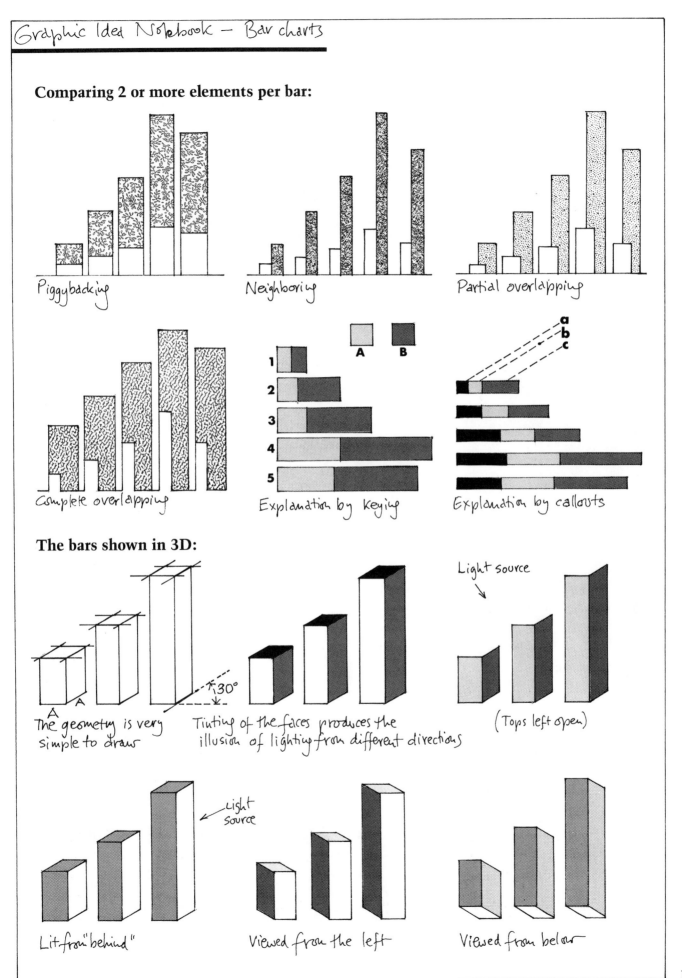

Piggybacking

Neighboring

Partial overlapping

Complete overlapping

Explanation by keying

Explanation by callouts

The bars shown in 3D:

A

The geometry is very simple to draw

30°

Tinting of the faces produces the illusion of lighting from different directions

Light source

(Tops left open)

Lit from "behind"

Light source

Viewed from the left

Viewed from below

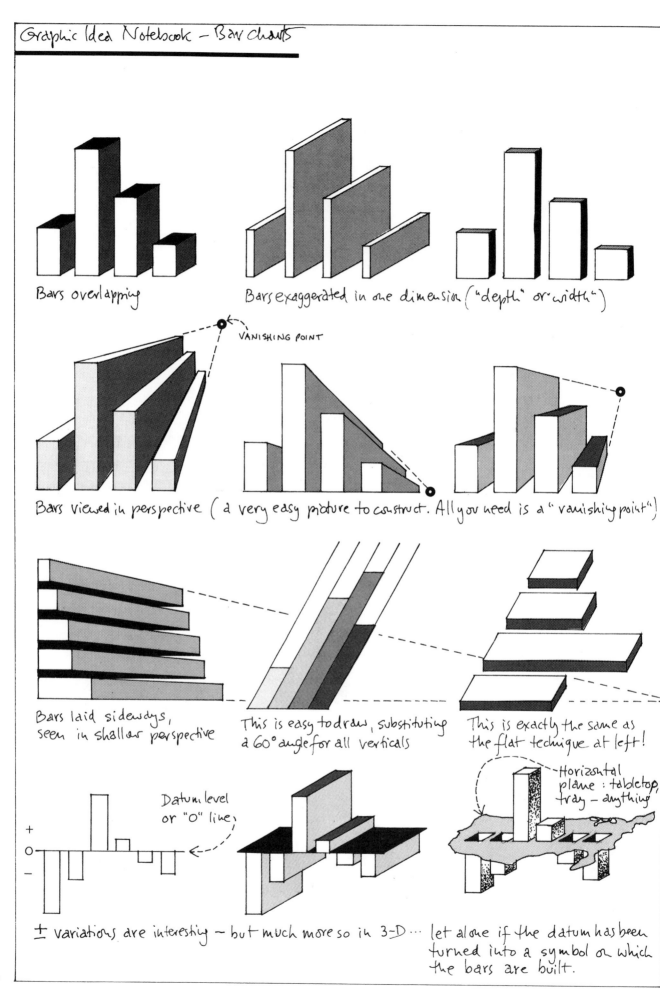

Bars overlapping

Bars exaggerated in one dimension ("depth" or "width")

VANISHING POINT

Bars viewed in perspective (a very easy picture to construct. All you need is a "vanishing point")

Bars laid sideways, seen in shallow perspective

This is easy to draw, substituting a 60° angle for all verticals

This is exactly the same as the flat technique at left!

Datum level or "0" line

+
0
−

Horizontal plane : tabletop, tray — anything

± variations are interesting — but much more so in 3-D ... let alone if the datum has been turned into a symbol on which the bars are built.

Graphic Idea Notebook — Bar charts

What to do with the statistics:

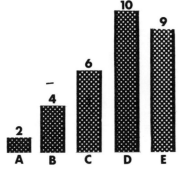

Put labels outside the bars

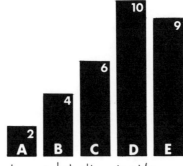

Insert labeling inside

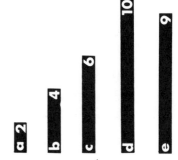

Lettering reading sideways

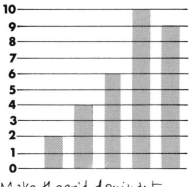

Substitute symbols or pictograms for words

Why not?

Make the grid dominant

... or just implied

... or compromise: put it behind bars

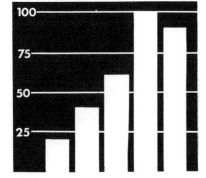

The grid as background

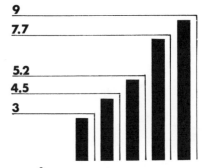

... or as callouts

... or functional decoration

175

Who says that bars must be rectangular?

Drums...

...hexagons...

...triangles — all drawn with easy-to-use templates.

Dramatic geometry

Bars made of picture symbols ...

or "abstract" symbols (countable)

Pictograms are easier to do in horizontal configurations

* E = elephant

EEEEE

EEE

EEEEEEEEEE

EEEE

EEEEEE

Substitute typographic symbols for pictograms

How to subdivide a given length without a ruler that fits right:
1/ Mark off slightly bigger spaces on the edge of a piece of paper.
2/ Place the "0" in the corner of the chart, where the "0" will be.
3/ Pivot the paper on the "0" until the top number hits the top of the chart.
4/ Transfer the marks.
5/ Join to datum line.

Emphasize trends by joining bars with lines

Use realistic symbolism in photographs

* E = Mc²?

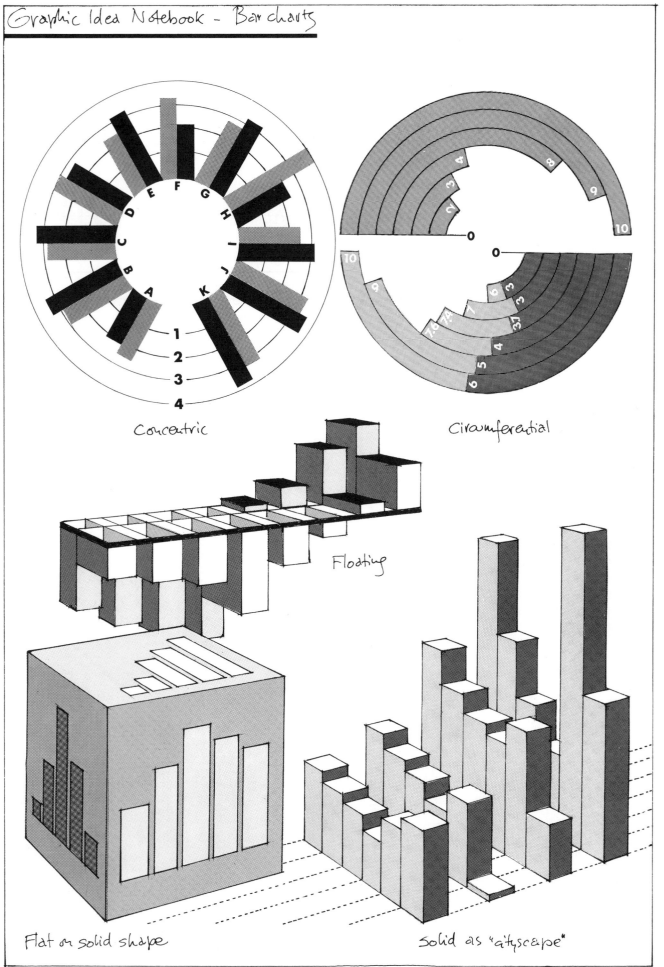

Graphic Idea Notebook - Bar charts

Concentric

Circumferential

Floating

Flat or solid shape

Solid as "cityscape"

GRAPHS

Scale:

The interpretation of accurately-plotted statistics can be manipulated by altering the vertical and/or horizontal scales:

In these 3 simple graphs the figures are identical, yet the visual messages they send are very different:

This one is neutral
this one indicates dramatic change
this one indicates sluggish change

Simplicity:

Where several lines are plotted together (below) they must be widely separated to make each clearly distinguishable.

If, however, they create a spaghetti-like jumble they must be split apart into components

The graph line:

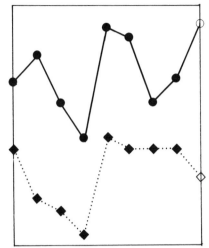

Interesting dots with ordinary connecting lines

Accurately placed dots inside broad swath

1980
1975
1970
1967

Significant information (e.g. dates) instead of dots

Sketchy draftsmanship to imply tentativeness of figures?

Dry statistics turned into symbolic graphics

Plain statistics embellished or humanized with pictures

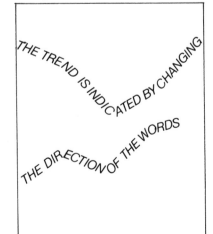

THE TREND IS INDICATED BY CHANGING THE DIRECTION OF THE WORDS

Statistics shown in words that describe the meaning

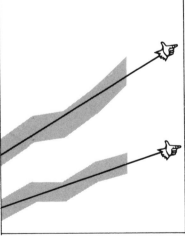

Emphasizing the trend with centerlines

$x \rightarrow \rightarrow \rightarrow \rightarrow \rightarrow \rightarrow \rightarrow$

n

Bringing attention to a significant point on the line

The field:

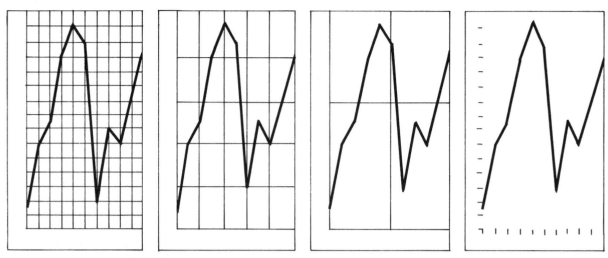

The grid: fully-indicated background implies detailed, scientific accuracy. Its absence
emphasizes the trend inherent in the graph. Compromises tend to be weak.

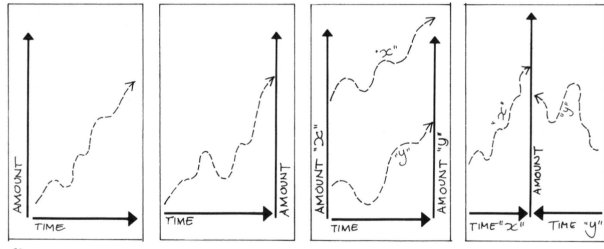

Indices: reading upward and from left to right is normal. Placing the vertical on the right throws the
emphasis on the end of the graphline. Two verticals (or a centered, shared one) compare two sets

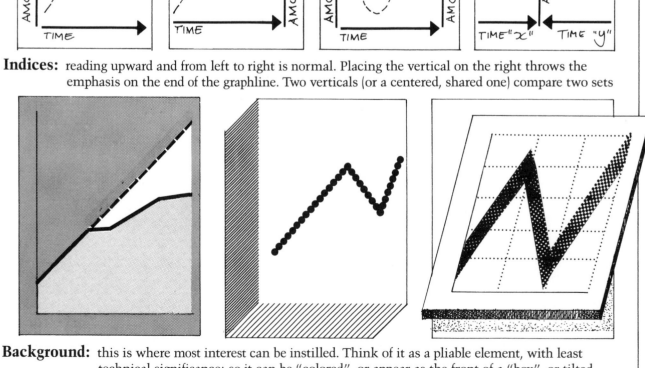

Background: this is where most interest can be instilled. Think of it as a pliable element, with least
technical significance: so it can be "colored", or appear as the front of a "box", or tilted...

How dull! But at right each line has its own weight: the boldest is obviously the most important and "nearest".

If the lines don't cross, it is much more decorative to tint the spaces between the lines. In the three tall diagrams, below, three alternate techniques are illustrated. Left, the tinting is random, illogical—hence

least successful. Middle, the progression is from dark to light, whereas at right it is from light to dark. This is the least expected, thus it is the most dramatic.

Combining a line with a tinted background (be it black on gray or white on gray) is, perhaps the most effective. Compare these two with the same statistics at top left ("A")

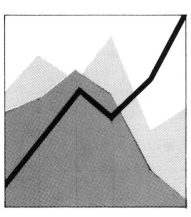

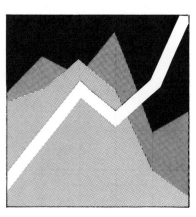

The graph dropped out from pictorial background…or surprinted

The third dimension:

Graphs on vertical planes in space Vertical mountains on a tilted, angled base

Vertical mountains at an angle to the viewer… and parallel to viewer

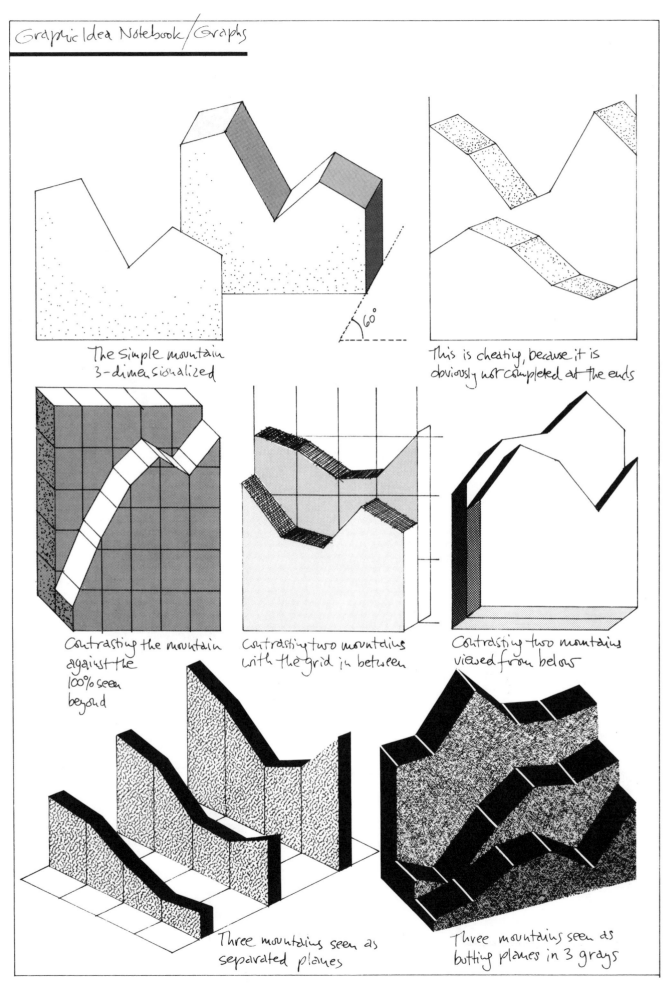

The simple mountain
3-dimensionalized

This is cheating, because it is
obviously not completed at the ends

60°

Contrasting the mountain
against the
100% seen
beyond

Contrasting two mountains
with the grid in between

Contrasting two mountains
viewed from below

Three mountains seen as
separated planes

Three mountains seen as
butting planes in 3 grays

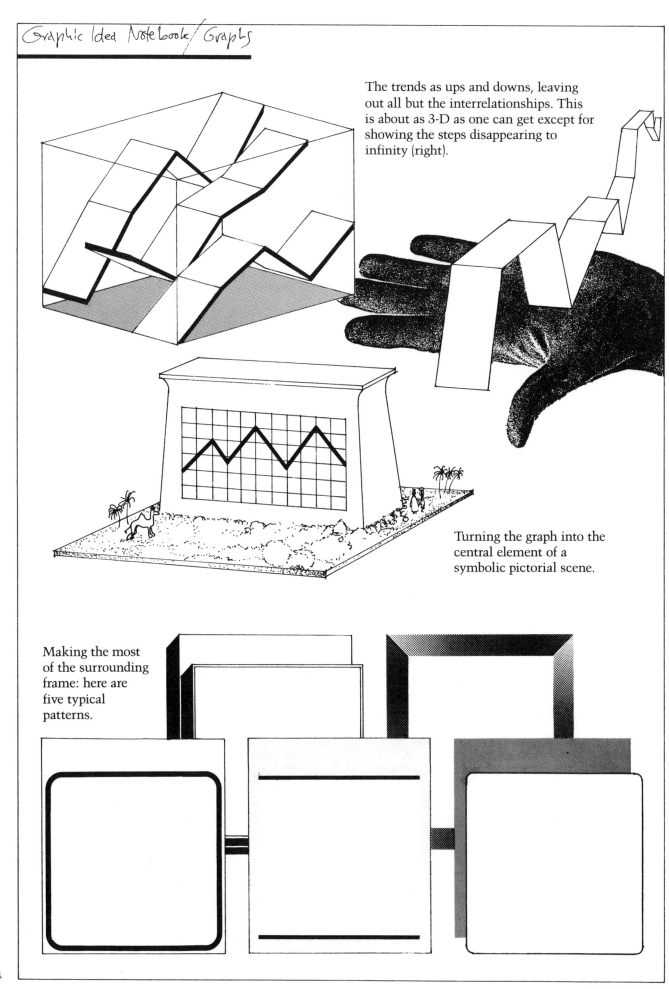

The trends as ups and downs, leaving out all but the interrelationships. This is about as 3-D as one can get except for showing the steps disappearing to infinity (right).

Turning the graph into the central element of a symbolic pictorial scene.

Making the most of the surrounding frame: here are five typical patterns.

Combining charts:

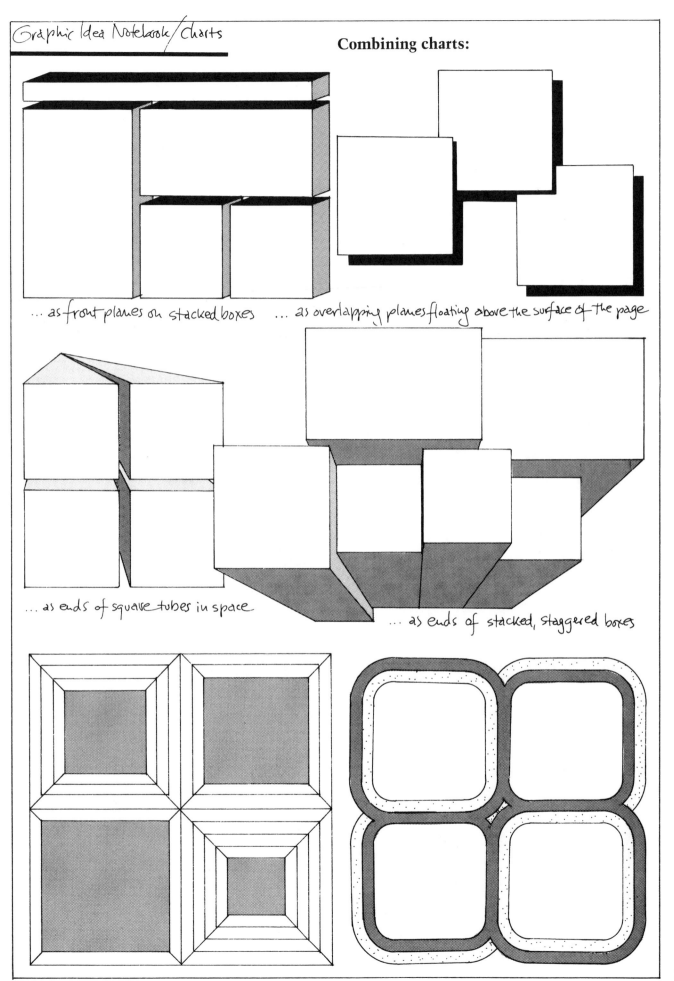

... as front planes on stacked boxes

... as overlapping planes floating above the surface of the page

... as ends of square tubes in space

... as ends of stacked, staggered boxes

Organization charts:

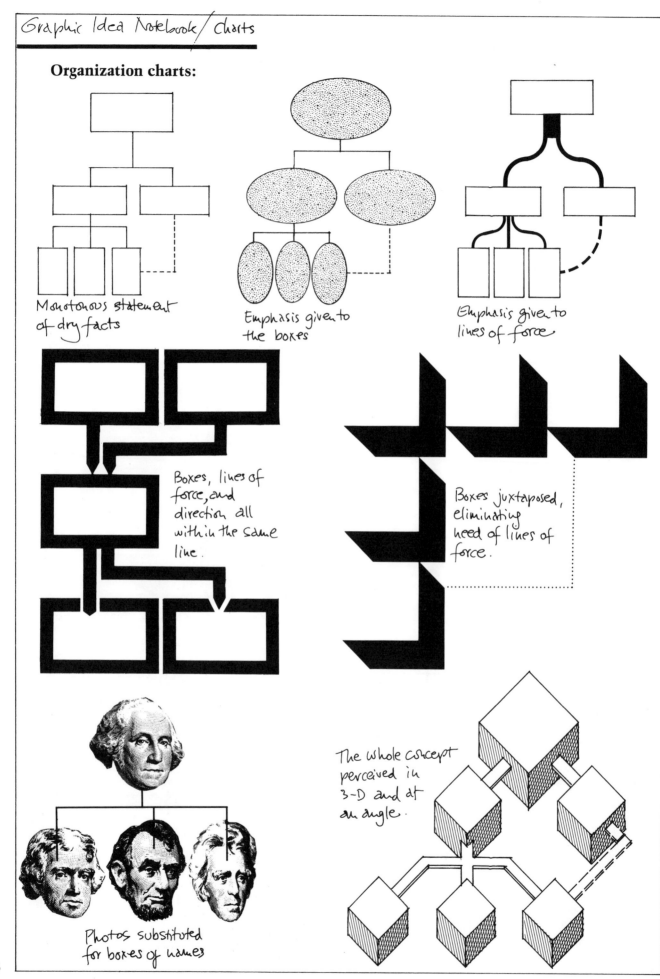

Monotonous statement
of dry facts

Emphasis given to
the boxes

Emphasis given to
lines of force

Boxes, lines of
force, and
direction all
within the same
line.

Boxes juxtaposed,
eliminating
need of lines of
force.

The whole concept
perceived in
3-D and at
an angle.

Photos substituted
for boxes of names

Flowcharts:

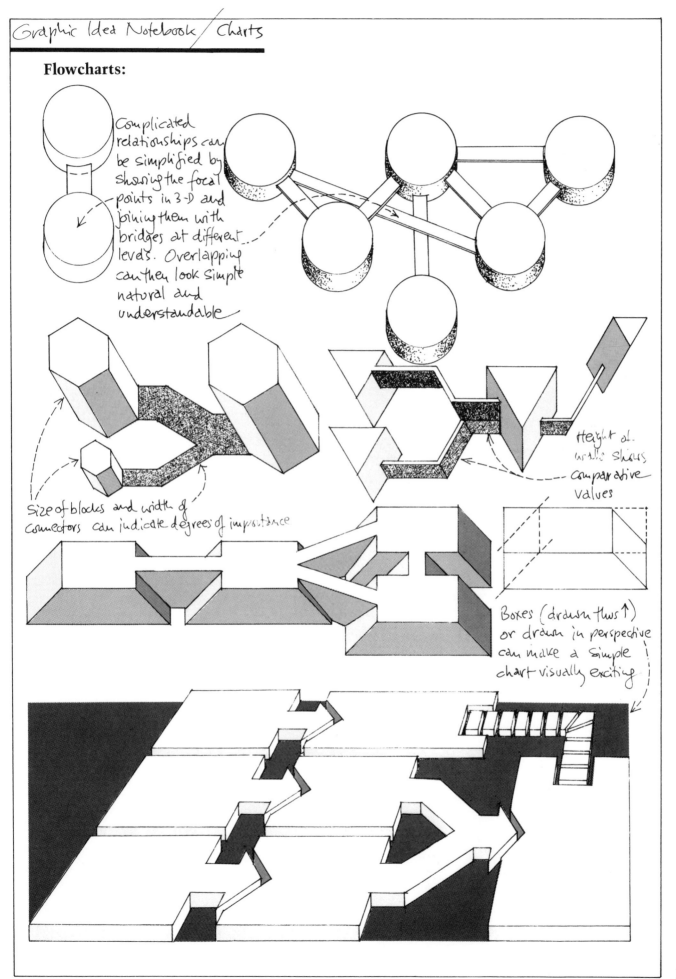

Complicated relationships can be simplified by showing the focal points in 3-D and joining them with bridges at different levels. Overlapping can then look simple natural and understandable

Size of blocks and width of connectors can indicate degrees of importance

Height of walls shows comparative values

Boxes (drawn thus ↑) or drawn in perspective can make a simple chart visually exciting

Maps

The island; with mountains, forests, settlements...its location lines. The intrepid tourists meeting the natives. The ships they used. The beasties that could well have devoured them; the winds that blew them there, and the friendly sun. Compass rose

MAPS

What is so fascinating about old maps? They are more than dry statements of where places are; they intrigue our imagination by telling a human story. Some of their charm also lies in their naïveté, and there is no denying that we feel smugly superior in our sophisticated knowledge of the *real* facts. But they are documents created with infinite care and patience (and even humor) as well as awe at the responsibility for accuracy accepted by the cartographer.

By contrast, we tend to think of the modern map as cut-and-dried—automatic images, standard shape, size, outline; with north at the top, the sea in blue (or gray, if no color is available); and covered with names. Too little thinking goes into defining the message the map is intended to convey, for we think of a map as a sterile cliché only capable of showing the relation of one place to another. Yet the basic map can be manipulated graphically to do far more than just that.

1/ Map as picture:
A naturalistic image of an area. Here, Alaska shown as a photo of a model with topography, colors & all.

2/ Map as diagram:
Plotting of places related to each other. Dot size represents size...width of connecting arrows represents volume of flow between them.

3/ Map as graph:
Areas built up of layers to indicate amounts—here: population of the boroughs of New York City.

How to peel a ball and spread the curved skin out so it lies flat—that's the problem. And there is no ideal solution to it. Each solution represents some compromise and requires some exaggeration in the image. That's why the choice of projection becomes an editorial decision: which version tells the story to the best advantage?

Photos of the globe are as realistic as we can hope to be, and the closest we can come to them in a drawing is by an oblique orthographic projection. This equatorial orthographic projection is just one stylized angle of viewing where the equator is taken as the horizontal.

Azimuthal equidistant Polar projection

The Mollweide Projection spreads the globe out, making all land masses visible (though distorted at the edges).

The globe opened up and viewed from above the North Pole.

Conic projection Northern Hemisphere

A combination of the two views above (Mollweide and Polar projections) yields a very legible and recognizable set of shapes—with two South poles (!)

Looking down at the North Pole but showing only the Northern hemisphere prevents the distortions inevitable when the entire globe is forced into one view—as in the version above.

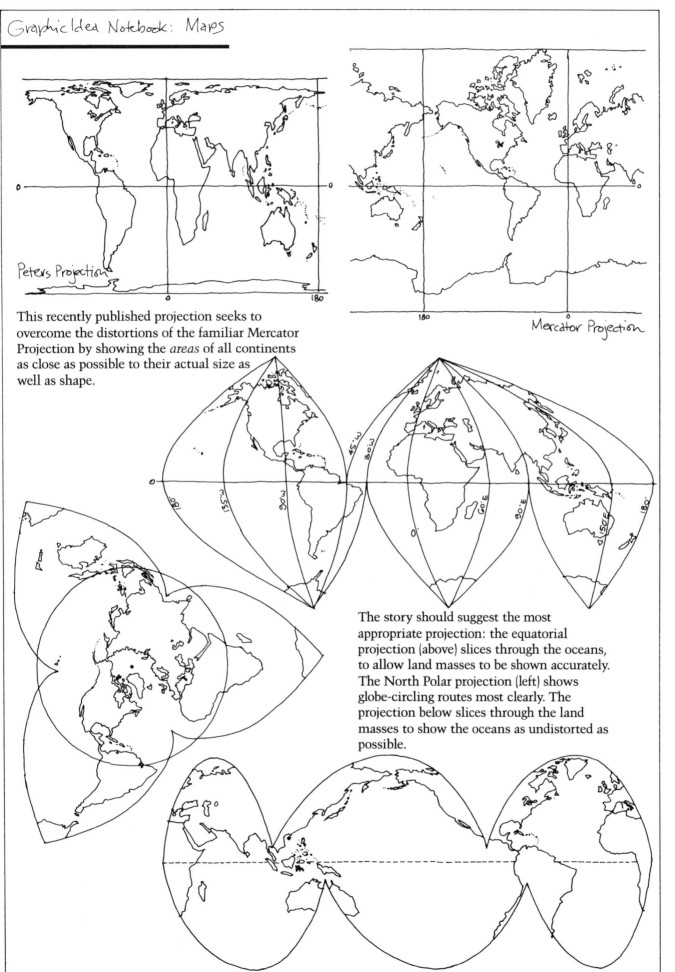

Peters Projection

Mercator Projection

This recently published projection seeks to overcome the distortions of the familiar Mercator Projection by showing the *areas* of all continents as close as possible to their actual size as well as shape.

The story should suggest the most appropriate projection: the equatorial projection (above) slices through the oceans, to allow land masses to be shown accurately. The North Polar projection (left) shows globe-circling routes most clearly. The projection below slices through the land masses to show the oceans as undistorted as possible.

193

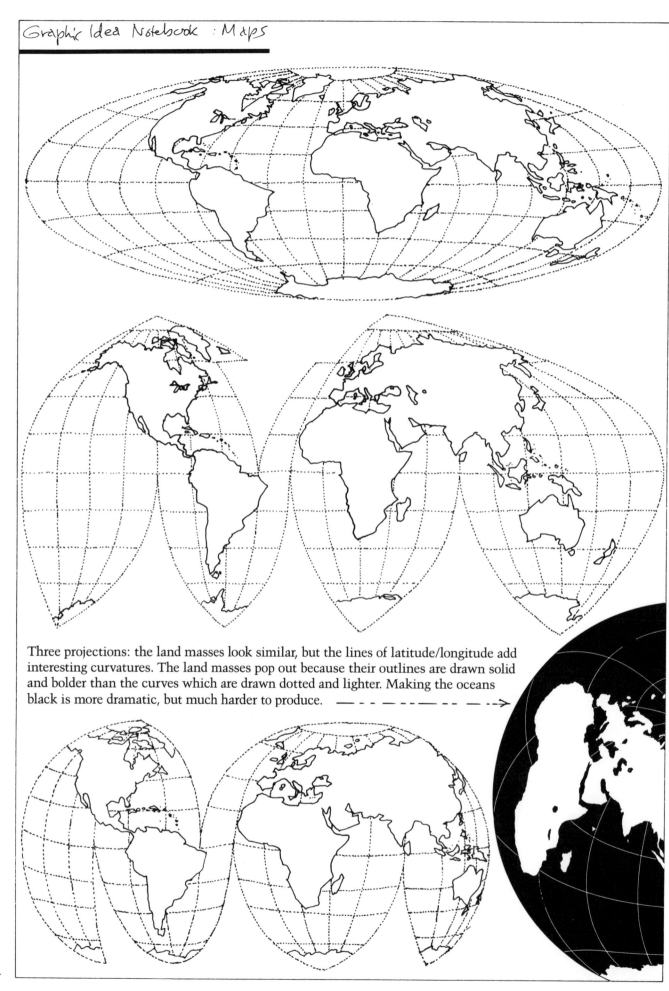

Three projections: the land masses look similar, but the lines of latitude/longitude add interesting curvatures. The land masses pop out because their outlines are drawn solid and bolder than the curves which are drawn dotted and lighter. Making the oceans black is more dramatic, but much harder to produce. — – – – – – →

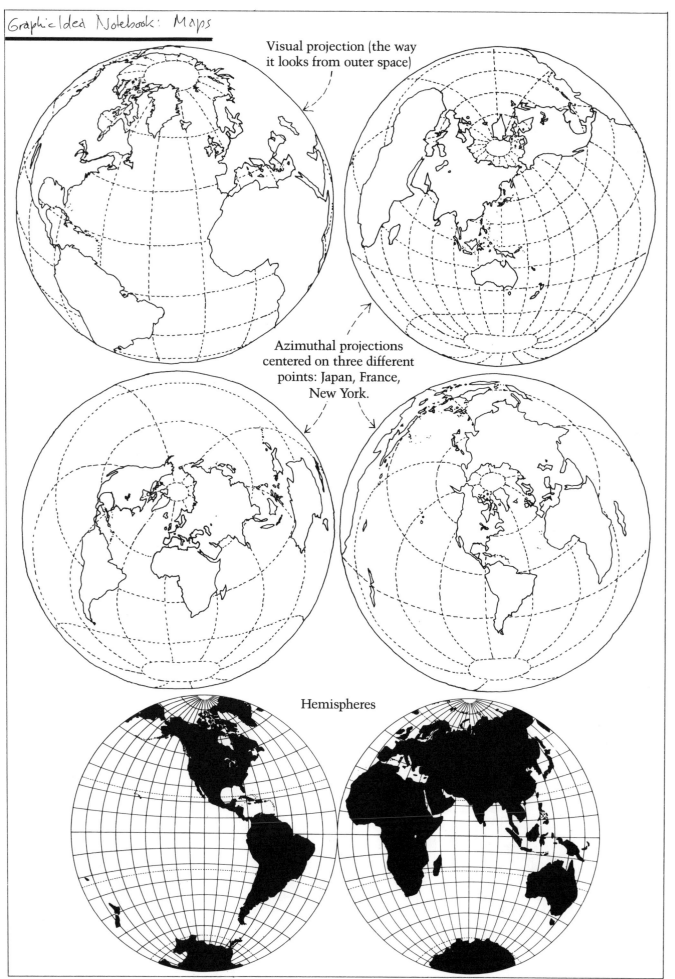

Visual projection (the way it looks from outer space)

Azimuthal projections centered on three different points: Japan, France, New York.

Hemispheres

Header

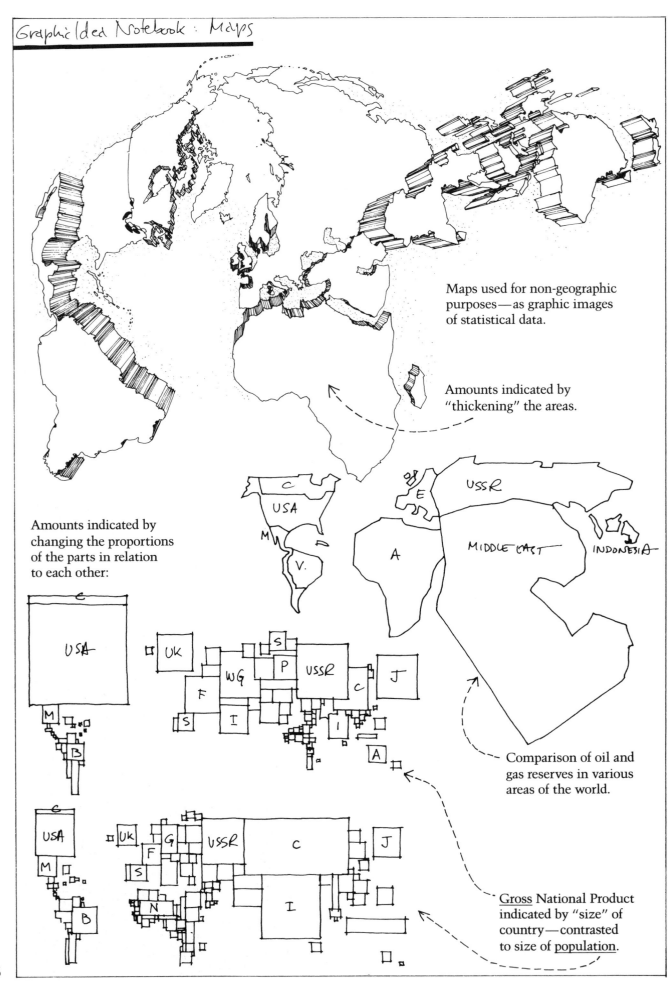

Maps used for non-geographic purposes—as graphic images of statistical data.

Amounts indicated by "thickening" the areas.

Amounts indicated by changing the proportions of the parts in relation to each other:

Comparison of oil and gas reserves in various areas of the world.

<u>Gross</u> National Product indicated by "size" of country—contrasted to size of <u>population</u>.

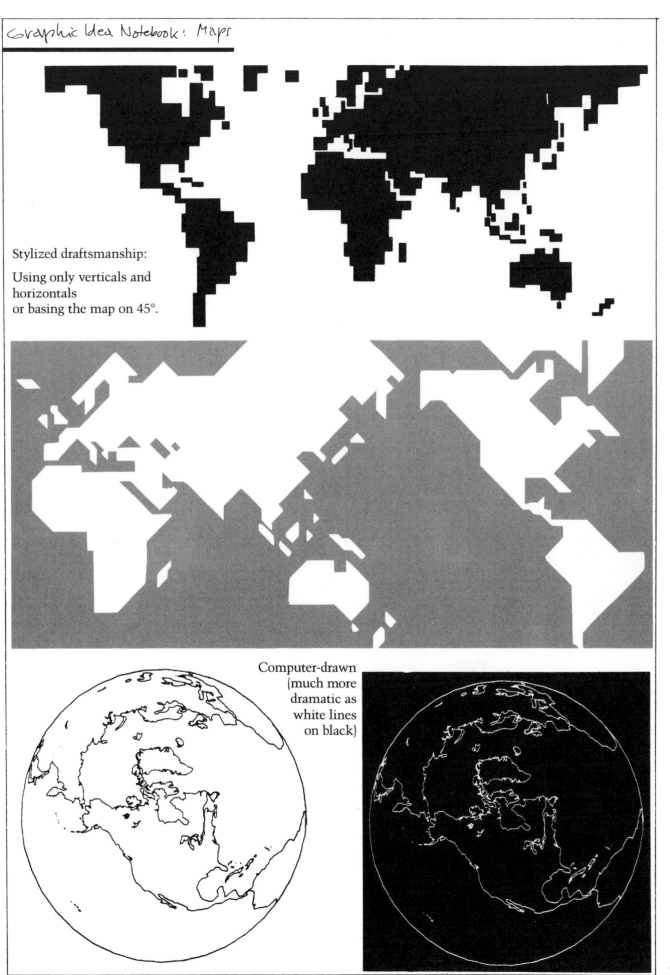

Stylized draftsmanship:

Using only verticals and horizontals
or basing the map on 45°.

Computer-drawn
(much more
dramatic as
white lines
on black)

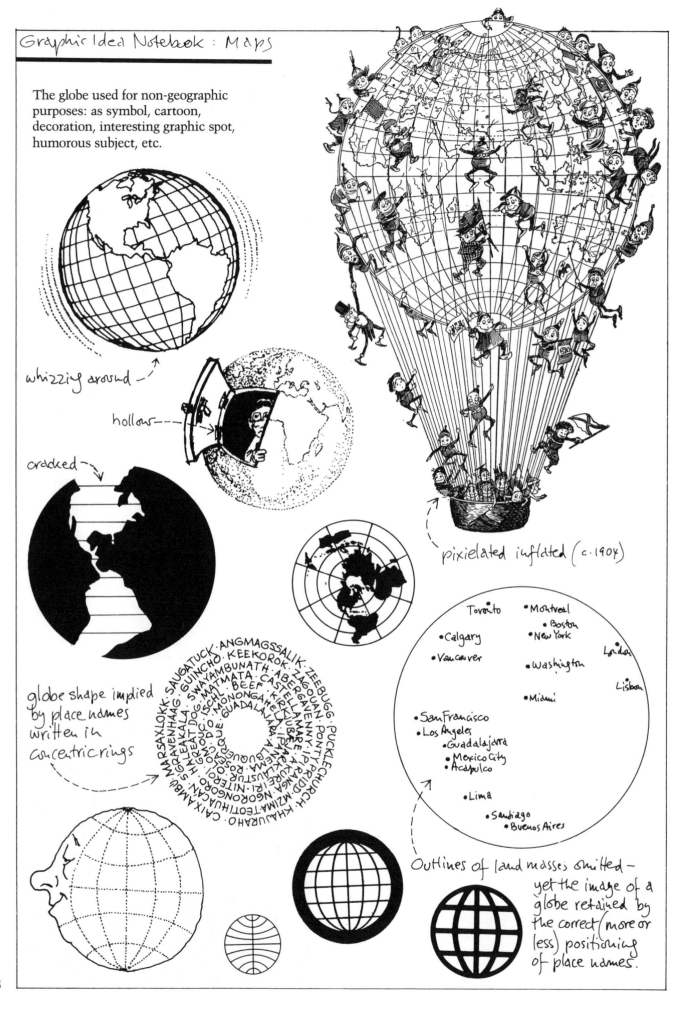

The globe used for non-geographic purposes: as symbol, cartoon, decoration, interesting graphic spot, humorous subject, etc.

whizzing around

hollow

cracked

pixielated inflated (c.1904)

globe shape implied by place names written in concentric rings

MARSAXLOKK · SAUGATUCK · ANGMAGSSALIK · ZEEBUGG · PUCKLECHURCH · GRAVENHAAG · GUINCHO · KEEKOROK · ZAGOUAN · PONTYPRIDD · SWAYAMBUNATH · ABERGAVENNY · IPRANGA · MATMATA · CASTELLAMARE · KUKE · HALEAKALA · MONONGAHELA · KIRKUBBE · LUBEC · GREAT DOG · ISCHL · BEEF · GROYC · O · ROSEO · GUADALAJARA · ANEMA · IRI · NITEROI · KHLAURAHO · MZIMA · TEOTIHUACAN · CAIXAMBU · NGORONGORO

Toronto · Montreal · Boston · New York · Calgary · Vancouver · Washington · London · Lisbon · Miami · San Francisco · Los Angeles · Guadalajara · Mexico City · Acapulco · Lima · Santiago · Buenos Aires

Outlines of land masses omitted — yet the image of a globe retained by the correct (more or less) positioning of place names.

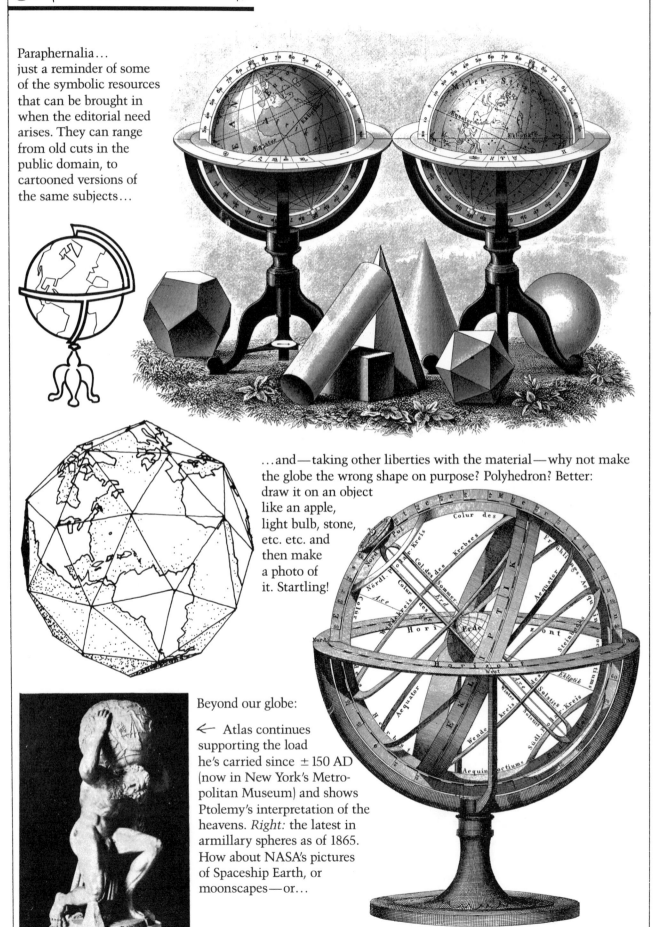

Paraphernalia…
just a reminder of some of the symbolic resources that can be brought in when the editorial need arises. They can range from old cuts in the public domain, to cartooned versions of the same subjects…

…and—taking other liberties with the material—why not make the globe the wrong shape on purpose? Polyhedron? Better: draw it on an object like an apple, light bulb, stone, etc. etc. and then make a photo of it. Startling!

Beyond our globe:

← Atlas continues supporting the load he's carried since ± 150 AD (now in New York's Metropolitan Museum) and shows Ptolemy's interpretation of the heavens. *Right:* the latest in armillary spheres as of 1865. How about NASA's pictures of Spaceship Earth, or moonscapes—or…

199

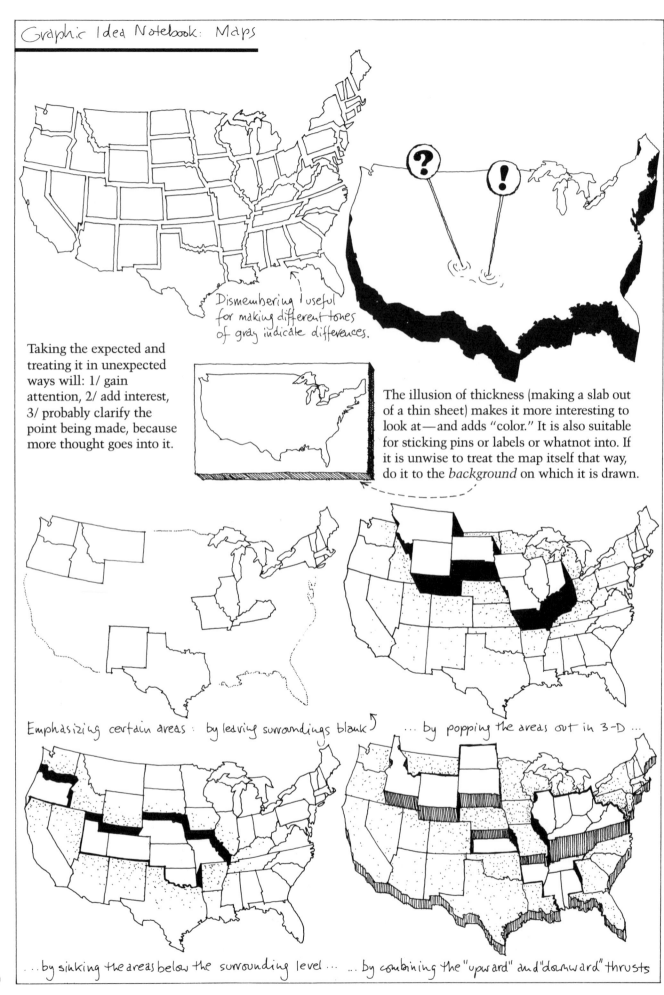

Dismembering useful for making different tones of gray indicate differences.

Taking the expected and treating it in unexpected ways will: 1/ gain attention, 2/ add interest, 3/ probably clarify the point being made, because more thought goes into it.

The illusion of thickness (making a slab out of a thin sheet) makes it more interesting to look at—and adds "color." It is also suitable for sticking pins or labels or whatnot into. If it is unwise to treat the map itself that way, do it to the *background* on which it is drawn.

Emphasizing certain areas: by leaving surroundings blank

... by popping the areas out in 3-D ...

...by sinking the areas below the surrounding level ...

... by combining the "upward" and "downward" thrusts

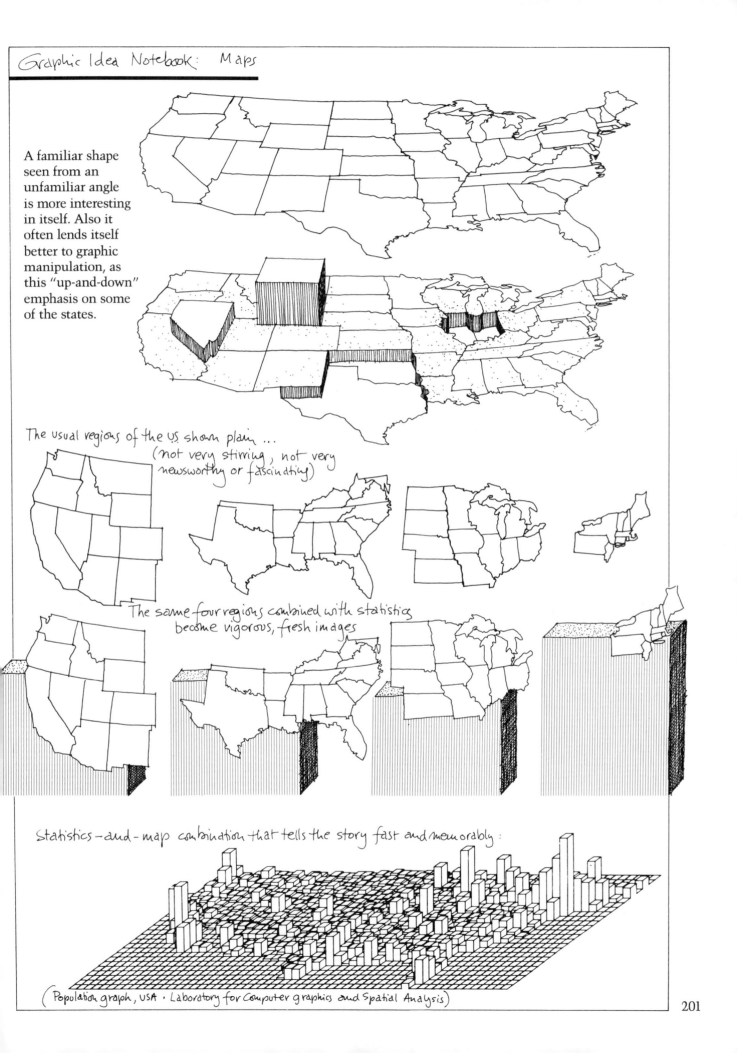

Graphic Idea Notebook: Maps

A familiar shape seen from an unfamiliar angle is more interesting in itself. Also it often lends itself better to graphic manipulation, as this "up-and-down" emphasis on some of the states.

The usual regions of the US shown plain ... (not very stirring, not very newsworthy or fascinating)

The same four regions combined with statistics become vigorous, fresh images

Statistics—and—map combination that tells the story fast and memorably:

(Population graph, USA · Laboratory for Computer graphics and Spatial Analysis)

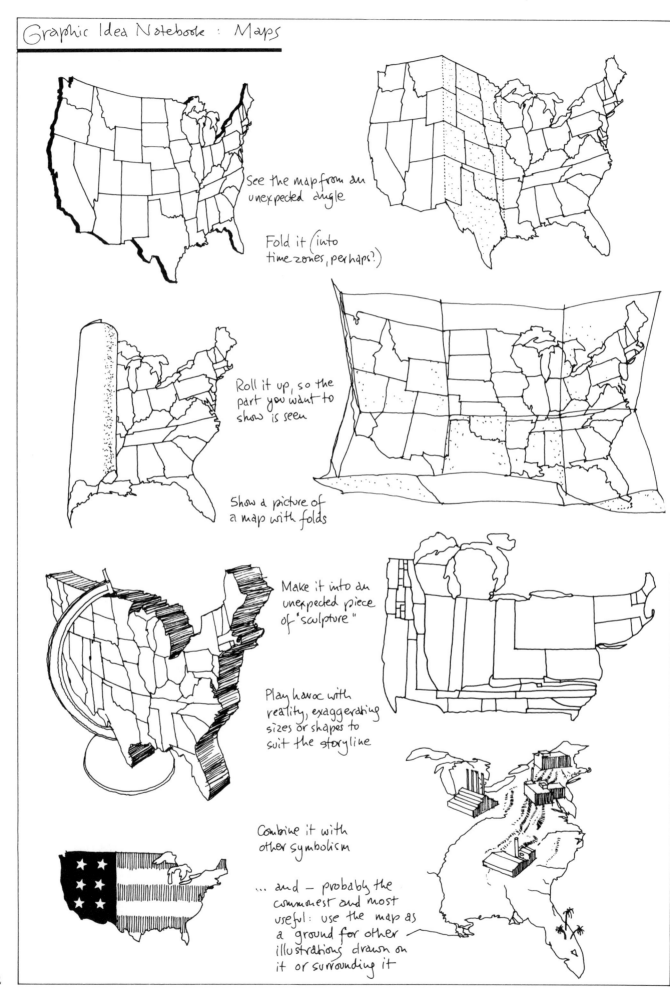

See the map from an unexpected angle

Fold it (into time zones, perhaps?)

Roll it up, so the part you want to show is seen

Show a picture of a map with folds

Make it into an unexpected piece of "sculpture"

Play havoc with reality, exaggerating sizes or shapes to suit the storyline

Combine it with other symbolism

... and — probably the commonest and most useful: use the map as a ground for other illustrations drawn on it or surrounding it

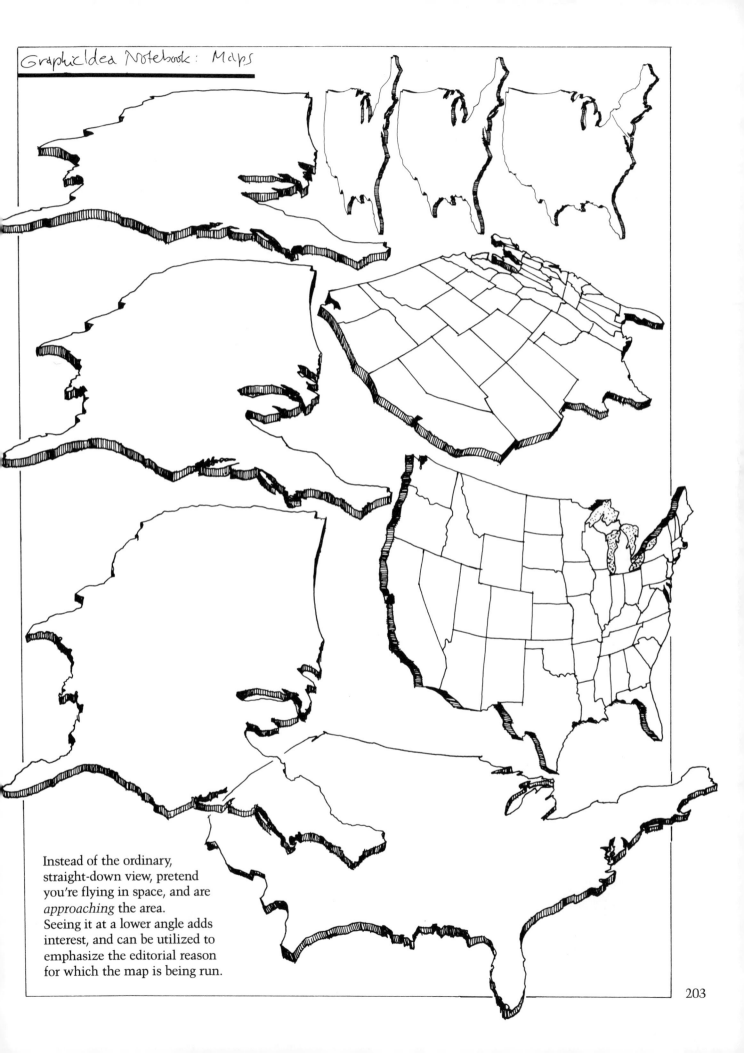

Instead of the ordinary,
straight-down view, pretend
you're flying in space, and are
approaching the area.
Seeing it at a lower angle adds
interest, and can be utilized to
emphasize the editorial reason
for which the map is being run.

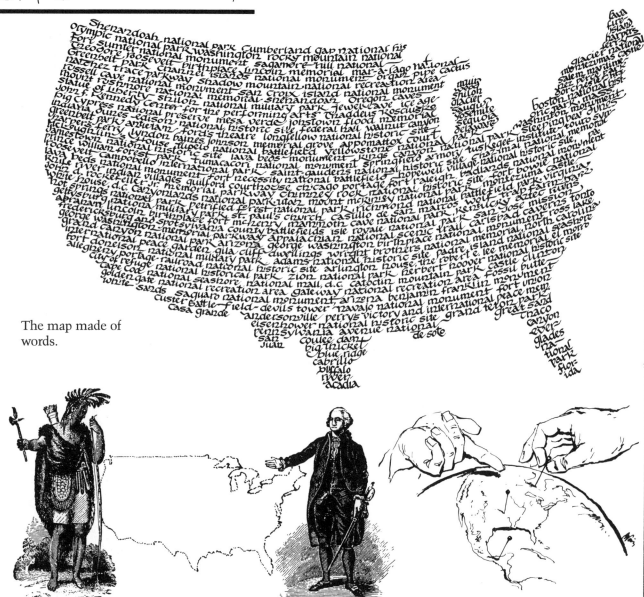

The map made of words.

To illustrate the technique of combining the map with external images of some sort (people, hands, whatever) to reveal the intended editorial meaning by means of their symbolism.

Cut the map out of unexpected material. Here a reproduction of sackcloth was used, and the edges retouched with pen and ink to simulate knots (well-enough to fool the eye at first glance, anyway). Far more dramatic: to make it of some REAL material and then photograph it as realistically as possible: as a pie? a steak? a brick walkway? plywood? carpeting? Anything flat is possible to use.

Superimpose the shape over a picture (here as a 40% screen over an old steel engraving).

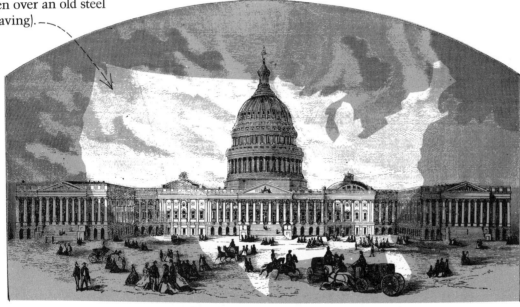

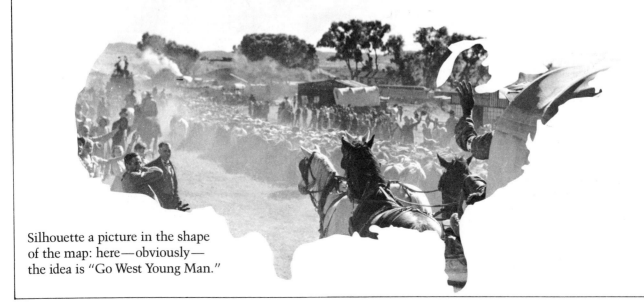

Silhouette a picture in the shape of the map: here—obviously— the idea is "Go West Young Man."